ART IN MIND

Art in Mind

How Contemporary Images Shape Thought

ERNST VAN ALPHEN

The University of Chicago Press | Chicago and London

Ernst van Alphen is Queen Beatrix Professor of Dutch studies and professor of rhetoric at the University of California, Berkeley, as well as professor of literary studies at the University of Leiden. He is the author of a number of books in English, most recently *Armando: Shaping Memory*; *Caught by History: Holocaust Effects in Contemporary Art, Literature, and Theory*; and *Francis Bacon and the Loss of Self*.

The University of Chicago Press, Chicago 60637
The University of Chicago Press, Ltd., London
© 2005 by The University of Chicago
All rights reserved. Published 2005
Printed in the United States of America

14 13 12 11 10 09 08 07 06 05 1 2 3 4 5
ISBN: 0-226-01528-9 (cloth)
ISBN: 0-226-01529-7 (paper)

♾ The paper used in this publication meets the minimum requirements of the American National Standard for Information Sciences—Permanence of Paper for Printed Library Materials, ANSI Z39.48–1992.

LIBRARY OF CONGRESS CATALOGING-IN-PUBLICATION DATA

Alphen, Ernst van.
 Art in mind : how contemporary images shape thought / Ernst van Alphen.
 p. cm.
 Includes bibliographical references and index.
 ISBN 0-226-01528-9 (cloth : alk. paper) — ISBN 0-226-01529-7 (pbk. : alk. paper)
 1. Art and society—History—20th century. 2. Art, Modern—20th century.
3. Art—Philosophy. I. Title.
N72 .S6A43 2005
709' .04—DC22

 2004015820

CONTENTS

List of Illustrations | vii

Acknowledgments | xi

Introduction | xiii

1 Thinking about Art in History | 1

PART 1 | EXPOSING HISTORY

2 The Portrait's Dispersal | 21

3 Shooting Images, Throwing Shadows | 48

4 The Representation of Space and
the Space of Representation | 71

PART 2 | REWRITING HISTORY

5 The Homosocial Gaze | 99

6 Men without Balls | 120

7 Facing Defacement | 140

PART 3 | WORKING THROUGH HISTORY

8 Caught by Images | 163

9 Playing the Holocaust | 180

Notes | 205

Bibliography | 213

Index of Terms and Concepts | 223

Index of Names and Titles | 226

ILLUSTRATIONS

1 *Bellezza,* emblematic figure from Cesare Ripa, *Iconologia* (1593) 7

2 Antoine Watteau, *The Judgment of Paris* (1720) 17

3 Pablo Picasso, *Daniel-Henry Kahnweiler* (1910) 26

4 Cindy Sherman, *Untitled Film Still,* no. 16 (1978) 29

5 Francis Bacon, *Three Studies of Isabel Rawsthorne* (1967) 33

6 Francis Bacon, *Studies from the Human Body* (1975) 34

7 Lucien Freud, *Interior with Plant, Reflection Listening (Self Portrait)* (1967–68) 36

8 Christian Boltanski, *Monuments* (1987) 39

9 Christian Boltanski, *The Clothes of François C* (1972) 41

10 Marlene Dumas, *Teacher (sub b)* (1987) 42

11 Marlene Dumas, *The First People (I–IV)* (1991) 42

12 Marlene Dumas, *Black Drawings* (1991–92) 45

13 Rineke Dijkstra, Kolobrzeg, Poland (July 23, 1992) 46

14 Fiona Tan, video still (colonial group portrait), *Facing Forward* (1999) 57

15 Fiona Tan, video still (tourist film), *Facing Forward* (1999) 57

16 Fiona Tan, video still (ethnographic film), *Facing Forward* (1999) 57

17 Fiona Tan, video still (cameraman), *Facing Forward* (1999) 57

18 Fiona Tan, video still (credit line), *Facing Forward* (1999) 61

19 Fiona Tan, video still (looking at), *Saint Sebastian* (2001) 63

20 Fiona Tan, video still (looking with), *Saint Sebastian* (2001) 63

21 Fiona Tan, video still (looking at), *Saint Sebastian* (2001) 64

22 Fiona Tan, video still (looking at), *Saint Sebastian* (2001) 64

23 Fiona Tan, video still, *Lift* (2000) 68

24 Fiona Tan, video still, *Lift* (2000) 68

25 Marien Schouten, *Untitled* (1987) 72

26 Jan Dibbets, *Perspective Correction (Four Horizontal Lines)* (1968) 78

27 Jan Dibbets, *Perspective Correction (My studio I, 1-Square on wall)* (1969) 79

28 Elenor Bond, *Social Centers* (1990) 82

29 Elenor Bond, *Social Centers* (1990) 82

30 Philips Koninck, *Landscape* (1664) 84

31 Marien Schouten, *Drawing with Wooden Slats* (1988) 86

32 Gerard Houckgeest, *Interior of the Old Church, Delft* (1654) 87

33 Marien Schouten, studio view: *Wall Painting* (1985) 89

34 Marien Schouten, *Painting with Wooden Boards* (1989) 89

35 Marien Schouten, *Steel Fence* (1996) 91

36 Marien Schouten, *Bronze Painting* (1995) 93

37 Marien Schouten, *Snake* (2001) 94

38 Matthew Barney, video still (two satyrs), *Drawing Restraint 7* (1993) 121

39 Matthew Barney, video still (kid satyr), *Drawing Restraint 7* (1993) 121

40 Matthew Barney, production still (dandy satyr), *Cremaster 4* (1994) 122

41 Matthew Barney, production still (Loughton sheep), *Cremaster 4* (1994) 122

42 Matthew Barney, *Unit BOLUS* (detail) (1991) 130

43 Matthew Barney, video still (satyr with long legs), *Drawing Restraint 7* (1993) 130

44 Matthew Barney, production still (leather suit with openings), *Cremaster 4* (1994) 132

45 Matthew Barney, production still (satyr-dandy within the Island of Man),
 Cremaster 4 (1994) 132

46 Matthew Barney, production still (Marti), *Cremaster 1* (1995–96) 135

47 Matthew Barney, production still (testicles), *Cremaster 4* (1994) 135

48 Matthew Barney, production still (fairies in yellow dresses), *Cremaster 4* (1994) 137

49 Matthew Barney, production still (naked fairies), *Cremaster 4* (1994) 138

50 Matthew Barney, production still (genital with tubes), *Cremaster 4* (1994) 138

51 Marlene Dumas, *Models* (1994) 141

52 Marlene Dumas, *Model* (1995) 144

53 Marlene Dumas, *The Cover-Up* (1994) 144

54 Marlene Dumas, *Rejects* (1994–) 145

55 Marlene Dumas, *The Human Tripod* (1988) 150

56 Marlene Dumas, *Pregnant Image* (1988–90) 150

57 Marlene Dumas, *Snow White and the Broken Arm* (1988) 156

58 Marlene Dumas, *The Ritual* (1988–91) 156

59 Marlene Dumas, *Snow White in the Wrong Story* (1988) 156

60 Marlene Dumas, *Snow White and the Next Generation* (1988) 158

61 Marlene Dumas, *Waiting (for Meaning)* (1988) 158

62 Marlene Dumas, view of studio with part of the *Magdalena* series (1995) 159

63 Marlene Dumas, *Magdalena: A Queen of Spades* (1995) 159

64 Christian Boltanski, "Washing in the Morning" from the *Comic Sketches* 181

65 David Levinthal, *Untitled,* no. 13, from the *Mein Kampf* series (1994–96) 182

66 Ram Katzir, cover image from *Your Coloring Book* (1996) 182

67 Zbigniew Libera, *LEGO Concentration Camp Set* (1996) 182

68 Ram Katzir, image from *Your Coloring Book* (1996) 191

69 Zbigniew Libera, *LEGO Concentration Camp Set* (detail) (1996) 192

70 David Levinthal, *Untitled* no. 16, from the *Mein Kampf* series (1994–96) 192

71 Roee Rosen, *Live and Die as Eva Braun,* no. 34 (1995) 193

72 Roee Rosen, *Live and Die as Eva Braun,* no. 2 (1995) 195

73 Ram Katzir, installation view of *Your Coloring Book: A Wandering Installation* 200

ACKNOWLEDGMENTS

Let me be brief in what could easily be a long discourse. I wish to thank a number of friends and colleagues for their responses to earlier drafts of the chapters of this book. Through their discussions with me about the artists and writers who are central in the thoughts developed in each chapter, they have contributed to this book in important ways. And the artists themselves have always responded with intelligence and insight, thus confirming the main thesis of this book. Most of these responses will show up in my references. I would especially like to mention Ken Apteker, Mieke Bal, Jill Bennett, Norman Bryson, Maghiel van Crevel, Chris Dercon, Hubert Damisch, Hercules Martins, David Reed, Nanette Salomon, Marien Schouten, Joost van der Vleuten, and Teri Wehn Damisch.

Special thanks are due to various institutions for the precious support they have granted me. First of all, I wish to thank the Getty Research Institute for their invitation to do research in the winter and spring of 2002. Without their exceptional generosity, the friendliness of the staff, and all the research facilities they provided, I would never have completed this book. Of the Getty staff, I am especially grateful to Charles Salas, and I am thankful to my research assistant Glenn Philips as well, who was always amazingly efficient. I am also grateful to Michael Ann Holly for the extraordinary hospitality that she offered me at the Clark Art Institute in Williamstown, Massachusetts, in the winter of 2001. My home institutions, first the Museum Boijmans Van Beuningen, then the Faculty of Letters at Leiden University, graciously allowed me to accept grants and take leaves of absence. In addition to putting up with my absences, my colleagues in the department of literary studies in Leiden provided me with the stimulating environment that I needed for developing my ideas.

I also thank the following journals and publications for allowing me to

reprint versions of published articles: *Portraiture: Facing the Subject*, edited by Joanna Woodall (chap. 2), *Vision in Context: Historical and Contemporary Perspectives in Sight*, edited by Teresa Brennan and Martin Jay (chap. 5), *Marlene Dumas: Models*, (chap. 7) *Image and Remembrance: Representation and the Holocaust*, edited by Shelley Hornstein and Florence Jacobowitz (chap. 8), *Art Mirroring Evil: Nazi Imagery Recent*, edited by Norman Kleeblatt (chap. 9).

In this book I will make a case for the power of art to transform ways in which cultural issues are being conceived. Art is a laboratory where experiments are conducted that shape thought into visual and imaginative ways of framing the pain points of a culture. To substantiate this view of art I will analyze the artistic, visual, and verbal means by which a number of artworks and artists practice cultural philosophy. I have selected contemporary art and literature to make this case.

This is by no means a novel conception of art. Although the dominant commonsense notions of art are still the expressive and conceptual ones, the importance of art is also quite often seen in terms that assign a much more active function, that is, a performative one. Art is then conceived as the realm where ideas and values, the building stones of culture, are actively created, constituted, and mobilized.

But in general this performative notion of art is not acknowledged or reflected in those scholarly disciplines that focus on artworks or literary texts professionally: art history and literary studies. In those contexts, art is usually "disciplined" as a historical product instead of as a historical agent. The discourses on art displace the agency of art to the historical period or figure from which it stems. This is one of the most striking paradoxes of the cultural disciplines: the widely underwritten aesthetics of art as agency is not, or is only poorly, accounted for in the writings of critics and scholars.

One of the motivations behind the relatively new interdisciplinary projects of cultural studies and visual studies is to develop a frame as well as a discourse that enable us to understand cultural objects and practices, including those of high art and literature, in terms of broader social practices. This does not mean, as some defensive opponents of cultural and visual studies have tried to argue,

that the historical understanding of art and literature is neglected or seen as superfluous.[1] On the contrary, genealogies increase rather than decrease in importance with these new approaches. An important difference between these interdisciplinary approaches and the more traditional ones, however, concerns the kind of genealogies within which cultural objects and practices are seen as being constituted. These are no longer limited to the history of artistic forms, of artists' intentions, of patronage, or of the social history of art. In the words of Douglas Crimp: "far from abandoning history, cultural studies works to supplant this reified art history with other histories. . . . What is at stake is not history per se [which is a fiction in any case], but what history, whose history, history to what purpose" (1999, 12). Crimp says this in the context of a discussion of the efforts by which art historians have tried to fit the work of Andy Warhol into the straitjacket of art historical conventions. Warhol was thus canonized. This admission into the domain of Fine Art went, however, at the cost of leaving undiscussed central issues addressed by Warhol's work. His work demands that we rethink the meanings of consumption, collecting, visibility, celebrity, sexuality, identity, and selfhood. These issues can be discussed as themes or, as Warhol did in his art, worked through as critical performance. But the disciplinary practices of art history are tongue-tied when faced with artworks that do not just thematize these issues but intervene or participate in them.

This example of the difficult insertion of Andy Warhol into the domain covered by art history also makes clear that cultural and visual studies is not, as is often assumed, restricted to privileging objects or practices from popular or mass culture. It is only that these objects and practices are no longer excluded. They can be discussed in juxtaposition to or within the same framework as objects and practices of literature or high art. This is not because there are no differences between popular, mass-produced objects and those traditionally construed as "fine art" but because they can arise from the same issues and raise similar questions, which transgress the restricted scope of the singular genealogy of either class of objects. Hence, although the coming chapters focus exclusively on images and texts that belong to the institutional realm of high culture, it is not their high culture status that I will address. I will try to contribute to the development of a kind of writing about cultural objects that accounts for their agency in culture.

For this approach I take my cue from the claim, strongly advanced by French philosopher and art historian Hubert Damisch, that art "thinks." Therefore, in order to explicate that notion I will devote the first chapter to his conception of art and, by extension, of art history. In order to substantiate the aesthetics of art as agency, I will follow Damisch's argumentation according to which art in its historical specificity engenders general, transhistorical, and philosophical ques-

tions. The way Damisch practices art history has much in common with what I have just described as the interdisciplinary project of cultural and visual studies. Not because he writes about popular or mass-produced culture, as he does not do that at all. But because he deals with artworks as historical articulations of problems that do not strictly belong to the reified repertoire of art historical genealogies. In this first chapter I will point out the methodological ramifications of the claim that art "thinks" and explore the different philosophical issues Damisch's work puts forward. The danger of such metareflections is that it is often hard to envision how they translate into a critical practice. This is why I will also show how Damisch put his theoretical claim to work in three of his books, which I consider to be his most important ones: *Theory of the /Cloud/, The Origin of Perspective*, and *The Judgment of Paris*.

The idea that art thinks is anchored in that tradition of modern aesthetics according to which art and literature are conceived as a form of critical understanding. The work of Theodor Adorno especially is a thorough, influential manifestation of this conviction. Adorno's central concept of the negativity of aesthetic experience considers modern works of art in their negative relationship to everything that is not art. It is this aesthetic negativity that determines the way artworks are experienced and should be conceived. However, the idea of art as critical understanding appears to imply that aesthetics is simply one discourse among many discourses and modes of experience that make up the differentiated realm of reason. One could object that this it is an utterly reductive view of aesthetic experience. For, such an objection would run, it is precisely art and literature that exceed the limits of reason underlying nonaesthetic understanding.

But this critique is based on a profound misunderstanding of the claim. Claiming that art should be dealt with as a mode of thinking is not the same as claiming that art yields positive understanding. Aesthetic experience is a process that starts out as an attempt at understanding, but this attempt is ultimately negated. In the words of Christoph Menke: "Aesthetic experience is a negative event because it is an experience of the negation (the failure, the subversion) of (the nevertheless unavoidable effort at) understanding" (1998, 24). In order to assess the difference between nonaesthetic understanding and the failed attempt at understanding of the aesthetic experience, Menke recasts the process of aesthetic understanding in semiotic terms. Nonaesthetic understanding is based on "automatic" understanding. This means that at the moment signifiers are identified, the meaning that is supposed to be embodied in them is identified. By contrast, the aesthetic enactment of understanding lacks such rules that make the identification of meaning possible. The viewer or reader is confronted "by the even more basic question of what, if anything, in this object

signifies" (34). Menke goes on to say that "since the signifier can never be definitely identified by the process of aesthetic understanding, but always loses itself in an unending vacillation, in aesthetic understanding, the bridge—which defines the comprehensible sign—breaks down between the two dimensions of semiotic representation" (36). The crucial function of aesthetic disruptions of understanding consists precisely in triggering efforts to form new signifiers. It is only through such efforts that the aesthetic enactment of understanding achieves a dissociation or distancing from conventional assumptions. It is in this sense that art is "autonomous"—not in the sense that it is independent of context but in that it has an agency of its own.

That agency changes the status of the frame in relation to art. If art "thinks," and if the viewer is compelled, or at least invited, to think with it, then art is not only the object of framing—which, obviously, is also true and important—but it also functions, in turn, as a frame for cultural thought. This intellectual importance of art is explored in the three parts of this book as three different manifestations of the intellectual and performative power of art.

In the first part, I will devote three chapters to the interventions art has made in central issues of culture through exposing the ways in which art practices in the Western tradition have inserted themselves in common cultural habits of dealing with these issues. Art has made interventions in thinking, imagining, and representing such key aspects of human existence as individuality, identity, and space. Each of these issues is of major relevance for cultural life, and each has been so keenly explored by artists that specific widespread genres are devoted to them. In these three chapters, portraiture, video, and landscape will be central—not so much as pictorial genres but as cultural areas of habit and debate. Pictorial genres and media have contributions to make in these areas, thus framing ways we conceive of our relationship to them.

In chapter 2, "The Portrait's Dispersal," I start from the close connection—perhaps even complicity—between the rise of individualism and its bond with a class society, and the heydays of the portrait as an artistic genre of high prestige. Contemporary art is alleged to comment, and offer critical thought, on the darker side of individualism. I will show how artworks probe contemporary alternatives for taking the person seriously without endorsing the hierarchies that once underlaid the individualistic philosophy of the subject. The traditional portrait gives authority not only to the self-portrayed but also to the conception of artistic representation that produces this increase of authority.

The illusion of the uniqueness and authenticity of the portrayed subject presupposes a belief in the unity of signifier and signified. As soon as this unity is challenged, as in the work of twentieth-century artists like Picasso, Warhol, Boltanski, and Dumas, whose work will be discussed in this chapter, the homo-

geneity and the authenticity of the portrayed subject falls apart. In twentieth-century art the portrait has become a problematic genre, marginal as well as central in a subversive way, for reasons primarily based on the breakdown of semiotic self-evidence or "naturalness." From a semiotic point of view the crisis of modernity can be seen as the recognition of the irreconcilable split between signifier and signified. At the moment that artists stop seeing the sign as a unity, the portrait loses its exemplary status for mimetic representation.

Artists who have made it their project to challenge the originality and homo-geneity of human subjectivity or the authority of mimetic representation often choose the portrait as the genre through which to make their point. The portrait returns in their work, but with a difference, now exemplifying a critique of the bourgeois self instead of affirming its authority; showing a loss of self instead of its consolidation; shaping the subject as simulacrum instead of as origin. The specificity and intimacy of the visual representations of the face in its assumed uniqueness constitutes a powerful, and powerfully specific, reflection on this disabused status of the individual. Only visual art is able to merge the two senses of reflection—intellectual and specular—so effectively that the resulting agency affects, rather than merely influences, the viewer at the threshold of awareness and sensation.

In the next chapter, this "visual unconscious" of the humanist epistemolog-ical regime that constitutes humanist subjectivity is further explored. Here, the video and film installations of Australian artist Fiona Tan are presented as ex-posing the ways in which the world is made to appear to the subject. The concep-tion of the "objecthood of images" depends fundamentally on the invisibility of the subject who observes the world as image. Tan, however, fundamentally un-dercuts the repercussions of this tradition by including the culturally specific observing subject into the image. In her works she "thinks" or, better, "rethinks" the image, by exposing in different ways the dependency of the image on the imagination of the observing subject. In her work the shooting of images is again and again followed by the foregrounding of the observer who throws the shadow of his presence onto the image shot.

In the last chapter of this section, "Representations of Space and the Space of Representation," I start from traditional seventeenth-century landscape and artists' theories about it to articulate ways in which both old and contemporary artists have proposed visual ideas about representation in its relation to space. In the Western tradition of art, the representation of landscape and of architec-ture has been subordinated to the higher demands of figuring history. I argue, however, that there are moments or cases in Western art where the depiction of landscape or architecture becomes the privileged pictorial practice. This shift implies more than a change of subject matter. Those moments of the promi-

nence of space are self-reflexive. The depiction of landscape or architecture is, then, not an end in itself as a representation of space but the way in which the space of representation itself is being explored. By means of representing space, artists make programmatic statements about the kind of space that is at stake when one makes images. This space of representation will be explored through the works of two contemporary Dutch artists, Jan Dibbets and Marien Schouten.

In this first part, then, art functions as a frame, in the sense that it actively frames historically sanctioned habits of conceiving and endorsing individuality as the key to subjectivity, the relationship between subjectivity and the constructed objecthood of images, and the world in which the subject is situated and specularly imprisoned. This framing must also be seen according to the negative, threatening sense of the word. As a frame-up, art exposes history.

Whereas in the first part, I primarily discuss the critical function of art, the second part of the book considers the intellectual and performative power of art to reinterpret, indeed to rewrite, powerful historical habits—in particular, the ways representations of gender in art have naturalized specific sociocultural gender constructions. To the extent that any radical rewriting denaturalizes what it rewrites, this rewriting is at the same time an intervention.

In the first two chapters of part 2, I consider how a critique of traditional masculinity (in chap. 5) makes possible a radical refusal of the masculinity-femininity opposition (in chap. 6). For the former, my cases are Ian McEwan's novel *The Comfort of Strangers* and Paul Schrader's adaptation of this novel for the screen. The literary work imagines the seductions and the violence of face-to-face interaction between men. This violence is dictated by one subject's gender history. I analyze the novel as well as the film as deconstructions of homosocial violence as the motor of male heterosexual desire. Within McEwan's allegory, the homosocial violence is literal and lethal violence. The visual motive of imagining, literalized as "taking pictures," locates the violence of the homosocial realm in the unseen: in a mode of looking. The violence originates in the gaze that disembodies and objectifies its objects. This analysis builds on the visual thoughts in imagining that we see at work in Tan's videos in chapter 3.

Building, in turn, on these ideas but shifting the emphasis, chapter 6 probes the way American artist Mathew Barney frames common assumptions about gender in his artwork. He questions the idea that sexuality is derived from a gendered identity. His works seem to explore, imagine, and "image" an open relationship between sexuality and gender. Masculinity is no longer constructed or "shaped" by means of the qualities that are ascribed to the male genitals. The result of this refusal opens a domain of phantasmic possibilities where imagination and image collapse.

The chapter "Facing Defacement" (chap. 7) is devoted to the exploration of traditional representations of the female body in visual art and the alternative vision that undermines the self-evidence of those interpretations. Here, the art under discussion queries the conflation of the female body with the perfection of art and of art with the perfection of the female body. South-African artist Marlene Dumas makes the motive of the model (artist's model, fashion model, pornography model) a central object of reflection in her work. Her images exploit the ambiguous status of the concept of mimesis. The object of mimesis can indicate the preexisting object from which the representation was made but also the resulting creation.

The term "model" refers to this ambiguity. It is a further specification of the accusative of mimesis. A model is not just any preexisting object or just any resulting creation. A model is, in one way or another, perfect. This implies that an ideal of perfection, beauty, can either be found in preexisting objects, in "megamodels" to use Dumas's own term, or it can be achieved through artistic labor. Many artists and art historians have taken this ambiguity to heart. They have persistently conflated the two meanings of beauty. Dumas, however, exposes, and then rewrites, the Western representational politics of representing women within the paradigm of the model in the sense of the ideal. Damisch posits the way art thinks about this connection in his *Judgment of Paris*. Art by Dumas is engaged as visual thought on the position of women in this tradition. And as with the portrait, the visuality of this thought is especially powerful as a rewriting of the visual regime that dictates the terms of this position.

The ways in which parts 1 and 2 propose that art frames cultural issues and debates might be construed as limited to intellectual issues only. One can perhaps fool oneself into thinking this for the issues raised in part 1, because in those issues philosophy and representation meet. Part 2 makes this more difficult because gender, however intellectually this issue has been discussed of late, affects the body and the subject's experience of it. And visual art, precisely because it is experienced differently from intellectual debate, is eminently suitable to affect the way we think. Thought, here, can no longer be severed from the body and the imagination that binds thought to body. Thus art influences thought on an embodied level, and it makes the influence visible, so that thought of any kind can no longer appear "natural." Rewriting historically naturalized habits is, then, an intervention in the strongest possible sense.

In order to make this specific, perhaps even specialized, way in which art frames thought, clearer, the last two chapters of my study deal with the least intellectual yet the most obviously important issue I can think of, namely, historical trauma. In two case studies on Holocaust-related contemporary art I will

argue that the way art thinks affects more than just intellectual debate. In spite of art's elitist social position, the radically innovative thought it visualizes is in principle able to contribute decisively new ideas on issues that deeply affect large constituencies.

In chapter 8, then, I will use a body of literary work to theorize—or rather, to demonstrate how this imaginative text theorizes—the importance of vision in traumatic experiences that deny access to the narrativity that is indispensable for even having an experience. This is a paradoxical effort that underscores how radically our ways of thinking and experiencing must be revised. American novelist Toni Morrison has insisted on the founding, grounding function of specifically visual images in the "re-membering," the healing activity of memory that present-day culture, facing the disappearance of the eyewitness, is struggling to articulate and implement. Doubling the paradox, it is most clearly and convincingly through creative written texts, commonly called "fiction," that this visuality and its truthfulness can be assessed. This chapter will discuss the trilogy *Auschwitz and After* of the Holocaust survivor Charlotte Delbo and is, to quote Toni Morrison, about the "'picture' and the feelings that accompany the picture" (1987b, 111).

Chapter 9 offers some thoughts toward closing the gap between historical ways of thinking and the present's own historicity. This chapter brings the notion of art that thinks to bear on the way in which art theorizes framing itself. Producing artworks that literally make the historical trauma the subject of play, artists of the second and third generation of Holocaust survivors make a claim for the indispensable ways in which art can reframe trauma so that it can be "worked-through." Artworks in the form of toys or play by the artists Ram Katzir, Christian Boltanski, David Levinthal, Zbigniew Libera, and Roee Rosen are critical contributions to the cultural necessity to shake loose the traumatic fixation in victim positions. This fixation might be partly responsible for the "poisonous" boredom that risks jeopardizing all efforts to teach the Holocaust under the emblem "never again." Clearly, in the face of the overdose of information and educational documentary material, there is a need to complete a process of working through that has not yet been done effectively. The imaginative act of playacting the Holocaust, enabled by the artworks under discussion, clears away everything that stands in the way of felt knowledge, of the emotions the Holocaust experiences entailed—primarily, of the narrative mastery so predominant in traditional Holocaust education.

This last part highlights the most powerful and socially constructive function that art as thought can fulfill in a world that cannot thrive without the "thick" thought offered by imaginative, imaging experiments. From the critical function of exposing, through the intervention and reorientation of rewriting,

this function of working through history clutches the case for art as thought. But thought itself, thanks to art's experimenting with its limits, is now no longer "just" intellectual. It is now, in the strongest possible sense of the word, aesthetic—binding the senses through an indelible bond forged between the subject and the world it tries so hard to inhabit.

1 Thinking about Art in History

{ ART AS THINKING }

In his treatise on painting (*Codex urbinas latinus* 1270), Leonardo da Vinci gives the following advice to painters:

> Do not despise my opinion, when I remind you that it should not be hard for you to stop sometimes and look into the stains of walls, or the ashes of a fire, or clouds, or mud, or like things, in which, if you consider them well, you will find really marvelous ideas. The mind of the painter is stimulated to new discoveries, the composition of battles of animals and men, various compositions of landscapes and monstrous things, such as devils and similar creations, which may bring you honour, because the mind is stimulated to new inventions by obscure things. (1956, 51)

It is remarkable that Leonardo places so much weight on the mind and ideas of the painter. The image we receive from his treatise on painting differs widely from the more romantic image of the artist that is still prevalent in the twentieth century. For Leonardo, painting is not an expressive, intuitive, sensuous, or emotional practice but, above all, an intellectual one. The painter thinks, discovers, and invents.

But the discoveries Leonardo talks about are not based on the recognition or identification of a perceived object or substance. On the contrary, because the forms of the observed "things" are "obscure," they do not constitute identifiable signifiers but rather nonsignifying patterns. The discoveries or inventions are the result of a process, or struggle, to make sense of something "obscure." This seems to be Leonardo's conception of a mode of thinking or understanding that is visual and not based on language.

The French philosopher and art historian Hubert Damisch has taken Leonardo's conception of art to heart. All of his writings are directed by the conviction that paintings and other cultural products perform, in one way or another, an intellectual or philosophical project. He never deals with paintings as mere passive manifestations of a culture or historical period or as the product of the artist's intention. Rather, the painter thinks, and she does that in her paintings. A painting is therefore for Damisch a reflection—not in the sense of the passive definition of the word, as a mirror image, but in the sense of the active definition, as an act of thought.[1] For this reason, I devote this first chapter to an exposition of his ideas, as a way of substantiating the claim that it is a useful way of positioning art in the cultural environment at large to consider it as a form of thought.

It is an axiom in the discipline devoted to the study of art that the meaning of art can only be formulated historically. An artwork, therefore, is always an expression of the historical period or figure that produced it. The importance attributed to the historical approach to the meaning of works of art has been so great that it even reflects itself in the name of the discipline: whereas disciplines that study cultural products like theater, film, or literature are called theater, film, and literary studies, the discipline that studies art calls itself art history. Thus, many art historians are surprised by Damisch's conviction that works of art appear to full advantage only if we deal with them as ways of thinking. For, unlike art historical interest in the artist's intention, Damisch's focus on thought does not refer to individual intention but, rather, to what Svetlana Alpers and Michael Baxandall in their book on Tiepolo (1994) would call "pictorial intelligence," a term that refers to the intellectual thrust of the image per se. The question that is therefore crucial to the definition of his approach is whether Damisch's work is ahistorical. In other words, is it art history after all, or does he locate himself, with his deviating approach and questions, outside the discipline of art history? And what does the answer to that question mean for the definition of art history?

It is obvious that Damisch is quite impatient with the way scholars claim history as the first and last word in the art historical tradition. In *Théorie du /nuage/* he characterizes the role of historical analysis in the study of art as a form of terror or tyranny that makes it impossible to ask questions that address more transhistorical or abstract issues. "The problem for theory is how not to surrender to the tyranny of humanism which will only recognize the products and epochs of art in their singularity, their individuality; and which considers illegitimate, even inadmissible, any inquiry into the invariants, the historical and/or transhistorical constants from which the plastic fact lets itself be defined in its generality, its fundamental structure" (1972, 143).[2] Damisch himself describes his works

as "structuralist." But we should not take this label too narrowly. The structural-ist approach as it flourished in the sixties in disciplines like anthropology, lin-guistics, and literary studies was often explicitly ahistorical. Systematic ques-tions were central and questions about the meaning or function of texts or cultures were being treated as text-immanent problems on which history had no influence.

However, it is impossible to recognize such a radical bracketing of history in Damisch's moves. History—the historical context of a work of art—has always been an important function in his structuralist analyses of art. Damisch's writ-ings stand out by his extraordinary knowledge of history. The place of history in his analyses is, however, surprisingly different from what we are used to in tradi-tional historical disciplines. He never lets the moves of his thinking be dictated by scholarly convention. He will not allow "history" to decide which questions are meaningful or legitimate. Nevertheless, Damisch fully acknowledges that whatever systematic, theoretical, or transhistorical question he asks, it must be addressed within the parameters of specific historical contexts. This is one of the reasons why it is not correct to place his work outside of art history. It is also the reason why I address his work here as a foundation for the chapters to follow.

Damisch's relation to history can best be clarified by means of the question he poses in the opening pages of *The Origin of Perspective:* "If history there be, *of what* is it a history?" ([1987] 1994, xix). This question sounds simple, but it has far-reaching and disenchanting implications. Through his demand for specifica-tion—*of what* is it a history?—Damisch, in fact, rejects the absolute meaning of the term "history." In Western culture, but especially in art history, it is standard to talk about history without an object. I have in fact invoked the same discur-sive strategy here by asking questions such as, What is the role of history in Damisch's work? By doing this, "history" is treated as a reality. And as a reality it becomes an unquestioned principle, a dogma. But for Damisch, history exists only insofar as it is the history of something. By using the term "history" in an absolute way, "History" receives an almightiness that is only comparable with that of "God." As a result, it becomes possible to imagine history as an active force that produces works of art—just as it produces wars as "natural" disasters. From this perspective, it is indeed legitimate to assume that the meaning of art can only be understood "historically" without reflection on what that adverb en-tails, and how it performs.

But Damisch assigns history to a more moderate albeit no less important place by consistently refusing to let it have an abstract or absolute meaning. This is due to his fundamentally interdisciplinary position. Whereas the philosopher Damisch prefers to ask general or abstract questions, the historian Damisch al-lows only a concrete use of the term "history." For the study of art, his concep-

tion of history leads to the unexpected yet commonsense question: Of what is art a history?

This question compels us to realize that the full significance of works of art cannot be appreciated in terms of history as an absolute concept. "History" is, but also has, a subject. The subject of art engenders general, transhistorical, and philosophical questions. "Historical" are the parameters within which a specific artist works, the idioms that have been passed on to her, and the specific articulation of her answers to a more general problematic. This more general problematic cannot, however, be reduced to purely historical terms. It is at least also philosophical and, hence, transhistorical. It pertains to the world of thought that we are steeped in at all times.

The implications of Damisch's assumptions that the meaning of art can only effectively be addressed by considering it as a form of thinking are twofold. First, as beholder, one is invited to think "with" the work of art, which means that one is compelled to start a dialogue with it by articulating questions of a more general—for instance, philosophical, political, or social—nature. Only when the beholder of art poses these kinds of questions will the work of art release its ideas. Second, that which is historical about the work of art can only truly be understood when one allows the work to be a historical articulation of a general, more fundamental problem. Damisch formulates this within his structuralist framework as follows: "Painting is a distinct object of historical study and must be dealt with as such: which means paradoxically that one must adopt a deliberately structuralist point of view, which only throws the historical dimension of phenomena into greater relief" ([1987] 1994, 444). This statement characterizes the moves made by Damisch in all of his writings. The historical approach is not placed in opposition to a more theoretical or, in his own words, structuralist approach. Rather, he redefines the role of history in art history by showing again and again that only a theoretical perspective enables us to see works of art as a history *of something*. In the case studies I am presenting here, this is the principle frame from which I start.

Damisch's notion of art as a mode of thinking leads to an art historical practice that fundamentally differs from the narrower premises of art history. Although his work is usually not associated with the interdisciplinary endeavor of cultural studies, the two have a lot in common. The fact alone that he articulates works of art, or other cultural objects, in relation to issues and ideas that transgress the restricted genealogies that define the discipline of art history shows the affinity between his and the broader inquiry of cultural studies.

The more specific parameters of this affinity are predicated on the kind of general questions or issues with which Damisch confronts works of art. Diverse as his work may be, it all ultimately leads to the question, Why do we look at art?

What pictorial qualities attract us, as viewers, to art? Or, in more sensuous terms, what attracts us to art? It is, of course, not possible to give a singular answer to these questions. Works of art can evoke fascination and claim the attention of the viewer for different reasons, based on a great variety of pictorial qualities. In each of his main writings Damisch focuses on a different pictorial element to demonstrate how that element in the history of Western or sometimes Eastern art has been developed to captivate the beholder in the most literal sense.

This interaction between philosophical questions and historically inflected answers can only be shown at work in Damisch's concrete elaborations of each. I will therefore describe these interactions in *Theory of the /Cloud/, The Origin of Perspective,* and *The Judgment of Paris.* To anticipate my conclusions, Damisch, unlike his art historical colleagues, indeed sets out in his three main texts to develop an epistemology of the unknowable, a visual theory of subjectivity, and finally, to do what Freud himself did not venture to do, which is to produce a psychoanalysis of the aesthetic.

{ AN EPISTEMOLOGY OF THE UNKNOWABLE }

In *Theory of the /Cloud/* Damisch develops a history of Renaissance and baroque painting on the basis of a signifier that, again and again throughout the ages, occupies a modest, inconspicuous but at the same time crucial place in that history, namely, the /cloud/. He conceives of a period style like the Renaissance as a pictorial system or language with its own rules of grammar and semantics. Renaissance paintings thus suppress the pictorial surface in the material sense in order to open up an illusion of depth. In Byzantine and medieval art, in contrast, the materiality of the picture surface plays an important role. The definition of a nonillusionistic heaven produced by the physicality of the gold leaf pressed onto the wooden support in Byzantine painting is a good illustration of this principle.

Damisch puts the signifier /cloud/ between slashes to indicate that he deals with clouds as signs that have different meanings in different pictorial contexts rather than clouds as realistic elements. Again and again the /cloud/ occupies an uncomfortable place within such pictorial systems. It never has an immanent function or meaning but receives one only in the relations of opposition and substitution that the /cloud/ maintains with the other elements of the pictorial system. The /cloud/ always opens up another dimension than the one at first revealed by the pictorial system of which it is part. Thus the /cloud/ always functions as a kind of hinge—as a hinge "in the relation between earth and heaven, between here and there, between a world that is obedient to its own laws and a

divine space that cannot be known by any science" (146). The /cloud/ thus has a value that is more than just decorative or picturesque.

The /cloud/ performs this special role first of all symbolically—that is, iconographically and thematically. A column or spiral of clouds can refer to the presence of Yahweh who guides his people through the desert from Egypt to the land of Israel. But in Francisco de Zurbarán's painting *Vision of the Blessed Alonso Rodriguez,* the clouds that surround Christ, Maria, and the angels in the upper part of the painting indicate that this image should be read as a representation of the vision of Alonso Rodriguez, who is depicted in the lower part of the painting. In a symbolic way the /cloud/ in this painting provides access to another dimension than the one pictorially evoked at first sight. In Andrea Mantegna's painting *The Resurrection of Christ,* the clouds indicate the miraculous event of the resurrection, whereas the clouds in Giotto di Bondone's fresco in the basilica of Assisi show that the Holy Fransiscus has been represented in divine rapture.

In the famous book *Iconologia* (Rome, 1593) by Cesare Ripa, the character of the allegory of beauty presents clouds in a totally different manner. In this case they are not divine or miraculous. Instead, they address the problem of what precisely is representable. Ripa's book provides allegorical figures for a great variety of ideas and phenomena. In a certain sense, the possibilities of allegorical representation are endless because an allegory does not have to be motivated by its subject. An allegorical code is arbitrary and artificial. However, when Ripa tries to convey the notion of beauty in the form of an allegory, the possibilities of allegory fail. We see a naked woman whose head disappears into clouds (fig. 1). For nothing is more difficult to know than Beauty. "She" is divine, and that explains why it is impossible to represent her in the language of mortal beings. Hence, in Ripa the /cloud/ has a theoretical function and indicates the limits of representation and the representable.

The function of clouds in Mantegna's ceiling painting in the palace of the duke in Mantua, or in Antonio Allegri da Correggio's dome painting *The Vision of the Holy John of Patmos* in Parma, does not fall under the domain of the symbolic or theoretical but must instead be seen as pictorial. Both ceiling paintings provide views of heaven: an endless space that is filled by clouds. The illusion of endlessness has been established here by means of a *dal sotto in sù* perspective, from bottom to upper edge without the depiction of a horizon. We look straight up into the air. How is it possible that clouds that block the view to open sky are able to evoke the illusion of endlessness?

An endless space as such is nothing and signifies emptiness. Paradoxically, therefore, picturing space can only be indicated by filling it with bodies. The pictorial function of bodies can consist of their power to evoke differentially emptiness and infinitude. But clouds are not physical bodies. They are bodies without

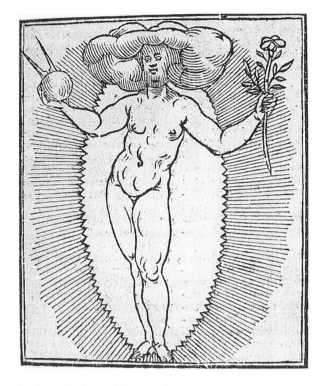

1 | *Bellezza,* emblematic figure from Cesare Ripa, *Iconologia* (Rome, 1593)

clear contours, without surface, and without concrete substance. From this per-spective, clouds occupy a position between the concrete reality of the earth and the emptiness, endlessness, and abstraction of heaven. In the cases of Correggio and Mantegna this in-between position is no longer articulated symbolically but in a purely visual way. The visual and material qualities of clouds enable the /cloud/ to perform this pictorial function. This is a good example of visual thought in its historical performance. Damisch points out that the Christian church that commissioned Correggio to paint endless heavens in the churches, slightly later also banned Galileo because of his new cosmology, which opened up heaven by pushing the earth from its center. While the church considered as pagan the mathematics that had given rise to this new cosmos, this new cosmos already presented its visual influence on Christian religion in the form of spe-cific pictorial images.

Damisch's next step is an analysis, on the basis of the /cloud/, of paintings in which the pictorial field is ordered according to the principles of linear perspec-

tive. His starting point is Filippo Brunelleschi's famous demonstration of perspective at the beginning of the fifteenth century. After having painted the baptistery in Florence on a small wooden panel, Brunelleschi made a tiny peephole in the panel. Then he designed a mechanism to look at the image. Standing in the spot from which the baptistery was painted, the viewer placed the back of the panel directly in front of his face and looked at the baptistery through the peephole. Looking through the same peephole at a mirror reflecting the painted surface of the panel, the views were revealed to be nearly identical. The image of the baptistery reflected in the mirror thus met the principles of the theory of linear perspective because in this way the vanishing point and the viewing point were geometrically synonymous. This demonstration also shows that perspectival representation concerns two constructed planes: the plane of the viewer—stationary, monocular—and that of the display.

It is significant that Brunelleschi did not paint the sky above the baptistery; rather he executed it in silver leaf. This silver reflected real clouds above the head of the viewer as he looked into the apparatus. This application of silver indicates that perspective was understood as a structure or architecture that could only grasp clearly delimited spaces and bodies with well-defined contours. The sky and the clouds, however, could not be analyzed by the order of perspective precisely because of their lack of contour and surface. But when Brunelleschi mirrors the clouds by means of silver, this artifice is more than a simple subterfuge to overcome the problem caused by linear perspective. In the words of Damisch: "It has the value of an epistemological emblem . . . to the extent that it reveals the limitations of the perspective code, for which the demonstration furnishes the complete theory. It makes perspective appear as a structure of exclusions, whose coherence is founded on a series of refusals that nonetheless must make a place . . . for the very thing it excludes from its order" (1972, 171). When Brunelleschi decides to include the clouds in his demonstration he seems to imply that the architectural order of perspective was not considered as a means to provide the scientific aspirations of the painter with endless, limitless possibilities. Perspective was rather seen as a technique that is conditioned in a fundamental way by the formless, the unformed, which is unknowable and unrepresentable. In the words of Rosalind Krauss, "If the /architectural/ came to symbolize the reach of the artist's 'knowledge,' the /cloud/ operated as the lack in the center of that knowledge" (1996, 335).[3]

Earlier I claimed that Damisch's work is always directed by the question, Which pictorial qualities and elements attract us and seduce us into looking at art? In *Theory of the /Cloud/* the answer is found in the /cloud/. By means of the /cloud/ we get access to those realms that are visually unrepresentable: the divine, the unknowable, the unformed. The attraction of works of art now consists

in a kind of visual epistemology: they are able to make present that which withdraws from our cognitive power. It is in line with this conception that the artworks discussed in chapters 2–4 attract us. They offer an articulation of issues we live by but that, precisely for that reason, we cannot know.

{ A VISUAL THEORY OF SUBJECTIVITY }

Brunelleschi's demonstration of the principles of perspective also plays a major role in Damisch's next book. However, that role is different from the one the title of the book, *The Origin of Perspective,* at first seems to suggest. Damisch is not really interested in tracing the historical origin of perspective, although he does concentrate for many pages on the historical moment that, in art history, is usually considered to be the birth of perspective, that is, Brunelleschi's demonstration of it. In his argument, the three so-called Urbino perspectives have a central place as the very early and perfect examples of perspectival presentation of space. The most well known of them is *The Ideal City* (ca. 1500), the only one that is really in Urbino. But the "origin" from Damisch's title should rather be understood in a spatial sense. Damisch is interested in the precise status of the point of origin—the subject—out of which the perspective is ordered. Brunelleschi's demonstration functions now within a problematic that differs widely from that of *Theory of the /Cloud/*: Brunelleschi figures now in a philosophical quest of a very different nature. Within a conventional historical point of view such a plural use of one historical moment can hardly be legitimized.

A study of perspective cannot escape reflecting on Erwin Panofsky's famous essay "Perspective as Symbolic Form" from 1924 ([1924] 1991). Damisch, likewise, conducts a sustained critique of it. It offers a good starting point for a discussion of the status Damisch assigns to perspective. Understanding perspective as an example of Ernst Cassirer's concept of "symbolic form," Panofsky suggests that perspective is for him part of "an independent and characteristic structure, which does not achieve its value from an outward, transcendent existence that is somehow mirrored in it. What gives a symbolic form its meaning is that it builds up a peculiar and independent, self-contained world of meaning according to an inherent formative law of its own" (Cassirer [1924] 1955, 383). Damisch convincingly shows, however, that Panofsky does little justice to Cassirer's concept of symbolic form. His lengthy psychophysiological comments even contradict it. By renaturalizing perspective Panofsky implicitly indicates that, for him, the image on the retina is the ultimate touchstone for perspectival construction. For Panofsky, perspective is actually a realistic or naturalistic form. It is only "symbolic" insofar as it is the symbolic form par excellence of the Italian Renaissance. But

this historicizing use of Cassirer's term has emptied it of all its theoretical and critical thrust. Damisch, in contrast, takes Cassirer *à la lettre*. He deals with perspective as a paradigm that is governed, in its regulated operation, by determinations and constraints of a structural order that, as such, is completely independent of both humanist culture and historical contingency.

Before he can expose his own vision, Damisch first must eliminate some misunderstandings about perspective. For example, he contends that the importance of perspective in cultural history is highly overestimated. Perspective is often considered to be one of the main contributions of the Renaissance. It is not only considered one of that period's most important products, but it is supposed to have fundamentally determined the way of thinking and looking of Renaissance man. But, Damisch points out, the number of Renaissance paintings actually painted according the principles of perspective is in fact relatively small. Their influence on "Renaissance man" cannot have been that great. Only now, in the twentieth century, do perspectival constructions surround us as a result of technologies such as photography, film, and video, which order our visual domain through the automatic use of linear perspective's principles. But here, Damisch demonstrates the drawbacks of historicism even in terms of history itself. Historical evolutionism, which is still dominant in cultural and art history, excludes the possibility of paying attention to that historical contingency. The ubiquity of perspective nowadays can paradoxically only be understood as an archaic remnant of the Renaissance.

The importance of the invention of perspective is overestimated not only in cultural history but also in art history. For Giorgio Vasari, perspective was only "a simple technique." For him it had practical value because it enabled the painter to produce surprising spatial effects. In the Renaissance, perspective had more important consequences for philosophy and geometry than for art. The Renaissance is conventionally characterized by a blurring of the borders between different domains of knowledge, of science and art. Thus painting could be used for demonstrating a scientific invention. But perspective was not designed as a technique to imitate or represent human vision. If that had been the case, perspective would also have had theoretical importance for Renaissance art. Instead, perspective was invented only as a means to present the visual domain.

But if Damisch relativizes the importance generally assigned to perspective, it does not follow that perspective is a negligible phenomenon for him. On the contrary, he attributes to perspective what may be considered an even more fundamental significance than it has had thus far. But that significance is no longer confined to cultural or art history. It is a form of thought. In order to demonstrate the full impact of this conception, Damisch equates the structure of perspective to the structure of an expression in language. This implies that there is

a subject who does the enunciation and an interlocutor to whom the enunciation is addressed.

The way Damisch understands the structure of an enunciation is determined by the linguistic theory of Emile Benveniste and the psychoanalytic theory of Jacques Lacan. For both theorists, an expression in language does not only have a referential or descriptive meaning; it is of importance above all as a structure that constitutes subjectivity. That capacity of language is unavoidable in the case of personal and demonstrative pronouns. These expressions have no fixed referent. They are called deictic or "shifters": they receive meaning only at the moment they are used. The personal pronouns "I" and "you," for instance, refer to a different person each time they are used by someone else. By using the expression "I" the speaker establishes her subjectivity because she presents herself as a "point" that can also be addressed by somebody else as "you." A second person is of crucial importance for the constitution of subjectivity because only a second person can acknowledge the subjectivity of the first person. If this moment of interpellation does not take place, the /I/ still has no meaning or subjectivity.

Because of language's capacity to produce subjectivity, Benveniste assumes that the essence of language consists of *deixis* rather than of reference. Something similar holds for Lacan. He does not focus on the dialogical situation between an "I" and a "you" but on a subjectivity that comes about through being interpellated by the symbolic order. This symbolic order consists of the world of language and representation as well as of all the cultural laws and rules. For Lacan, integrated, unified subjectivity arises only in contact with the symbolic order because it is the symbolic order that provides the structures and distinctions that can give the subject form. It acts as the "you" who confirms but also stipulates the conditions under which subjectivity can emerge.

In the case of perspective, the relation between symbolic order and subjectivity takes shape spatially and visually. The subject sees its origin reflected in the system of representation. Whereas in art history the viewer of perspectival constructions is usually considered to dominate the visual field that stretches out in front of her, in Damisch's conception this power relation is reversed. The viewer depends on perspectival constructions for the illusion of her or his unified subjectivity. This dependence also explains the attraction of perspectival constructions for viewers. Facing a perspective painting, the viewer is "unified." A deeper significance of perspective is thus existential or philosophical rather than merely (art) historical.

Damisch not only expounds on his vision of perspective, he also demonstrates it by his mode of writing. The third part of his book is written in the first person; this first person addresses explicitly a second person, a "you." In doing so, Damisch invokes the tradition of Socratic dialogues. The second person in his

text is not the reader of his text, as you are of my text but is, rather, the topic or "subject" of his book. In the same way that the viewer is addressed in front of a perspective painting, Damisch does not speak *about* perspective; he starts a dialogue with it. He begins a conversation with historical treatises on perspective.

By using this striking, provocative rhetorical structure, Damisch indicates in a theatrical way that a perspective painting cannot be compared with a text in the third person that provides disinterested information about an object. The structure of, for instance, the three Urbino perspectives has nothing in common with that of an atlas or a tourist guide. The illusion of mastery and ownership of the visual field provided by a perspective painting is an effect of the viewing position: seemingly the viewer has not had any position in the constellation of the perspective. The image presents itself as third-person text that has no room for an "I" or a "you." But it is precisely the implicit "I" that defines the structure of perspective. The lines of perspective in front of the painting create the viewing point. It is due to this invisibility and to the implicit nature of the I-you structure that the "I," that is, the viewer, can mirror him- or herself in the illusion of objectivity and coherence provided by perspective-as-a-seemingly-third-person-text.[4]

This probing interpretation of perspective turns a pictorial device into a subject-constituting cultural semiotic. It argues for a vision of art that binds intellectual to experiential—indeed sensuous—living. It is but a small step from this fundamental view to the specific discussion of the impact of cultural structures on the ways we live our gendered, sexualized subjectivity. In this sense the artworks discussed in chapters 5–7 can be seen as specifying elaborations of Damisch's structural view of perspective.

{ WORKING THROUGH AESTHETICS }

Damisch's works are intricately related to one another. Brunelleschi's demonstration links *Theory of the /Cloud/* with *The Origin of Perspective*. Ripa's allegory of beauty links *Theory of the /Cloud/* with the third work I wish to discuss, *The Judgment of Paris*. According to Ripa it is so hard to behold or to paint beauty because the light that surrounds beauty blinds us. He formulates, or "theorizes," the impossibility of seeing beauty by means of the image of a naked woman with her head covered by clouds (fig. 1). In his treatise on clouds, Damisch, too, was especially interested in the use of clouds as a conveyer of the idea that beauty is unknowable and unrepresentable. In his book *The Judgment of Paris*, Ripa's allegory figures within a complex of reflections of a different nature. This time Damisch's moves between art and history concern the essence of beauty and that which remains hidden or repressed when we see beauty.

In *The Judgment of Paris* Damisch ponders the quality that for many people is still synonymous with art: beauty. But what is beauty and what role does beauty play in considering art? This question seems both fundamental and impossible to answer. We constantly make judgments about the beauty of something; whether an object possesses it or not, or to what degree. In philosophy, these judgments are known as aesthetic judgments. But when we want to know precisely of what beauty consists, it is difficult to say anything substantial. Remarkably, at a time when most of us find such judgments rather shameful and prefer to keep them implicit, this is the very problematic to which Damisch devotes an entire book.

His approach to the problem is highly unexpected. Damisch confronts the remarks on beauty of two thinkers whose place in history starts somewhere in the past and continues until today, Sigmund Freud and Immanuel Kant. The first has admitted that he has little or nothing to say about beauty; the second has put aesthetic judgment as the central subject of one his most important works. Despite Freud's remarks that psychoanalysis is powerless to say anything about the idea of beauty, his concise observations enable Damisch to read Kant "differently."[5] The text in which Freud has expressed himself most directly about beauty is *Civilization and Its Discontents*. Two of Freud's observations, which both describe beauty as something paradoxical, play a crucial role in the moves of Damisch's argument. Freud states that "beauty has no obvious use; nor is there any clear cultural necessity for it. Yet civilization could not do without it" ([1905] 1953, 82). A page later, he makes the following observation: "'Beauty' and 'charm' are originally attributes of the sexual object. It is worth remarking that the genitals themselves, the sight of which is always exciting, are nevertheless hardly ever judged to be beautiful; the quality of beauty seems, instead to attach to certain secondary sexual characters" (83). Freud struggles here to articulate a possible relation between receptiveness for beauty, that is, aesthetic emotion and sexual excitement. These two emotions seem to be closely related as well as mutually exclusive.

The history of Western art seems to confirm Freud's observations. The representation of genitals in painting or sculpture has almost always been considered indecorous. In order for a painting to be judged "beautiful," the representation of genitals had to be avoided. Nevertheless, we cannot resist the temptation, as Damisch remarks, to browse works of art, like a child hiding under the table with a book, precisely for the sight of genitals.

In his *Three Essays on the Theory of Sexuality* Freud makes another observation on the relation between art and genitals that puts the relation between the broader notion of beauty and sexual excitement into perspective. "The progressive concealment of the body which goes along with civilization keeps sexual cu-

riosity awake. This curiosity seeks to complete the sexual object by revealing its hidden parts. It can, however, be diverted (sublimated) in the direction of art, if its interest can be shifted away from the genitals on to the shape of the body as a whole" (148). On the basis of this quotation, Damisch raises the possibility that beauty (defining art) is in some way derived from the object of sexual desire. In terms of his psychoanalytic theory Freud would call this a displacement. Rhetorically speaking, beauty would be a synecdoche—*toto pro parte*—for the genitals. Indecorous indeed.

This suggestion is countered by the text that is held as the most significant one in Western culture treating the judgment of beauty: Kant's *Critique of Judgment.* Kant's notion of taste, defined as the power to judge whether something is beautiful, presupposes an unbiased observer, an absolute disinterest on the part of the person who makes the aesthetic judgment. It is precisely this condition of "taste" that forbids the representation of genitals. Given the sexual excitation that the sight of genitals engenders, the disinterest of the viewer is jeopardized and her or his judgment nullified. This explains why we can only talk about beauty after the possibility of sexual excitement has been displaced or repressed. That is why genitals cannot be present in "beautiful art."

The notion of beauty cannot be applied to genitals because, Damisch claims, beauty is usually understood in terms of form, unlike the genitals, which belong, rather, to the realm of the formless. This does not imply that beautiful form is a substitute for formless genitals. The psychoanalytic concept of sublimation requires that we acknowledge the fact that the sovereignty of the unformed continues to play its role as an understream in the domain of form, of beauty that is.

Although Kant would be horrified by such an "impurity" and interestedness of aesthetic judgment, Damisch is able to spot precisely those passages in Kant that imply this unwittingly. In his *Observations on the Feeling of the Beautiful and Sublime,* written twenty-six years before his *Critique of Judgment,* sexual difference plays a remarkable role. Kant claims that the qualities of the female can be associated with those of the beautiful, whereas the qualities of the male can rather be understood in terms of the sublime. This brings to mind the question: Is the judgment on the beauty of a woman for Kant a matter of "taste;" does it concern a disinterested aesthetic judgment? Barely.

But Kant himself poses a similar question in his *Critique.* He asks: "What do we think when we say: 'That is a beautiful woman?'" This question forms a problem for his philosophy of aesthetic judgments because his notion of aesthetic judgment can only be applied to art, not to nature. His justification is as follows: in the case of a beautiful woman "we then judge nature no longer as it appears as art, but insofar as it actually *is* art (though superhuman art)." ([1790] 1987,

179–80) Whereas Kant has done everything to reserve aesthetic judgments for art, at this particular moment the sexual desire, which had to be repressed to reach his goal, returns. Kant's solution, to promote woman to the status of divine art in order to save his philosophy about aesthetic judgment, is ultimately unsatisfactory. That is why, inspired by Freud's concise remarks and further by Balzac's short story on absolute beauty in art, *Le Chef d'oeuvre inconnu,* Damisch concludes that in one way or another "there is a woman behind it somehow." In other words, for Damisch, any aesthetic judgment has an undertone or undertow of sexual desire.

As Damisch shows in the rest of his book, the myth of origin about aesthetic judgment—the Greek story of the judgment of Paris—and the representation of this myth in the history of Western art cannot help but convey precisely this to the viewer and reader. Paris, the unlucky prince/shepherd, was chosen to judge which goddess was the most beautiful: Hera (Juno), Athena (Minerva), or Aphrodite (Venus). Paris chooses Aphrodite by presenting her with a golden apple. He in turn receives the mortal woman Helen as his reward, which leads to the Trojan War and the destruction of an entire civilization.

But is it acceptable to read a Greek myth and its representation in Western art exclusively from the perspective of Kant's *Critique* and Freud's *Civilization?* Isn't this anachronistic? Basing himself on the work of Aby Warburg, Damisch would answer that the Greek myth, the representation of it in art, as well as Freud's and Kant's texts, are all part of the same mythical complex. This is one of his most crucial structuralist moves. Importantly, however, this is not to say that they can all be reduced to the same meaning. Rather, it means that they can only be understood in close connection to each other. This is a good example of Damisch's methodological point of departure: if we want to know about the historical dimension of a cultural product, we must first decide of which history it is a part. For Damisch, the Greek myth, Freud, Kant—but also paintings of the judgment of Paris by Peter Paul Rubens, Lucas Cranach, or Antoine Watteau and even Édouard Manet's *Déjeuner sur l'herbre* and Paul Cézanne's or Picasso's variations on it—can only be understood in a meaningful way by considering them as historically specific manifestations of the general tension between aesthetic judgment and sexual desire.

Now, the next move is to consider the myth as thought. When we see Kant, Freud, and the Greek myth within the same framework, the myth confronts us with the following problem: How is it possible that Western civilization has assigned to itself a mythical origin that at first sight seems to be the story of a faulty aesthetic judgment? Faulty, because it falsifies the premise on which culture seems to be based, namely, the repression of sexual desire. Whereas Hera represents sovereignty and promises Paris power as a reward, and Athena repre-

sents strength and holds out the prospect of victory to Paris, he chooses Aphrodite, the goddess of love and fertility, who rewards him with woman. It looks as if Paris has not chosen Aphrodite as the most beautiful goddess but, rather, came under her spell. Yet, if we can say that Paris falls for Aphrodite, it implies that the myth of the first aesthetic judgment is at the same time a myth of the first "sin." And it becomes difficult to distinguish Paris from Adam. It is not insignificant that an apple plays an important role in both myths.

On the basis of older Indo-European myths, Damisch argues that the judgment of Paris should not be read as a myth about gradual differences in beauty and a misjudgment. The myth addresses, instead, the issue of the essence of beauty. By choosing Aphrodite as ultimate beauty, the myth makes a statement about the nature of beauty, its relationship to desire and the judgments about both. Beauty can be understood neither in terms of Hera's sovereignty or wisdom nor in terms of Athena's strength. Beauty, however, should be understood within the tension between form and the unformed as being activated by love and sexual desire. The myth claims, in fact, that a disinterested aesthetic judgment à la Kant is an impossibility. From the perspective of such a reading of the Greek myth, it becomes understandable that the judgment of Paris functions as a myth of origin in Western civilization.

Damisch draws on a wide diversity of paintings, drawings, and prints to present his argument. Each representation occupies a different position in the history of reflections on aesthetic judgment. One painting, however, is clearly preferred because it represents most precisely and openly the displacement and repression of sexuality as a phase that precedes aesthetic judgment. It concerns Antoine Watteau's oil sketch of the Judgment of Paris (1720), in the collection of the Louvre (fig. 2). We see Paris represented at the moment he gives the apple to Aphrodite. The goddess is naked as usual; Hera and Athena, to the contrary, are fully dressed. The first can be recognized on the basis of the peacock, her conventional attribute. Athena holds up her shield, which functions as a mirror for Aphrodite. Yet most surprising in this painting is Aphrodite's position. While we usually see her frontally, we now see her from the back. Paris cannot see her face and breasts because she covers them with a veil. We see the reflection of her face in Athena's shield, but no sight of her genitals is offered to us. In the case of this painting, the displacement of Paris's judgment to our judgment is, in the most literal sense, "a displacement of the genitals (which have not participated in the development of human forms toward beauty) onto secondary sexual characteristics; a displacement of the sexual organs onto the face; a displacement of the unformed onto the formed, but also a displacement of form onto the *parergon*, the 'supplement' making it possible to conceptualize form in its very difference" (309). The reader struck, and bothered, by the exclusive gender positions

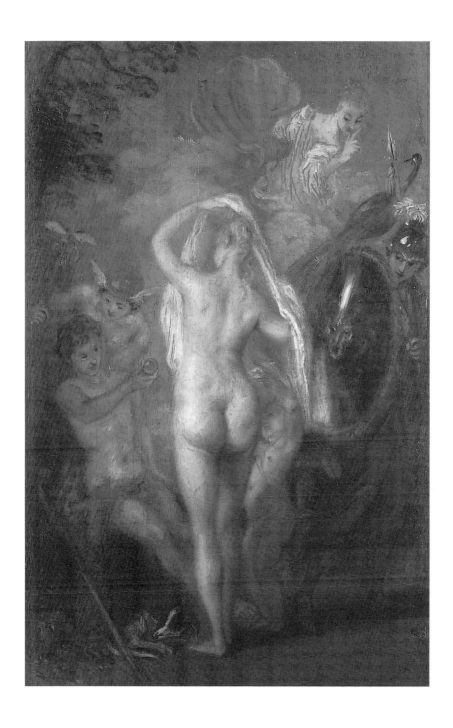

2 | Antoine Watteau, *The Judgment of Paris* (1720), oil on wood. Courtesy of the Louvre, Paris. Photo credit: Erich Lessing/Art Resource, New York.

in this argument will be relieved to hear that the last word has not been said on the difficulty of reconciling sexual and aesthetic attraction. My chapters devoted to these issues "rewrite" such a rigid division. Moreover, I draw this mode of thinking itself into a principle of working through history. In chapters 8 and 9 I argue, apropos of an altogether different cultural theme, for the importance of keeping general, structural issues on par with the different historical manifestations of the tensions inherent in these issues. Only then, I gather from Damisch's work, is it possible to work through, with art, what history has turned incomprehensible as well as unacceptable.

Through a rigorous analysis of the concept of beauty in philosophy and psychoanalysis, and a consideration of the motif of beauty in Western myths and art, Damisch succeeds again in *The Judgment of Paris* in formulating an aspect of art that makes it attractive. As in *Theory of the /Cloud/* and *The Origin of Perspective,* he again deals with a fundamental problem of the philosophy of culture. In *Theory of the /Cloud/* he shows that "cloud" paintings have the paradoxical capacity to allow, pictorially, a glimpse of realms that are not visually representable. He thus designs an epistemology of the unknowable. In *The Origin of Perspective* he analyzes the capacity of perspective paintings to confirm the viewer's precarious illusion of personal autonomy, which is the basis of subjectivity. He thus designs a visual theory of subjectivity. In *The Judgment of Paris,* Damisch shows how the beauty of art, in spite of Kant's opinions about it, draws the viewer somatically into the process of viewing it. This time he offers a psychoanalytic aesthetics. The three theoretical constructions he thus offers, moving through the history of art as thought, design the rules of the interaction in which culture consists. They regulate three of the most fundamental domains of culture: knowability, subjectivity, and desire.

PART 1 | EXPOSING HISTORY

2 The Portrait's Dispersal

{ THE AUTHENTICITY OF THE PORTRAIT }

The pictorial genre of the portrait doubly cherishes the cornerstone of bour-
geois Western culture, where the uniqueness of the individual and his accom-
plishments is central. And in the portrait, originality comes in twice. The por-
trait is highly esteemed as a genre because, according to the standard view, in a
successful portrait the viewer is confronted not only with the "original,"
"unique" subjectivity of the portrayer but also with that of the portrayed. Linda
Nochlin has expressed this abundance of originality tersely: in the portrait we
watch "the meeting of two subjectivities" (1974, 29).

Such a characterization of the genre immediately foregrounds those aspects
of the portrait that heavily depend on specific notions of the human subject, as
well as of representation. As for the represented object, this view implies that
subjectivity can be equated with notions like the self, personality, or individual-
ity. Someone's subjectivity is defined in its uniqueness rather than in its social
connections; it is someone's interior essence rather than a moment of short du-
ration in a differential process. Someone's continuity or discontinuity with oth-
ers is denied in order to present the subject as personality. One may ask if this
view does justice even to the traditional portrait.

As for the representation itself, the kind of notion we get from this view of
the representational characteristics of the portrait is equally specific. It implies
that the portrait refers to a human being that is (was) present outside the por-
trait. A comprehensive book on portraiture makes this notion of the portrait ex-
plicit on its first page: "Fundamental to portraits as a distinct genre in the vast
repertoire of artistic representation is the necessity of expressing this intended

relationship between the portrait image and the human original" (Brilliant 1991, 7).[1]

The artistic portrait differs, however, from the photographic portrait as used, for instance, in legal and medical institutions, by doing a bit more than just referring to somebody. It is more than documentation.[2] The portrayer proves her or his originality and artistic power by consolidating the self of the portrayed. Although the portrait refers to an original self already present, this self needs its portrayal in order to secure its own being. The portrayer has enriched the interiority of the portrayed's self by bestowing exterior form on it. For, without outer form, the uniqueness of the subject's essence could be doubted. The artistic portrayer proves her or his own uniqueness by providing this proof.

The traditional portrait in this equally traditional view seems to embody a dual project. Two interests are intertwined in this genre. The first interest is quite obvious, and an institution like the National Portrait Gallery in London is an explicit and extreme embodiment of it: the portrait's investment in the authority of the portrayed. To drive this point home I suggest that a general characteristic of the traditional portrait is being intensified as soon as we see it hanging in the National Portrait Gallery.[3]

The most innocent reading of the portraits hanging in such a gallery would be that the sitters were portrayed because they had authority in the first place, in whatever field of society. But since our insight into the past distribution of authority is mediated through, among other things, the portraits of historical figures to which, because they have been worthy of portrayal, we attribute authority, this intuitive acceptance of the "real" authority of the sitter is actually the reverse of that other activity, namely, placing authority in them through the function of the portrait. From the perspective of the viewer this innocent reading is a case of analepsis, of chronological reversal. It is because we see a portrait of somebody in the National Portrait Gallery that we presume that the portrayed person was important, and the portrayed becomes the embodiment of authority in whatever way. Thus, authority is not so much the object of portrayal but its effect. It is the portrait that bestows authority on an individual self. The portrait, especially when it is framed by its place in the National Portrait Gallery or a comparable institution, expects us to stand in awe, not so much of the portrait but of the portrayed.

The portrait, however, does more than this. It gives authority not only to the self portrayed but also to the mimetic conception of artistic representation that produces that increase of authority. Since no pictorial genre depends as much on mimetic referentiality as the traditional portrait does, it becomes the emblem of that conception. The German philosopher Hans-Georg Gadamer is a clear spokesman for this exemplary status of the portrait. He writes:

The portrait is only an intensified form of the general nature of a picture. Every picture is an increase of being and is essentially determined as representation, as coming-to-presentation. In the special case of the portrait this representation acquires a personal significance, in that here an individual is presented in a representative way. For this means that the man represented represents himself in his portrait and is represented by his portrait. The portrait is not only a picture and certainly not only a copy, it belongs to the present or to the present memory of the man represented. This is its real nature. To this extent the portrait is a special case of the general ontological value assigned to the picture as such. What comes into being in it is not already contained in what his acquaintances see in the sitter. ([1960] 1975, 131)

In the portrait, Gadamer claims, an individual is represented as neither idealized nor in an incidental moment but in "the essential quality of his true appearance."

This description of the portrait as exemplum of the (artistic) picture reveals the contradictory nature of mimetic representation. It shows how the traditional notion of the portrait depends on the rhetorical strategy of mimesis, that is, of a strategy of "make-believe."[4] According to Gadamer, in the portrait, more than in any other kind of picture, an "increase of being" comes about. This increase of being turns out to be the essential quality of the true appearance of the sitter. The portrait refers to this sitter who exists outside the work. Since the sitter exists outside the work, we may also assume that her or his essence exists outside the work.[5]

This implies that the portrait brings with it two referents. The first is the portrayed as body, as profile, as material form. The second is the essential quality of the sitter, his unique authenticity.[6] Within the traditional notion of the portrait, it is a truism to say that the strength of a portrait is judged in relation to this supposed essential quality, not just in relation to the looks or appearance of a person. This explains the possibility of negative judgments on photographic portraits. Although a camera captures the material reality of a person automatically and maximally, the photographer has as many problems in capturing a sitter's "essence" as a painter does. Camera work is not the traditional portrayer's ideal but its failure because the essential quality of the sitter can only be caught by the artist, not by the camera. The artist adds a semantic density to the sitter's features.

But in Gadamer's text we don't read about an essential quality that has been captured. The essential quality of the sitter is the increase of being that seems to be produced by the portrayer in the portrait. "What comes into being in it is not already contained in what his acquaintances see in the sitter." The portrayer makes visible the inner essence of the sitter and this visualizing act is creative

and productive. It is more than a passive rendering or capturing of what was presumed to be already there, although interior and hence invisible. The portrayer gives this supposed interiority an outer form so that we viewers can see it. This outer form is then the signifier (expression) of the signified (the sitter's inner essence).

What to do with the surplus of the increase of being? It is clear that Gadamer does not use the term "increase of being" for the portrait's "likeness" with the sitter's material form. He indicates the second referent of the portrait: the sitter's essential quality. He makes us believe that what comes into being in the portrait is the same as the referent or origin of the painting. He presumes an equivalence because they have been worthy of portrayal, between increase in being and the essential quality of the sitter, or semiotically speaking, between signifier and signified. By presuming that unity, he denies that the increase of being is a surplus. By doing that, Gadamer exemplifies the semiotic economy of mimetic representation. This economy involves a straightforward relationship of identity between signifier and signified.

This identity between signifier and signified is not inevitable. Andrew Benjamin historicizes the kind of semiotic conception that also underlies Gadamer's view in the following terms: "The signifier can be viewed as representing the signified. Their unity is then the sign. The possibility of unity is based on the assumed essential homogeneity of the signified. The sign in its unity must represent the singularity of the signified. It is thus that authenticity is interpolated into the relationship between the elements of the sign. Even though the signifier and the signified can never be the same, there is, none the less, a boundary that transgressed would render the relationship inauthentic" (1991, 62). Most surprisingly, Benjamin attributes authenticity neither to the signifier nor to the signified but to the special relationship between the two. In the case of the portrait this semiotic economy implies that the qualifications authenticity, uniqueness, or originality do not belong to the portrayed subject or to the portrait or portrayer but to the mode of representation that makes us believe that signifier and signified form a unity. In connection with the issue of authority, this entails a socially embedded conception: the bourgeois self depends on a specific mode of representation for its authenticity.

The link between a mimetic rhetoric and the production of authority can be illustrated with the example of Rembrandt. We think we know the face of Rembrandt because he was a prolific self-portraitist. We think this even though other painters have presented a face of Rembrandt quite different from his self-portraits.[7] Perhaps Jan Lievens's or Govert Flinck's Rembrandts come closer to what the artist "really" looked like, but how can we mistrust such a great artist to tell us the truth about himself?

My earlier remark that the portrait embodies a dual project now becomes clearer because more specific: the portrait gives authority to the portrayed subject as well as to mimetic representation. The illusion of the uniqueness of the portrayed subject presupposes belief in the unity of signifier and signified. As soon as this semiotic unity is challenged the homogeneity and the authenticity of the portrayed subject falls apart.

In twentieth-century art the portrait has become a problematic genre, marginal as well as central in a subversive way. From a semiotic point of view, this is so because the crisis of modernity can be seen as the recognition of the irreconcilable split between signified and signifier. At the moment artists stop seeing the sign as a unity, the portrait loses its exemplary status for mimetic representation. But artists who have made it their project to challenge the originality and homogeneity of human subjectivity, or the authority of mimetic representation, often choose the portrait as the genre to make their point. The portrait returns but with a difference, now in order to expose the bourgeois self, historically anchored and naturalized, instead of its authority; to show a loss of self instead of its consolidation; to shape the subject as simulacrum instead of as origin.

{ SUBJECTED SUBJECTS }

In an article on the end of portraiture, Benjamin Buchloh sees Picasso's 1910 portraits of his dealers, Kahnweiler (fig. 3), Vollard, and Uhde, as pronouncements of the death of the genre: "These antiportraits fuse the sitter's subjectivity in a continuous network of phenomenological interdependence between pictural surface and virtual space, between bodily volume and painterly texture, as all physiognomic features merge instantly with their persistent negation in a pictorial erasure of efforts at mimetic resemblance" (1994, 54). In these cubist paintings Picasso not only explored a new pictorial, representational mode but also articulated a new conception of subjectivity. What kind of subjects emerge from these cubist portraits, and how?

In the 1910 portraits, Picasso no longer made use of a plastic system of signs that referred iconically to referents, fictional or not. His representational mode was no longer mimetic. Instead, he used a small number of forms that signify in relation to each other, differentially. This new mode of representation was based on an economy in which no signifier forms a fixed unity with a signified. Yve-Alain Bois has described this cubist mode of signification in great detail in his seminal article "Kahnweiler's Lesson." He writes: "A form can sometimes be seen as 'nose' and sometimes as 'mouth,' a group of forms can sometimes be seen as 'head' and sometimes as 'guitar'" (1990, 90). The signs Picasso used in these por-

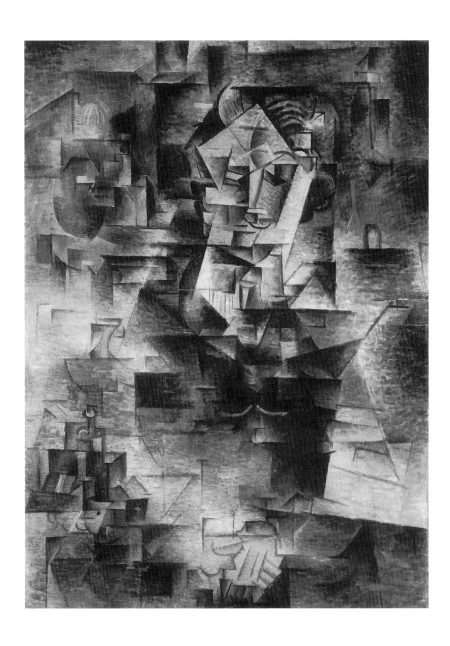

3 | Pablo Picasso, *Daniel-Henry Kahnweiler* (1910), oil on canvas, 100.6 × 72.8 cm. Courtesy of the Art Institute of Chicago. Gift of Mrs. Gilbert W. Chapman in memory of Charles B. Goodspeed, 1948.561. © 2004 Estate of Pablo Picasso/Artists Rights Society (ARS), New York.

traits are entirely "virtual, or nonsubstantial" and can no longer be assumed to relate mimetically to the object of representation. The portrayed subjects were shaped mainly as a result of a differential process between the signifiers used.

But does this signifying model based on structural difference also give rise to a new conception of subjectivity? Based on my earlier claim about the intertwinement of these two kinds of conceptions, one should expect so. There are remnants of the mimetic model insofar that the portrayed dealers look different. They can be distinguished from one another. Those who have known the sitters in person can perhaps even say that they recognize them. But as we have seen, a "good" portrait claims much more than physical recognizability, and it would be ludicrous to claim that Kahnweiler is depicted here in his full presence or essence. Instead, the process of shaping and constructing the illusion of subjectivity with forms that are arbitrary and exchangeable has become predominant. To differentiate subjects from one another, to depict them as individuals, is not the same as bestowing authenticity on them.

This becomes even more striking in portraits made by photographers, since their medium practically stands for accurate mimetic representation. Buchloh's reading of the portraits of the German photographer August Sander is based on the same principle of structural difference. Although the representational mode has little in common with Picasso's cubist portraits of 1910, a similar conception of subjectivity is implied in the works of the two artists. Sander made no single-frame portraits; his portraits always belong to series. And he always portrayed his subjects embedded in their social or professional context. His serial and contextual approach to the portrait leads to a conception of subjectivity that is again structural and differential. The significance of Sander's portrayed subjects is determined by the series in which they are included and by the social context that surrounds them. Browsing through Sander's portfolios we see repetitions of subjectivity rather than unique selves. In short, these subjects are not represented as self-determining subjectivities.[8]

The notion of subjectivity that is hesitantly emerging in Sander's portraits is social. The subjects are contained in the public space of urbanity or of rural villages and in a differential network of professions and social roles. This development in portraiture does not mean, however, the gradual rounding off of the bourgeois subject or the immediate decline of the pictorial genre of the portrait. Buchloh argues, for instance, that postwar–New York photographers like Diane Arbus, Richard Avedon, and Irving Penn reassert the bourgeois concept of subjectivity. Photography is often the medium used for regressive reactions to new conceptions of the subject. Buchloh sees photographers' works as desperate efforts to hold onto unique individuality. Since the mythical dimension of this notion is increasingly exposed, they try to convince by representing extreme cases.

They focus on forms of eccentricity and on sitters who are the "victims of their own attempt to shore up traditional bourgeois conceptions of originality and individuality." When the notion of individual subjectivity is more and more contested, it is safeguarded as a spectacular sight. It is hard to deny "uniqueness" in the forms of the grotesque or in the life of freaks.

Andy Warhol's portraits have played a major role in posing questions concerning the social and public dimension of subjectivity. In his work, the subject took on explicit mythical proportions. This ironic mythification leads to a disappearance of all subjectivity on both sides of the portrait: that of the portrayer and that of the portrayed. Warhol's individuality, his painterly performance, is systematically absent. His photographically based, mechanically produced portraits leave no room for the illusion of the unique self of the portrayer. But the portrayed sitters are also bereft of their interiority. They are exhibited as public substitutes for subjectivity. They are represented in the public mode and myth of the "star." We see not a unique self, but a subject in the image of the star, totally modeled on this public fantasy of "stardom."

The avant-garde opposition to the portrait by pop artists like Warhol stems from a critical insight into the formative dimension of the mass media. In the 1980s, feminism gave a new and more fundamental dimension to the conviction that identity is not authentic but socially constructed. Here it is not specifically the domain of the mass media that predominates in its effect of making—or rather emptying out—the subject but representation in the most general way. The *Untitled Film Stills* (fig. 4) by Cindy Sherman address this issue most disturbingly. These famous black-and-white photographs, used again and again as emblematic examples in discussions of postmodernism, feminism, or intertextuality and art, show female characters (always Sherman herself) in situations that recall, and thus expose, Hollywood films of the 1950s. The *Untitled Film Stills* give the illusion that they are based on original shots from existing films and that Sherman has reenacted, imitated such an original still. Each effort to point out the original film that the photographs are based on is, however, frustrated. There is no "original" of a Sherman *Untitled Film Still*. As Krauss writes: "Not in the 'actual film' nor in a publicity shot or 'ad,' nor in any other published 'picture.' The condition of Sherman's work in the *Film Stills*—and part of their point, we would say—is the simulacral nature of what they contain, the condition of being a copy *without an original*" (1993, 17). It is not by accident that Sherman "made her point" within the genre of the (self) portrait, because it is exactly the relation between subjectivity and representation that is scrutinized in her work. The standard relation between subject and representation is now reversed. We don't see a transparent representation of a "full" subjectivity; instead, we see a photograph of a subject that is constructed in the image of representation. The

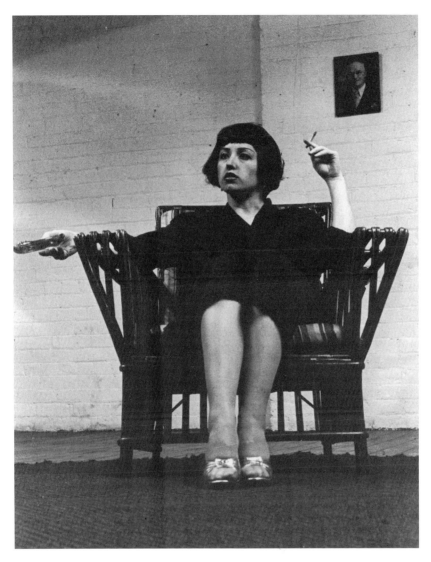

4 | Cindy Sherman, *Untitled Film Still,* no. 16 (1978). Courtesy of the artist and Metro Pictures, New York.

traditional portrait, or rather the standard view of the traditional portrait, is turned inside out.[9]

In all of Sherman's *Untitled Film Stills* we are compelled to recognize a specific visual style and a type of femininity. "The images suggest that there is a particular kind of femininity in the *woman,* whereas in fact the femininity is in the image itself, it *is* the image" (Williamson 1983, 102). This conclusion could sug-

gest that there is little difference between the notion of the subject in pop-art portraiture and in Sherman's *Untitled Film Stills.* For both oeuvres short-circuit the idea that the portrait provides a representation of a subject that is authentic and original. Instead, they both propose the subject's identity as the product of its images.

There is, however, a major difference between the pop-art portraits of the 1960s and the feminist photographs of Sherman of the late 1970s. This difference gives a totally new edge to the deconstruction of the portrait by twentieth-century artists. Rosalind Krauss puts this difference in the following words: "Indeed, almost two decades of work on the place of woman within representation has put this shift into effect, so that a whole domain of discourse no longer conceives of stereotype as a kind of mass-media mistake, a set of cheap costumes women might put on or cast aside. Rather stereotype—itself baptised now as 'masquerade' and here understood as a psychoanalytic term—is thought of as the phenomenon to which all women are submitted both inside and outside representation, so that as far as femininity goes, there is nothing *but* costume" (1993, 44). This implies that representations in the restricted sense—films, advertisements, novels, paintings—are part of a far more encompassing set of mechanisms, of representation in the broader sense, called the symbolic order in Lacanian psychoanalysis. Subjectivities are shaped, are constructed by this symbolic order.

The portrait receives a new significance in the light of this feminist, psychoanalytically informed conception of subjectivity. In Sherman's case, the portrait is not used as a critique of the mass media but as the framework that explores and exposes modes of femininity. This had to be done within the genre of the portrait precisely because, according to the standard view of the traditional portrait, that was the place where we could watch femininity in all its fullness, as an essential quality. If the portrait has been one of the main frameworks in which the notion of "real" femininity had been advocated, it is of course the most relevant space for a deconstruction of that notion.

{ SUBJECTING POWERS OF REPRESENTATION }

Although I have assumed an intertwinement in the portrait between the conception of subjectivity and the conception of representation, I have so far focused on that twentieth-century portraiture whose main point it is to propose new notions of the subject. But not all twentieth-century artists who have challenged portraiture began by reflecting on subjectivity. Some of them gave rise to new conceptions of subjectivity as a result of their challenging reflections on the ef-

fects and powers of representation, especially the representation of human subjects. Because of the intertwinement of the two conceptions, the difference is often hard to discern. Challenging the notion of subjectivity has immediate consequences for the notion of representation—and the other way round. But emphases shift. Therefore, I will now focus on artists who have changed portraiture by means of their reflections on representation.

In his book on photography, *Camera Lucida,* the French critic and semiotician Roland Barthes has written about the nature of the relation between portrait and portrayed (1982). In his view, the image has a strong hold over the subject through the ability to represent the body of the subject as whole, an ability that the subject itself lacks. For the subject has only transient bodily experiences and partial views of its own body. To transform these fragmented experiences and views into a whole, the subject needs an image of itself.

Barthes, however, sees the dependence on the unity and form-bestowing relation with the image not as desirable but as mortifying. "I feel that the photograph creates my body or mortifies it, according to its caprice" (1982, 11). Barthes's remark about the effect of photographic portraiture must be read as a characterization of discourse and representation in the most general sense.[10] The subject loses itself when it is objectified in representation. This loss of self is brought about because the objectification of the subject that bestows the experience of wholeness on her or him is a discursive transformation that translates the subject into the terms of the *doxa,* the platitudes of public opinion. The subject falls prey to a representation that constructs it in terms of the stereotype. Hence, according to Barthes, in the portrait the subject is not confronted with itself in its essential quality, but, on the contrary, by becoming an image it is alienated from itself because assimilated into the *doxa.*

As a result, Barthes's view on the portrait is highly ambivalent. One depends on portraiture for the illusion of wholeness, but at the same time one has to pay for that illusion with a loss of self. One's image is always cast in terms of the already represented. Barthes needs the portrait and resists it, which makes the portrait into a space of conflict, into a battleground. Barthes's view of the alienating effect of representation helps me to discuss the disturbing quality of the portraits of Francis Bacon. Barthes's account of the relationship between representation and subjectivity as a discursive conflict makes it possible to see Bacon's portraits as efforts to unsettle the kinds of representations of the self that mortify any self-experience.

In his interviews with David Sylvester, Bacon's incessant emphasis on the need for distortion in order to represent the "real" appearance of somebody can be understood as a fight against stereotypical representations of the subject.

FB: What I want to do is to distort the thing far beyond the appearance, but in the distortion to bring it back to a recording of the appearance.

DS: Are you saying that painting is almost a way of bringing somebody back, that the process of painting is almost like the process of recalling?

FB: I am saying it. And I think that the methods by which this is done are so artificial that the model before you, in my case, inhibits the artificiality by which this thing can be brought about. ([1975] 1987, 40)

Bacon talks about his portrayals as conflicts between the artificiality of representation and the resistance of the model to that artificiality. That which Bacon depicts is exactly the fight between subject and representation. He folds the subject back onto itself, endorsing the resulting fragmentation as the inevitable consequence of this denial of the unity-bestowing power of representation.

There are many motifs in Bacon's portraits that in a very consistent way give rise to this view of the generally mortifying effects of representation on the portrayed subject.[11] Let me digress for a moment on one motif that strikingly and literally substantiates the power of the portrait qua representation to threaten subjectivity.[12] The painting *Three Studies of Isabel Rawsthorne,* 1967 (fig. 5), not only is a portrait but is also a work about the portrait. The figure Isabel Rawsthorne is portrayed on different ontological levels. We see her in the primal space of the painting but also as the subject of a portrait nailed to the wall. In this painting the distinction, or tension, between inside (subjectivity) and outside (representation) is first of all thematized in a literal way. We see the figure opening or closing a door.[13] But she does this with her back turned to the act she is executing. This suggests that there is danger or revulsion involved in this act, a reading supported by *Painting,* 1978, in which we see a naked figure locking or unlocking a door. The extremely artificial pose in this latter painting expresses even more unambiguously the danger and anxiety involved in this simple act. But the ambiguity between inside and outside, and the ambivalence of the distinction as such, are repeated in the relationship between reality and representation, here thematized as the distinction between literal, primary space and figural, represented space. We see the female figure not only inside and outside the door; we see her as a shadow on the white door and in a drawing or painting nailed on the wall. Thus she is represented indexically as well as iconically. This image on the wall encapsulates the tensions produced by the painting of which it is part. As in many Bacon portraits, it is as if the represented figure is coming out of the image; or perhaps it is the other way around and a figure is being sucked into an image. The figure is both inside and outside the image.

Studies from the Human Body, 1975 (fig. 6), contains a comparable situation. On the right we see a female figure walking in the primary space. In the center

5 | Francis Bacon, *Three Studies of Isabel Rawsthorne* (1967), oil on canvas, 119 × 152.5 cm. Staatliche Museen Preussischer Kulturbesitz, Berlin. Photograph by Jörg Anders (Marlborough Gallery, London and New York). © 2004 Estate of Francis Bacon/Artists Rights Society (ARS), New York.

there is a male figure half inside, half outside the flat surface of an image. On the left side, a figure is totally encompassed by the dimension of representation. The direction in which the female figure walks, in which the male figure lies down, and in which the third figure looks suggests that these figures are being sucked into the level of representation. If we read the direction of the movement in the painting in this way, it is also possible to read the framing of the female figure's face by a circle as the beginning of this process. The circle has the same light blue color as the two surfaces of the levels of representation into which the figures are being sucked.

Bacon's representational logic also manifests itself in *Three Studies of Isabel Rawsthorne,* 1967, in the form of another motif recurrent in his oeuvre. The portrait within the portrait is pinned down to the wall by means of a nail. This nail immediately evokes another series of Bacon paintings: his *Crucifixions.*[14] In the context of Bacon's allegorical polemic with the Western tradition of mimetic representation, the motif of the crucifixion signifies more than just bodily suffering and sacrifice. Within Bacon's consistent reflection on the effects of representation the crucifixion betokens the inevitable consequence of representation,

6 | Francis Bacon, *Studies from the Human Body* (1975), oil on canvas, 198 × 147.5 cm. Collection of Gilbert de Botton, Switzerland. Photograph courtesy of Marlborough (Marlborough Gallery, London and New York). © 2004 Estate of Francis Bacon/Artists Rights Society (ARS), New York.

the tearing apart of the subject, the destructive effect of reproductive mimesis. And this is even more obvious in those works where the crucifixion is not represented by the cross or by slaughter but subtly and microscopically by nails. As indexes of the immense suffering and the total mortification of the body, the nails suggest that any attempt to represent mimetically may be regarded literally as an attempt to nail the subject down. Bacon indicts mimetic representation, and he does so by foregrounding its mortifying effects on the subject. As Damisch's artists do with clouds, Bacon also picks up a motif from the history of art whose meaning he highlights by literally fleshing it out. Thus he exposes what the history of Western art has done to, inflicted on, the subject.[15]

Francis Bacon's portraits are often compared to those by Lucien Freud. The idea is that both British painters represent the human body in a challenging, unidealized way. The presumption is that these painters are more truly (or nihilistically) pursuing a mimetic project than other painters so far have done. I contend, however, that if both painters have fundamental doubts about mimetic portrayal, they pursue those doubts in radically different ways. Both oeuvres contain consistent reflections about portraying the human subject, but the point of their reflections and the forms by which they make their point are quite different. When we look at the paintwork, the surface of the paintings, Freud's portraits seem, at first sight, more traditional. His techniques of working and scraping the paint creates a dense, thick surface that draws attention to the painting as material surface. It gives the bodies of the sitters *body*. It denies the signifying nature of representation by creating the illusion of pure presence of the sitter. And as I pointed out earlier, this idea of pure presence is inscribed within the logic of the traditional portrait. The body of paint transforms itself easily into Gadamer's "increase of being."

The surfaces of Bacon's paintings are very different from those of Freud's. The spaces surrounding the figures are usually made up of a layer of extremely thin paint that refuses to yield an illusion of depth. The painting draws no attention to itself as a material presence. On the contrary, the figures, especially their faces (the traditional locus of subjectivity and identity), are painted in heavy, almost violent impasto. This facial impasto, however, does not give the figures' bodies body. Their bodies become a battleground. The violent impasto can be seen as the marks of an aggressive activity that involves representing subjectivity. This fight causes loss of self because the subject turns out to be the loser.

Freud's deconstructive reflections on portrayal are foregrounded in other aspects of his works. Andrew Benjamin has argued that Freud's self-portraits *Interior with Plant, Reflection Listening (Self Portrait)* (1967–68; fig. 7), *Interior with Hand Mirror* (1967), and *Reflection with Two Children* (1965) allegorically address the question of what is being betrayed within portrayal. In *Interior with Plant* Freud's body

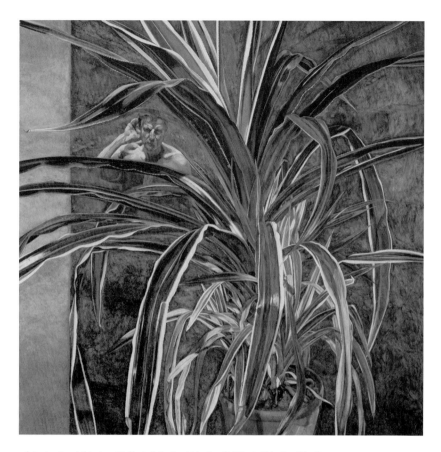

7 | Lucien Freud, *Interior with Plant, Reflection Listening (Self Portrait)* (1967–68), oil on canvas, 121.75 × 121.75 cm (48 × 48 inches). © Lucien Freud/Private Collection/Bridgeman Art Library.

is dislocated to the background. It can be perceived between the leaves of a plant that occupies the whole painting. We see him with a cupped ear and closed eyes. What is the meaning of this dislocation? Once the eye of the viewer "is focused on the 'self-portrait,' on the face, then what is revealed is precisely that mode of cognition that displaces the centrality of the eye. The eye therefore is drawn to what cannot be seen. It moves ineluctably to the representation of that which is inherently unrepresentable, namely sound. The eye is focusing on listening" (Benjamin 1991, 67). By foregrounding in this self-portrait that which cannot be visually portrayed, it short-circuits the intentional logic of the representational (self) portrait. It confronts us with the idea that portrayal is necessarily a betrayal of the quality of essence because it dislocates the "essence" of subjectivity to the visual.

All three paintings discussed by Benjamin present self-portraits in the form of mirror reflections. Of course, the notion of reflection is crucial within the traditional logic of self-portrayal as a mimetic endeavor. According to Benjamin, reflection involves "the desire for a temporality of simultaneity" (1991, 63). The mirror is thought to be the site of an absolute but momentary return. In my view, it is not so much that "the temporality of simultaneity" is the object of desire but, rather, that its transience is the disenchanting reality behind an illusion: the simultaneity of a mirror reflection can only be temporal, fleeting, because what the mirror holds ands returns must be present.

From this perspective, the traditional portrait is a mirror reflection without its shortcomings: it provides simultaneity without temporality. The simultaneity does not depend on the act of looking of the reflected person. Freud, however, presents his self-portraits emphatically as mirror reflections. It is as if he wants to say that (self) portraits do not overcome the transitory. Like mirror reflections, they are only able to portray transient moments of likeness without any claim to essential (atemporal) qualities.

{ PORTRAITS REFERRING DIFFERENTLY }

The portraits of Sherman and of a pop artist like Warhol undermine the idea that the portrait is able to refer to somebody outside the portrait. Portraits are caught up in the realm of representation. They refer to mass media–produced stereotypes, simulacra, or masquerades that function as screens that block a transparent view of reality or individuality. Does this mean that reference is a passé notion in contemporary portraiture?

I don't think so. Instead, referentiality has become an object of intense scrutiny. The work of the French half-Jewish artist Christian Boltanski explores the concept of reference in a fundamental way, especially within the genre of the portrait. Boltanski is very outspoken in his desire to "capture reality." Many of his works consist of rephotographed "found" snapshots that he incorporates into large installations. In *The 62 Members of the Mickey Mouse Club* (1972), for instance, he presents rephotographed pictures of children that he had collected when he was eleven years old. The original photos were pictured in the children's magazine *Mickey Mouse Club*. The children had sent in a picture that represented them best. We see them smiling, well groomed, or with their favorite toy or animal. Looking at these pictures seventeen years after he collected them, Boltanski is confronted with these images' incapacity to refer: "Today they must be all be about my age, but I can't learn what has become of them. The picture that remains of them does not correspond anymore with reality, and all these chil-

dren's faces have disappeared" (quoted in Gumpert 1994, 36). These portraits don't signify "presence" but exactly the opposite: absence. If there were "interiority" or "essence" in a portrait, these photographs should still enable Boltanski to get in touch with the represented children. But they don't, and instead they evoke only absence.

In some of his later works he intensifies this effect by enlarging the photos so much that most details disappear. The eyes, noses, and mouths become dark holes, the faces white sheets. These blow-ups remind us of pictures of survivors of the Holocaust just after they were released. This allusion to the Holocaust, which I call Boltanski's "Holocaust effect," is not caused by choosing images of Jewish children.[16] He has always avoided using actual photographs from the death camps and in only two of his works did he use images of specifically Jewish children: in *Chases High School* (1987) and *Reserves: The Purim Holiday* (1989).

The Holocaust effect undercuts two elements of the standard view of the portrait. By representing these people as (almost) dead, Boltanski foregrounds the idea that these photographs have no referent. And by representing these human beings without any individual features, he undermines the idea of the presence in the portrait of an individual. All the portraits are exchangeable: the portrayed have become anonymous, absent figures. There is an absence of a referent outside the image, as well as absence of presence in the image. About his *Monuments* (1986; fig. 8), for which he used a photograph of himself and seventeen classmates, he says the following: "Of all these children, among whom I found myself, one of whom was probably the girl I loved, I don't remember any of their names, I don't remember anything more than the faces on the photograph. It could be said that they disappeared from my memory, that this period of time was dead. Because now these children must be adults, about whom I know nothing. This is why I felt the need to pay homage to these 'dead,' who in this image, all look more or less the same, like cadavers" (quoted in Gumpert 1994, 80–83). The photographs don't help him bring back the memories of his classmates. He calls his classmates "cadavers," because the portraits of them are dead. The portraits are dead because they don't provide presence or reference. He only remembers what the picture offers in its plain materiality as a signifier: faces. He clearly denies any "increase of being."

The dead portraits are in tension with another important element of Boltanski's installations. The installations are always framed as monuments, memorials, altars, or shrines. The portraits are in many cases lightened by naked bulbs as if to represent candles, to emphasize its status as memorial or shrine. These framings make the intention of the installation explicit. These works want to remember, to memorialize, or to keep in touch with the subjects portrayed. However, in evoking absence rather than presence, the photographs produce an ef-

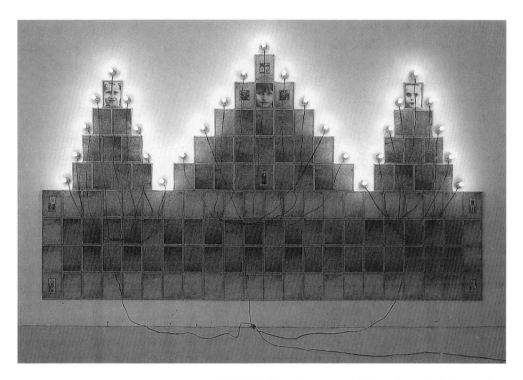

8 | Christian Boltanski, *Monuments* (1987), seventeen color photographs, tin frames, five lights with wires, 130 × 60 cm. Courtesy of Marian Goodman Gallery, New York.

fect that is in conflict with this intention. This is why the memorials are memorials not so much of a dead person but of a dead pictorial genre. The portrait is commemorated in its failure to fulfill its traditional promises.

But Boltanski has made other kinds of work that are slightly closer to fulfilling the standard claims of portraiture. In 1973 and 1974 he made several installations, generically called *Inventories,* which consisted of the belongings of an arbitrary person. In his *Inventory of Objects That Belonged to a Woman of New York,* shown in the Sonnabend Gallery in New York (1973), he presented the furniture of a woman who had just died. The function of these belongings was to witness the existence of the woman who had passed away. Semiotically speaking, these *Inventories* are fundamentally different from the installations with photographs. While the photographs refer iconically (or rather, fail to do that), the inventories refer indexically. The pieces of furniture represent the woman not by means of similarity or likeness but by contiguity. The woman and her belongings have been adjacent.[17]

The point here is the shift from icon to index.[18] The difference between the iconical and the indexical works is a matter of pretension. The photographic portraits claim, by convention, to refer to somebody and to make that person present. They fail, as I have argued, in both respects. The indexical works, however, do not claim presence: they show someone's belongings, not the person her- or himself. And strangely enough, they are successful as acts of referring to the person to whom the objects belonged. This success is due to the fact that one of the traditional components of the portrait has been exchanged for another semiotic principle. Likeness, similarity has gone, and contiguity is proposed as a new mode of portraiture. When we stay with the standard definition of the portrait, Boltanski's indexical works fit much better in the genre of the portrait than do his photographic installations.

Although referentiality is more successfully pursued in the indexical installations, the problem of presence in these works is again foregrounded as a failure to call up presence. In *The Clothes of François C* (fig. 9), for instance, we see black-and-white tin-framed photographs of children's clothing. The photographs of these clothes immediately raise the question of the identity and the whereabouts of their owner. This leads again to the Holocaust effect. The clothes refer to the storage places in the death and concentration camps where all the belongings of the internees were sorted (thus depriving them of individual ownership) and stored for future use by the Germans. After the war some of these storage places were found and became symbols or, better, indexical traces of the millions who were put to death in the camps.[19]

Marlene Dumas, a Dutch artist born in South Africa, whose work I will discuss in chapter 7, also addresses the problem of reference in her oeuvre, which mainly consists of group or individual portraits. Dumas is even more explicitly concerned with the problems of reference than the other artists just discussed. She has said about her work: "I want to be a referential artist. To refer is only possible to something which has already been named. (But names are not always given by you)" (1982, 16). Like artists such as Warhol and Sherman, Dumas is aware of the screen of images and representations that makes reference impossible, but she does not accept the situation. Instead of foregrounding the screen and the impossibility of plain reference, she fights, while referring, against the conventional "names" that were not given by her. How does she do this?

The portraits and group portraits of 1985–87 show faces that often look like masks. The faces are usually very light; they look like sheets or screens that are emptied out. Black pupils surrounded by white attract attention in these bleached faces. The eyes are very ambiguous in an uncanny way. It is not clear whether in their round darkness they should be read as remnants of subjectivity—as eyes peeping through holes in the artificial mask—or whether they are

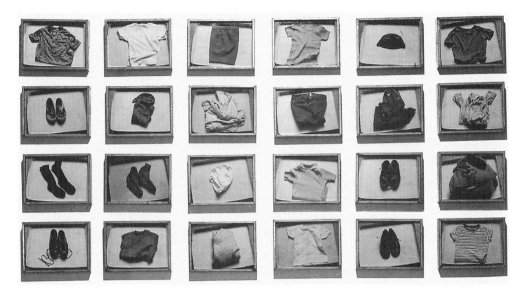

9 | Christian Boltanski, *The Clothes of François C* (1972), black-and-white photographs, tin frames, glass, each photograph 22.5 × 30.5 cm. Musée d'Art Contemporain Nîmes, on loan from the Fonds National d'Art Contemporain, Paris (Marian Goodman Gallery, New York).

nothing more than stereotypical signs in a mask, only indicating eyes. This masklike quality of the faces in Dumas's portraits produces a particularly relevant effect. It is the toll by means of which these portraits expose history. The mask, as well as the caricature, has had an important function in dismantling the traditional portrait in twentieth-century art. Buchloh describes this role of the mask and the caricature as follows: "Both caricature and mask conceive of a person's physiognomy as fixed rather than a fluid field; in singling out particular traits, they reduce the infinity of differential facial expressions to a metonymic set. Thus, the fixity of mask and caricature deny outright the promise of fullness and the traditional aspirations toward an organic mediation of the essential characteristics of the differentiated bourgeois subject" (1994, 54)[20] The mask represents essential features of subjectivity as fixed, mechanical, or grotesque. Although this is relevant for an understanding of Dumas's work, her masklike portraits at the same time yield a very different quality. The faces in her work evoke emptiness and death. Subjectivity is not present but, rather, is absent, impossible. Like Boltanski's installations these portraits give rise to a Holocaust effect.

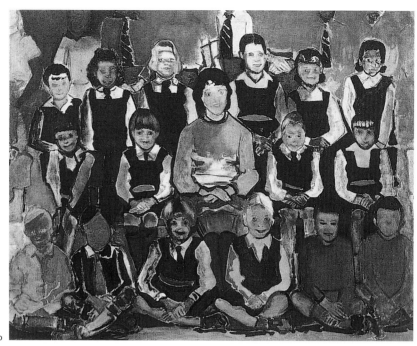

10

11

10 | Marlene Dumas, *Teacher (sub b)* (1987), oil on canvas, 160 × 200 cm. Private collection, Amsterdam.

11 | Marlene Dumas, *The First People (I–IV)* (1991), oil on canvas, each of four paintings 180 × 90 cm. Collection De Pont Stichting, Tilburg.

In her group portraits it seems that the group as such is responsible for this. In *Teacher (sub a)* (1987), *Teacher (sub b)* (1987; fig. 10), and *The Schoolboys* (1987) she portrays a class of schoolchildren in uniform. A school uniform is usual in South Africa, but this portrayal emphasizes how Apartheid culture fixes identities on the basis of the most superficial exteriority. As a consequence, the expressions of the children's faces are as empty, uniform as their clothes. In the *Teacher* paintings, we see that the uniform expression of the students is that of their teacher. This sameness is presented as death or absence. The question arises, then, whether it is the situation of the group as such or the portrayal of a group that causes this putting to death of subjectivity, this holocaust effect? One cannot help remembering here that Apartheid was quite literally the representation or portrayal of groups. But Dumas's work goes beyond such a political statement alone. She explores the intricate relationship between the political situation of Apartheid and the representational consequences of mimetic portrayal, looking for essences. Thus, she quite literally exposes history.

For Dumas's later portraits suggest in their difference that these earlier works are part of an overall project to explore and systematically challenge the conventional characteristics of the traditional portrait as a politically invested genre. In the later works she continues to pursue the genre's conventions but takes a different approach. She begins to experiment with format. While portraits are usually vertical (reflecting the human subject in its most respected posture—namely, standing), an extreme horizontal format is also introduced. In such images the figures are stretched out in all their horizontality. It is as if they are pulled down, made powerless, by the format of the portrait.[21] There is a relation between being depicted horizontally and powerlessness, a relation that is differentially produced through opposition to the connection between the vertical format of the portrait and the authority of the portrayed person. This becomes provocatively clear when Dumas paints a male nude in this horizontal position in *The Particularity of Nakedness* (1987). Dumas tells about a museum director's response to this painting (1992, 43), who considered it a failure because it had too many horizontals. A successful painting needs verticals, he seemed to imply, without realizing that Dumas had purposefully represented masculinity in this painting in such an non-erect way. Unwittingly, he exposed the historically anchored gender aspect of portraiture.

Dumas's explorations of the relation between format and authority are shaped by contrasts. While representing masculinity horizontally, she depicts babies vertically in four vertical paintings: *The First People (I–IV)* (1991; fig. 11). When depicted horizontally, we would see babies in these poses in all their vulnerability and powerlessness, which is the case, for instance, in her painting *Warhol's Child*. But, made erect, these little creatures suddenly become monsters with

grabbing claws. Enlarging this authority effect of the vertical format Dumas deconstructs this quality of the traditional portrait. She undoes the "increase of being" by means of bestowing authority on the portrayed. She does this by giving it grotesque proportions and by attributing it to inappropriate exemplars.

In her work *Black Drawings* (1991–92; fig. 12) and the portraits she made for the mental institution Het Hooghuys, in Etten-Leur, the Netherlands (1991), Dumas explores portrayal in yet another way. This time she makes no individual portrait or group portrait but a group of portraits. *Black Drawings* consists of 112 portraits of black people. The other work, made for Het Hooghuys, consists of thirty-five paintings, with one panel having a poem by the Dutch poet Jan Arends. Most of the paintings are portraits of people who are living in the mental institution, but some are of animals.

These two groups of portraits are radically different from the earlier group portraits. They don't produce a Holocaust effect. Nor do they work as a collection of original subjectivities. Instead of promoting black subjects or mentally ill subjects to the status of bourgeois subjectivity, she constructs a conception of subjectivity based on variety and diversity but not on unique individuality. The portrayed models are endowed with subjectivity not in terms of original presence but in relation to each other. They are subjects because they are all different. This is why they all deserve their own panel within their collective portrayal. This is also why Dumas's portraits recall, and then reject, the traditional individualist portrait, why they allude to Picasso's differential mode of portraying, and why they connect to Sherman-like masquerade but go beyond the singularity of those works. Recalling Boltanski's seriality, Dumas's groups of portraits demonstrate the dispersal of the portrait in the very gesture that reinstates the genre.

{ FACE THOUGHTS }

The development of and within the portrait as genre that I have sketched so far, is, of course, less linear and unified than my account of it might suggest. I have focused on art that exposes and contests the genre. There are also other practices that, from this perspective, seem to lead to regressive manifestations of the genre. A good example of this ambivalence is, for instance, the work of the Dutch photographer Rineke Dijkstra. Her work consists of series of photographic portraits of people in similar poses and similar contexts. What is most characteristic for the subjects Dijkstra portrays is not that they look alike but, rather, that they pose alike. They are all subjects who in the exposure of their bodily self are extremely vulnerable before the camera: male adolescents with pimples, female

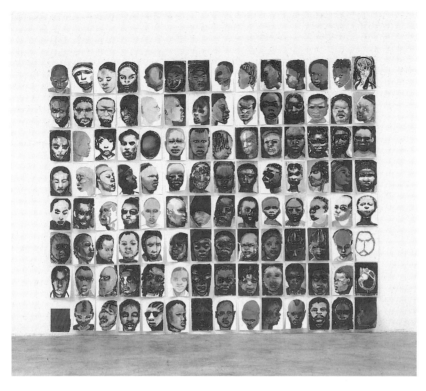

12 | Marlene Dumas, *Black Drawings* (1991–92), ink on paper, slate, each of 112 drawings 25 × 17.5 cm. Collection De Pont Stichting, Tilburg.

adolescents in bathing suits, immigrants in shelters, naked women who have just given birth, bullfighters immediately after the fight, or members of the Israeli army on active duty (fig. 13).

Dijkstra engages the history of the genre in a different way from the artists I have discussed so far in this chapter. Unlike in the traditional portrait, it is the individual's being in time, not essential identity, that is the subject of Dijkstra's portraits. This difference makes an important assertion about human visibility. Whereas in the history of photography, posing has become synonymous with masquerade and fake or false identity, Dijkstra is often said to succeed in catching, I would almost say, releasing, the "real" inner selves of people whose identity is far from solid. This does not mean that she is after the individual identity of her sitters. She wants them "to open up," so that we can get a glimpse of innerness. This innerness is not seen as individual but, rather, as "abstract or universal," which allows viewers to identify with the portrayed people.[22] She engages, perhaps reconfigures, the "Family of Man."

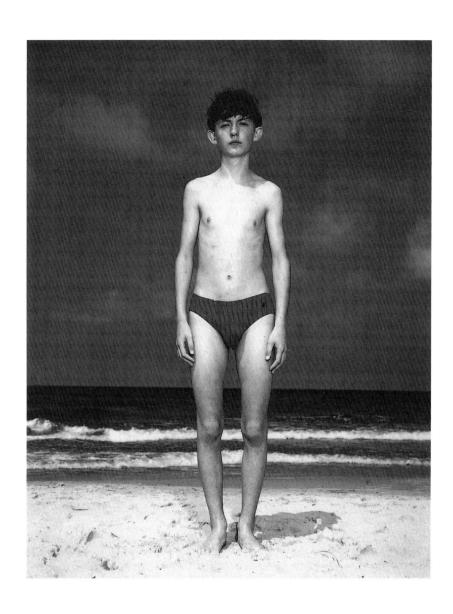

13 | Rineke Dijkstra, Kolobrzeg, Poland (July 23, 1992), C-print, 62 × 52 cm

Dijkstra's work is interesting from the perspective of photographic practice. Common belief has it that someone's identity can only be caught in a quick, unexpected snapshot and not in artificial posing. Dijkstra, however, is said to succeed in observing someone's identity in the act of posing. Dijkstra's psychological portrayals seem to be involved in a phoenixlike project. Individual identity rises from the dead, from several decades of the subject having been declared dead, lost, or fragmented. Most of the art practices or theories that have undermined the glorious status of humanist, bourgeois subjectivity have done so through a thorough reflection on the interactive and constitutive relationship between subjectivity and representation, between subjectivity and the look of the other/Other, between subjectivity and the symbolic order. This kind of critical reflection seems to be missing in Dijkstra's work and in a lot of other contemporary photography that has been so successful recently.[23] Theoretically speaking, one could say that observation and representation are deployed here, not reflected on. This does not mean that Dijkstra's work harbors no thought. Whereas she portrays subjects formerly excluded from portraiture, and thus challenges the genre's exclusions, one can take issue with the universalist humanism that is the motor of her project. Whatever one thinks of this particular philosophy, this "visual thought," it is also undeniably a demonstration of thinking and, specifically, of thinking about history. Her work does not simply regress to the traditional genre.

The kinds of images I have discussed in this chapter all suggest that the portrait has not at all become a dead genre in twentieth-century art, as some critics have claimed recently. Conceptions of subjectivity and identity have been challenged; mimetic conceptions of representation have been undermined in all kinds of ways. This has led to the implausibility of the intertwinement of bourgeois subjectivity with mimetic representation but not to the death of the genre as such.

Although genres are of course contaminated by their histories, it is not necessary to define a genre by its history. Artists like Sherman, Bacon, Boltanski, and Dumas show how a genre can be liberated from its history by means of exposing that history so that it can become an arena for new significations. The project of "portraying somebody in her or his individual originality or quality of essence" is no longer the sanctifying function of portraiture. It can still have that function, as artistic practices like that of Dijkstra suggest. But then, too, it self-consciously reflects on its history. Portraiture as a genre has become the form of new conceptions of subjectivity and new notions of representation—a genre that does not take its assigned place in history but embattles what history had naturalized.

3 Shooting Images, Throwing Shadows

{ THE PASSING OF IMAGES }

The entanglement of memory and imagination in relation to images is one of the central themes of Fiona Tan's video *Linnaeus' Flower Clock* from 1998. The video opens with a list of names of flowers and the times of the day when they open and close. There is a flower for each hour of the day, which together forms a complete clock cycle. However, these images do not suggest a cyclical conception of life but, rather, suggest, in the words of Rilke that are quoted at the end of the video, these things "live by dying." This idea is strongly conveyed by high-speed footage of flowering poppies, in which we see the buds open then close within a period of a few seconds. This footage is repeated several times in the video. The flowering poppies do not suggest the idea that passing is passing away but, rather, that passing away is just passing.

The work alternates between video images and short texts, which are written on a black screen. One text, shown after the images of the poppies, suggests an allegorical reading of them: "The passing of these pictures is part of their nature." The poppies become an organic metaphor for the life span of images. According to this allegorical reading, it is impossible mentally to hold on to images, for as they pass through our minds, they appear and disappear, bloom and fade just like flowers.

Other footage suggests, however, that the repetition of images is not passive but a highly active and creative act. Several times we see archival footage of young men diving from a diving board. We then see new footage of Tan herself diving like the boys but with her head facing backward rather than forward. This striking juxtaposition of obviously old and new footage emphasizes Tan's act of placing herself in the image. Like Alice in Wonderland she has found ac-

cess to an imaginary world. She appropriates the old images into her present. But in order to do so she must face backward, her backward gaze leading these old images into the present world.

Images of far away worlds, or events that happened long ago, are not placed at a distance. On the contrary, images of these worlds or events are presented as passing, as appearing and disappearing in the present. This implies that acts of memory and imagination are no longer seen as directed into opposite directions, the first to the past, the second to the future. They are both seen as "passing images." Memory can even be thought of as taking place in the future, directed toward the present. This entanglement of memory and imagination is elaborated specifically in relation to images. It is articulated in *Linnaeus' Flower Clock* as follows: "I try to imagine what I will remember in 30 years." And even more puzzling: "I try to remember what I will imagine in 30 years." *Linnaeus' Flower Clock* can be seen as a visual reflection on how we depend on images for building and living our reality.

When I say image, I especially mean the photographic and filmic image. For it is primarily since the invention of photography and film that the image has developed a specific, epistemological function. Until that moment, paintings and drawings had more typically functioned as instructive models, as idealizing models, or as objects of wonder. Photographic and filmic images, in contrast, quickly came to function as epistemological tools to get to know reality. That is why collecting images in the form of photo or film archives is a way of collecting the world.

This vision of photography and film as purveyors of "truth" about reality has become so dominant that today it underlies any commonplace thought about the image. In *Linnaeus' Flower Clock,* but also in her other works, Tan exposes this historical "picture" of the image and does everything to challenge it. She visually argues that images are not built of reality but that we build our own reality with images. This reversal entails that image and reality are not self-contained. On the contrary, in Tan's work the image is consistently represented as relational. In her documentary *Kingdom of Shadows,* she articulates this as follows: "An image does not exist without eyes that look at it. Thus the act of looking is the act of creating." This remark can be seen as a starting point for all of her works. But in each work she develops it in different directions, probing different functions of the image and different ways of relating to the image.

An important theme in Tan's work, for instance, is the relationship between image and (especially cultural) identity. Tan problematizes the fixity of cultural identity. Herself a migrant, she was born in Indonesia, the daughter of a Chinese-Indonesian father and an Australian mother. She spent her childhood and adolescence in Australia but left for Europe at the age of eighteen to study there.

She now lives in Amsterdam. In her documentary made for Dutch public television, *May You Live in Interesting Times* (1997), she undertook a search for her own cultural background and identity, which led her to Australia, Indonesia, Germany, the Netherlands, Hong Kong, and China.

At first sight, the epistemological pursuit of "getting to know her cultural identity" predominates in Tan's documentary. In this respect, it is comparable to the novel of her American namesake Amy Tan, *The Joy Luck Club* (1989), in which the narrator tries to get to know her cultural background by focusing on her mother's Chinese identity. In Amy Tan's novel and in Fiona Tan's documentary the narrators wish to know and convey their cultural identities. They do this through tracing themselves back to their histories, to the older generations in their families, and to their homelands. In these cases, time and place are homogeneously interwoven: facing backward means looking for the homeland, and vice versa.

But on closer inspection, Tan's search for her cultural identity is less straightforward than it appears. The documentary takes frequent recourse to different types of representations that expose the contrived nature of the history into which she dives for her search. She collates representations, such as photographs of family members, extracts read from her diary, and shots of a video monitor replaying footage that we just saw as part of the reportage. This introduces a self-reflexivity into her documentary that foregrounds the issue of the relationship between representation and (cultural) identity. It suggests that people also derive their identity from images. This is one of the reasons why people cherish certain images. In one way or another they conceive themselves by means of a cherished image.

Images are, thus, no longer assigned an epistemic role but a formative one. This different attitude toward the relationship between representation and cultural identity can also be recognized in a considerable number of allegedly autobiographical texts by migrants. For instance, Maxine Hong Kingston's autobiographical novel *The Woman Warrior* (1976) stages a heroine who struggles with the problem of understanding neither the Chinese culture of her parents nor the American culture in which she lives. Her problem is that she does not feel a part of any world or cultural identity, let alone one that could be represented, adequately or not. By means of her narrative she attempts to create continuity with the cultures among which she is living. Hence, in this case the issue is not the truthfulness or plausibility of the autobiographical narrative but, rather, its performative effectivity.

Hong Kingston's text seems to exemplify the postmodern view of the relation between representation and reality. In the first place, this text is formally postmodern in that it uses postmodern devices: It draws attention to its fictive and

linguistic nature, it represents multiple realities in juxtaposition, it flaunts intertextual allusions, and the narrator conspicuously draws attention to her manipulative interventions in a self-reflexive manner. Hong Kingston's text loses the realism and historical accuracy expected in an autobiography and becomes emphatically fictional.

Anthropologist Michael M. J. Fisher has formulated valuable hypotheses for understanding these postmodern autobiographical texts by migrants (1986). According to Fisher, these texts yield the following conceptions of cultural ethnicity. First of all, ethnicity is not found, transmitted, or taught, but each individual and each generation must invent and interpret it anew. Second, there is no archetype or "role model" of, for example, a Chinese-American or a Chinese-Australian-Dutch. The issue is to create a voice or style that does not do violence to the varied cultural components of which the self consists. Third, the search for ethnic identity, including the part played therein by memory, is future-oriented. Just like a performative speech act, (cultural) ethnicity should not be judged in terms of accuracy, completeness, or plausibility regarding the past but, rather, in terms of how successful, how livable it is. Components of the cultural past, such as stories transmitted by a father or mother, are often being used for the construction of ethnic identity, but they do not compose it.

This postmodern or constructivist notion of cultural identity short-circuits the straightforward relationship between time and space and, hence, radically questions the meaning of place. The homeland is no longer necessarily located in the past. And when it becomes located in the future, it is not necessarily as the destiny of the migrant's route but more as a narrative component, which can, or perhaps has to be, integrated into the migrant's notion of self.

Ultimately, Tan's documentary *May You Live* also comes to this conclusion. In it she declares the following: "It started off as a search, now it feels as if I'm constantly in search of my search." It is at that moment that the shots in which we see her looking at the footage shot by herself, receive deeper significance. It is in the image that she is able to search for her search and thus expose history on the personal level. Her film does not document her search for identity. Rather, her making of the film constitutes the search from which she derives her identity.

Tan's challenge to the epistemological role of the image does not stop at emphasizing its constitutive role in cultural identity. Tan's videos and films also complicate the relation between image and viewer by drawing our attention to the context of each of them—in terms of institutions as well as a specific place and time. Tan foregrounds time and place by means of her choice and sequencing of images. She often uses archival footage, which references the filmic discourse of the traveler and the ethnographer. She chooses footage that connotes moments from faraway places and cultures. It consists of the filmic discourse of

the traveler and the ethnographer. This material is emphatically old, not only because of its discursive framing but also because the visual qualities of the footage itself foregrounds a sense of pastness. This effect is further emphasized by the fact that the old footage is juxtaposed to new, often self-reflexive, filmic material. We see shots of an iris, of a cameraman, and sometimes of Tan herself. These kinds of images instill a reflexive awareness of the operations of the camera.

All of Tan's videos and films reflect on how different media function as agents that create specific relationships between the viewer and the image. In his essay on Tan, Stephan Schmidt-Wulffen puts it as follows: "The query 'Who am I' can never be answered without considering who is asking it, when and in which medium, and who is looking on" (2000, 161). But in contrast with the central subject in Tan's documentary *May You Live in Interesting Times,* the subjects in her videos who are looking, filming, and selecting old footage do not need to be read as actual migrants. The central agents in her videos can be seen as the focalizing subjects who are endemic to images and texts, in any medium.

Her works, then, offer a kind of metadiscourse on the nature of the image and the question of which aspects of the medium are defining for the image. Whereas in conventional film the subject of the gaze is usually invisible, Tan foregrounds the role and place of the subject of the gaze. Although her artistic work is not "about" migrancy or migrant identity, I will argue that migrancy remains an important issue for that work. However, it is no longer the life and identity of the migrant that she explores in her images but the other way around: she explores the life and identity of images through the notion of migrancy. So, in order to better understand her assessment of the image, I first reflect on migrancy.

{ VIRTUAL MIGRANCY }

Massive migration is one of the main features of the late twentieth and early twenty-first centuries. I am not only referring to the end of the last century; as early as the first half of the twentieth century, enormous numbers of people had left their homelands for economic or political reasons. The patterns of migration have not always flowed from the same places to the same destinations. Migration has been an ongoing global phenomenon in this past century. One effect of this massive migration is that it is becoming more and more impossible to map cultures onto places. In the past, it was taken for granted that nation-states embodied cultures. This was never really, in fact, the case but, rather, an ideological belief that functioned as a legitimation of the nineteenth-century project of nation building. Nevertheless, that belief has led to the still-current assumption that

when you visit the Netherlands, you experience a homogeneous culture, namely, Dutch culture. And when you visit China, you are immersed into Chinese culture.

Of course, there are many historical examples of cultures that do not follow this easy rule of mapping cultures onto places, namely, nation-states. The borders of nation-states are often arbitrary, and certain cultures can end up in two or three different nations. The Kurds and the Armenians are obvious examples. More often then not, such situations—of cultures that cannot be mapped onto a nation—have led to long-lasting and violent political conflicts. It is precisely these conflicts that confirm the notion that cultures "want" to be mapped onto nations: if such mapping does not occur, then it becomes a political goal.

Currently, however, the situation seems to have changed more radically. It becomes more and more difficult to see peoples or cultures as identifiable spots on a map. Because of migrations that have been ongoing, in multiple directions throughout the past century, there are practically no places left in the world that are not hybrid in terms of culture. This cultural hybridity is not only the result of a literal bodily migration of people but also of a general cultural condition, a phenomenon that has been called "virtual migrancy."[1]

Even those peoples who have never migrated—peoples who have lived for centuries in the same location, in the same homogenous community—do not live in the same "local" culture as before because of radio, television, film, and the Internet. Through those media, capitalism has reached nearly every community in the world, and even in the most faraway places televisions and computers can be found. James Clifford describes the result of this for people who have never traveled and who still live in their traditional community as follows: "They do watch TV; they have a local/global sense; they do contradict the anthropologist's typifications; and they don't simply enact a culture" (1997, 28). The result of this virtual migrancy is, of course, not exactly the same as the result of real migration. Virtual migrancy complicates a person's culture. It creates cultures "within," which ultimately also leads to a hybridization of culture in general. And it is this transformation of a culture that was once experienced as stable and homogeneous into a culture of virtual migrants, which changes the relationship to place. In the words of Gupta and Ferguson: "In this sense, it is not only the displaced who experience a displacement. For even people remaining in familiar and ancestral places find the nature of their relation to place and the culture broken" (1992, 10). In this respect, the effects of migrancy, virtual or not, imply that place has been radically disconnected from culture.[2]

The relationship between place and culture has become one of disconnection, displacement, and incommensurability. But one can wonder whether this disconnection results in the redundancy of the notion of cultural identity. Does

the cultural state of migrancy mean that, in the constitution of a (virtual) migrant's identity, place has become an irrelevant category because the only place that now exists is the global world? In other words, do migrants experience their identity as that of a "world citizen"? This would be a naively idealistic or pessimistic conclusion. James Clifford, among others, has convincingly argued that the erosion of such supposedly natural connections between peoples and places has not at all led to the modernist specter of global cultural homogenization or world "citizenship."[3]

One could even argue that, because of (virtual) migrancy, the relationship between cultural identity and place has become more rather than less crucial. The difference is that "place" no longer has the same meaning in the same sense of the word. We are no longer speaking about geographical place but, rather, about imagined place. As Gupta and Ferguson have it: "The irony of these times, however, is that as actual places and localities become ever more blurred and indeterminate, *ideas* of culturally and ethnically distinct places become perhaps even more salient" (1992, 10). What becomes more obvious in the present situation is that ideas of culturally and ethnically distinct places cannot be conflated with geographic place. The place is imagined rather than real.

But what "imagined" means remains to be specified. For "imagined" is not the same as "imaginary." Imagined places are not fairytale places, they are not just fantasy. In one way or another, imagined places do have a connection with a place that exists geographically. However, the mode in which this geographic place is experienced is ontologically different: geographic place is experienced not through real interaction but, rather, through the imagination. This does not cancel out concrete interactions of a political and economic order, but it does foreground the particular aspects of migrancy that make it an urgent and important object of analysis for the humanities.

A place is somewhere "out there" in the world, whereas an imaged place is an act of the imagination, with a subject responsible for performing this act in relation to a place. This subject, located in the present, does the imagining. It is very important to realize this, as it has consequences for the status of cultural identity. If the cultural identity of the migrant is shaped in terms of imagined place, it means that this identity was not carried along wholesale from homeland to destination. It is, rather, actively created and re-created in an act of identification with the homeland.

Paul Gilroy argues something similar in *The Black Atlantic,* when he describes the black diaspora as a genealogy that is not based on any direct connection with Africa or foundational appeal to kinship or racial identity. He exposes that historicist view as disempowering. How, then, should we conceive of what black people all over the world, many outside of Africa, share, namely, this history or

"tradition" of slavery and racial subordination? Gilroy uses the term "tradition" for what defines the black Atlantic, but in order to be able to do this he redefines the term:

[Tradition] can be seen to be a process rather than an end, and is used neither to identify a lost past nor to name a culture of compensation that would restore access to it. Here, too, it does not stand in opposition to modernity nor should it conjure up wholesome, pastoral images of Africa that can be contrasted with the corrosive, aphasic power of the post-slave history of the Americas and the extended Caribbean. Tradition can now become a way of conceptualizing the *fragile communicative relationships across time and space* that are the basis *not of diaspora identities but of diaspora identification.* Reformulated thus, [tradition] points not to a common content for diaspora cultures but to evasive qualities that make inter-cultural, trans-national diaspora conversations between them possible. (1993, 276; my emphasis)

In Gilroy's account the act of identification does not concern a place or a homeland but a history: the history of slavery and racial subordination, which enables conversations between black people transnationally and transculturally. Gilroy rejects Africa as a privileged place. But like my description of migrant identity in relation to imagined space, he stresses the fact that specific acts of identification are what people in diaspora have in common. For him this is even a valid reason to reject the term "identity," caught up as this term is with the notion of a fixed, pregiven entity instead of an agency or act.

As in Tan's *May You Live,* it is of crucial importance in Gilroy's argument that he brackets the importance of Africa as homeland and that he emphasizes the history of slavery and racial subordination as the basis of diaspora identification. For, especially in the case of the black diaspora, it is precisely the shared history that enables subjects to envision political goals. The shared homeland, in contrast, is too abstract, too large, and too diverse to fulfill the function of "Holy Land."

A qualification is needed here. Although Gilroy's position is strategically very important for the black diaspora, it does not imply that it can be generalized for all diasporas. The Jewish diaspora is a good example of an experience that resulted in a diaspora identity for which place—the homeland Israel—is as important a component as is the history of racial subordination, pogroms, and the Holocaust. But Israel is built precisely on the problem he formulates. The tragedy of this mapping of a culture onto a nation-state is that the same place, imagined in only partly different tropes, is also the focus of Palestinian diasporic identity.[4]

This difference between diasporas—or difference within the concept of diaspora itself—requires a specific cultural analysis in which the general concept of diaspora and its consequences—cultural hybridity and the subsequent imagined

place—is confronted with cultural utterances that further inflect the forms of experience in which migrancy entangles its subjects.

The conclusion that migrant, and by extension, all cultural identity, is imagined, is also presented as inescapable in Tan's video *Facing Forward*. At first sight, *Facing Forward* does nothing other than face backward. Appropriating from several filmic discourses, *Facing Forward* consists entirely of archival footage of a colonial and ethnographic nature. In weaving fragments from different genres together, the video exposes the heterogeneity of the history each of these genres claim to record. The work opens with footage of a colonial group portrait (fig. 14). We see rows of military officials and civil men, surrounded by their "native" subordinates. They all hold a pose, standing for the camera, to be appropriated visually. The next archival extract belongs to another genre, the ethnographic film. A single line of male tribesmen poses for the camera (fig. 15). The video consists of many extracts from this genre of film, showing natives from a broad variety of "exotic" cultures: Indonesian, Japanese, Chinese, and African cultures. The scientific pretext for this film genre is most explicitly and painfully enacted when the posing natives turn around on request, showing front, back, and both sides of their bodies. A third genre of film Tan inserts into her video is more touristic. Archival footage shows images of an Indonesian city with pedestrians, cyclists, and cars—in short, colonial street life (fig. 16). Nobody poses for the camera; the subjects are shot at random.

The three genres juxtaposed so far all show places and cultures that are far away from Europe. And they are archival: these are places of the past, fragments of history. However, the video also contains footage of a fundamentally different nature. Two times we suddenly see archival footage of a cameraman filming (fig. 17). In relation to the other footage, this footage functions as a countershot, as suture.[5] But this footage is also historical. As viewers of Tan's films, we are led to identify only partly with the subject position of the cameramen. We, too, are viewing but not necessarily in the same way as they did long ago. The context from which we look is different.

Facing Forward can be seen as a kind of visual archive. The footage is old, and the sequences between the different footage are arbitrary. Together, they do not form a narrative. Modeling her video on the genre of the visual archive, Tan relates her work to an epistemological tool that has an important place in the Western tradition. In his essay, "The Archive without Museums" (1996a), Hal Foster argues that visual archives can consist of any sort of cultural images. Thereby,

14

16

15

17

14 | Fiona Tan, video still (colonial group portrait), *Facing Forward* (1999). Courtesy of the artist, Galerie Paul Andriesse, Amsterdam, and Frith Street Gallery, London.

15 | Fiona Tan, video still (tourist film), *Facing Forward* (1999). Courtesy of the artist, Galerie Paul Andriesse, Amsterdam, and Frith Street Gallery, London.

16 | Fiona Tan, video still (ethnographic film), *Facing Forward* (1999). Courtesy of the artist, Galerie Paul Andriesse, Amsterdam, and Frith Street Gallery, London.

17 | Fiona Tan, video still (cameraman), *Facing Forward* (1999). Courtesy of the artist, Galerie Paul Andriesse, Amsterdam, and Frith Street Gallery, London.

they presuppose a universal viewer-consumer who may be the ultimate descendant of the humanist subject traditionally associated with the Renaissance.

As of that period, in which world travel and discovery became paramount, this subject is positioned in the center of the world and observes the world around it, an illusion Damisch effectively exposes in *The Origin of Perspective*. For this kind of humanist subject, the world is a picture to be observed. Heidegger has said the following about this transformation of the subject in humanism:

> The interweaving of these two events, which for the modern age is decisive—that the world is transformed into picture and man into *subiectum*—throws light at the same time on the grounding event of modern history, an event that at first glance seems almost absurd. Namely, the more extensively and the more effectually the world stands at man's disposal as conquered, and the more objectively the object appears, all the more subjectively, i.e., all the more importantly, does the *subiectum* rise up, and all the more impetuously, too, do observation of and teaching about the world change into a doctrine of man, into anthropology. It is no wonder that humanism first arises where the world becomes picture. (1977, 177)

Heidegger claims here that when the world was subjected to, or transformed into a picture, in the same visualizing practice "man" rose up.

Tan inserts herself into this tradition of the visual archive that constitutes humanist subjectivity by analyzing the world as a picture or visual object. She fundamentally undercuts the repercussions of this tradition by including the culturally specific human observing subject into the image. The cultural other is subjected to observation; but the observing self is also included. The footage of the cameraman shooting images of the cultural other is the radical turning point in *Facing Forward*. By inserting these shots, Tan reveals the visual unconscious of the humanist epistemological regime. For, in order to subject the world to observation, the subject itself had to remain in the center and, thus, be invisible.

The idea of a visual unconscious is given poignant, albeit comical, emphasis by the playful "Indian" feathers the white cameraman has stuck on the back of his head. Toying—as in children's play—with empathy, he cannot help "imaging" the infantile impulse in the desire to play Indian, to look like the other that fascinates Western man.

Heidegger sees the discipline of anthropology as emblematic for the humanist visual regime and the notion of subjectivity on which it depends. This explains why Tan's use of archival footage of an ethnographic and colonial nature is effective in its exposure of the history of the humanist subject. This kind of footage is paradigmatic for the notion of the image she wants to challenge and complicate. It is no coincidence that the involvement of Tan-the-artist with

ethnographic visual discourse is mirrored by the recent interest of anthropology in visual art. Indeed, while in the past two decades artists have explored cultural identity, anthropologists have started to model themselves on artists. They began to suffer from "artist envy." "In the days when anthropology became self-reflexive, the artist became a paragon of formal reflexivity, a self-aware reader of culture understood as text" (Foster 1996b, 180).

James Clifford is one of the main instigators of this envy. The introduction of the textual model into anthropology fundamentally changed the ways anthropologists think about what they do when they "do" observation. Because of this reflection in textuality, the ethnographic text could no longer be written as a third-person text with an external narrator. Observation was no longer seen as a neutral process, but as an interactive one that determined the product or result of observation. In the words of Clifford: "'Cultures' do not hold still for their portraits. Attempts to make them do so always involve simplification and exclusion, selection of a temporal focus, the construction of a particular self-other relationship, and the imposition or negation of a power relationship" (1986, 10). This kind of self-reflexive anthropology has transformed the ethnographer-as-authoritative-observer into a person who constructs representations of cultures. But whereas previously the ethnographic project had consisted of observing and visualizing the other, anthropology began to take distance from its implicit visualism and its trust in and reliance on observation. The discourse of observation and visualism was exchanged for a discourse of dialogue and, a bit later, performance.[6]

In relation to Tan's work, this entails a paradox: when ethnographers started to suffer from artist envy, their envy was not fueled by art's visuality. On the contrary, that visuality had to be either questioned or ignored. Rather, it was a fascination with art's constructedness that inspired this envy. It has not led to a reinforcement of anthropology's implicit visualism but to a radical challenge to the participant-observer tradition. In her critical endorsement of ethnographic material, Tan, in contrast, does not abjure the image. Her work thus "discusses" the foundations of anthropology through visual thought about vision. She does not cast out visuality but uses the image in such a way that the viewer and her context is no longer invisible. A closer look at *Facing Forward* will show the subtle and poetic way in which Tan does this.

In *Facing Forward,* Tan uses two strategies to complicate a naive use of archival footage showing the cultural other. I previously discussed the insertion of so-called countershots, the footage of a cameraman. A second reflexive level is introduced by a voiceover quoting from Italo Calvino's book *Invisible Cities.*[7] The voiceover narrates hypothetical conversations between the traveler Marco Polo and the emperor Kublai Khan. The emperor asks his guest whether his under-

standing of his self, the world, and his place within the world is inevitably predicated on his own history. The questions to the traveler Marco Polo are emblematic of the migrant's puzzled way of relating to images or stories of the homeland in the past:

Possibly, in a conversation with Kublai Khan, Marco Polo said: "The more he was lost in unfamiliar quarters of distant cities, the more he understood the other cities he had crossed to arrive there." At this point Kublai Khan interrupted him to ask: "You advance always with your head turned back? Is what you see always behind you? Does your journey take place only in the past?" And Marco Polo explained that what he sought was always something lying ahead, even it was a matter of the past. Arriving at each new city, the travel finds again a past of his he did not know he had: the foreignness of what you no longer are, or no longer possess, lies in wait for you in foreign unpossessed places.

According to this doubly recycled historical figure, past, present, and future no longer form a linear continuity. The past is something that can only be reached in the present or the future. Thus, Tan indicates that the status of places visited in the past is no longer real but by definition imagined.

Places from the past are reenacted in the places where Marco Polo arrives in the present. But the status of places in not only the past has changed; the present and the future are also transformed into screens onto which the imagined places from the past are projected. Hence, even the present receives a constructed, imagined quality. Marco Polo is not only excluded from the past but also from the present. This becomes clear when the voiceover quotes for the second time from Calvino's novel: "By now, from that real or hypothetical past of his, Marco Polo is excluded. He cannot stop; he must go on to another city where another of his pasts awaits him. . . . 'Journeys to relive your past?' was the Khan's question at this point, a question that could also have been formulated: 'Journeys to recover your future?'" Past and future are inextricably entangled within the subject, who relates to the present by imagining past as well as future cities. But in order to imagine past or future cities, Marco Polo becomes dependent on the city where he arrives or dwells in the present. It is within the quality of the present city that the past city is "relived" or "recovered."

This conclusion becomes very concrete at the end of Tan's video when the credit line declares that all of the archival footage comes from the Netherlands Film Museum in Amsterdam (fig. 18) How are we to interpret this credit? Although *Facing Forward* should be seen as a fictional text and not as Tan's autobiographical account of her imagined originating places, it is telling that the past places and cultures we see totally depend on the history of the place where Tan lives now, in the present, namely, Amsterdam. She could not have made this

18 | Fiona Tan, video still (credit line), *Facing Forward* (1999). Courtesy of the artist, Galerie Paul Andriesse, Amsterdam, and Frith Street Gallery, London.

work anywhere else. The material collected by the Netherlands Film Museum is mainly Dutch, connected to Dutch history and the Dutch production of film. Thus, it is Dutch colonial history and the special relations the Netherlands maintained in the past with Japan that decisively determines the nature of the places in the past that can be imagined in this video.

Thus, if we see migrant identity as an imagined, identificatory relation to an originating place, the so-called homeland, the historical dimensions of the place where the imagining act actually takes place radically frame the act of imagining homeland identity. The place that is of primary importance to the migrant reliving past places is the place where she resides in the present. When I watch *Facing Forward* I look backward via the present and future-oriented collecting policies of the Netherlands Film Museum in Amsterdam. Ultimately, I only see Amsterdam. And it is in the sight of Amsterdam that past, faraway places await me.

{ SHADOWS ON THE IMAGE }

In Tan's video installation *Saint Sebastian* (2001), the life and identity of the image as understood in terms of migrancy gets yet other ramifications. This time she rethinks the idea that the visual world is objectified in the image. For instance, the so-called objecthood of images is nicely articulated in the expression "to shoot an image." The visual domain is objectified in such a degree that it can be shot. The transformation into an image is performed by means of the aggressive act of shooting. This shooting results in a visual spectacle, an image.

This paradigmatic expression also has its narrative version: the mythical story of Saint Sebastian. Sebastian, living in the third century after Christ, was

an officer in the guard of Roman emperor Diocletianus. When it was discovered that he had converted to Christianity, the emperor ordered that he be executed by bowmen. Pierced with arrows he was left for dead on the Marsfield. But it turned out that he was still alive, and at night a widow, Saint Irene, took care of him. Thanks to her loving care he recovered. When the emperor discovered this, Sebastian was successfully killed, this time by means of sticks. This story has been enormously popular in Western art, in part because the scenario provides an opportunity to turn the male body into a visual spectacle. It is typically the same moment in this narrative that is painted, sculpted, or, in the twentieth century, photographed: the beautiful body of a young man pierced by arrows.[8] The shooting of arrows has resulted in a visual spectacle. Saint Sebastian's masculinity may be disempowered, but the visual effect of the display of his body in this emasculated condition is more impressive than ever. In the history of art it has become the occasion for displaying the male body as a beautiful image. In the wake of this tradition, in the twentieth century, representations of Saint Sebastian have become an emblem of the attractiveness of the male body in gay subculture. In the story of Saint Sebastian as well as in the expression "to shoot an image," there is significant connection between shooting andlooking—that to make a successful shot is physically to touch (e.g., by means of an arrow) the exact spot at which the eye is looking. This contributes to the poignancy of the Saint Sebastian scene, as the pierced body presupposes a number of gazes outside the frame concentrating on the body.

When we take this popular tradition of representations of Saint Sebastian into consideration, Fiona Tan's video installation *Saint Sebastian* is surprising in all respects. First of all, there is no beautiful male body to be gazed at, no Saint Sebastian, and, second, also no male bowmen shooting their arrows into Sebastian's body. Even the scene that has also been used—albeit less frequently—in representing this narrative cannot be recognized: namely, Saint Irene taking care of the wounded body of Saint Sebastian. Instead we see a group of Japanese girls in traditional costume shooting with bow and arrow. The images are shot in a temple in Kyoto, Japan. The girls are involved in a coming-of-age ceremony called the *Toshiya*. The girls have just turned twenty, and they challenge each other in an archery competition. This ceremony is an annual ritual that has been taking place for more than four hundred years. But this anecdotal information is not what the video installation is about.

The installation consists of a large screen hanging diagonally in the middle of a gallery space. A different projection is shown on each side of the screen (fig. 19). On one side, we see the Japanese women, mostly obliquely, from behind. We are stimulated to look with them, although we never see the object of their gazes (fig. 20). On the other side of the screen, we see the same women, but this

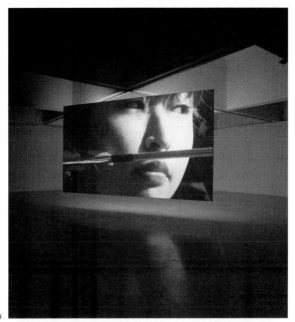

19

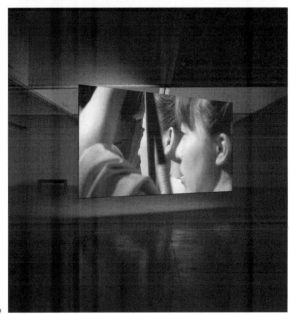

20

19 | Fiona Tan, video still (looking at), *Saint Sebastian* (2001). Courtesy of the artist, Galerie Paul Andriesse, Amsterdam, and Frith Street Gallery, London.

20 | Fiona Tan, video still (looking with), *Saint Sebastian* (2001). Courtesy of the artist, Galerie Paul Andriesse, Amsterdam, and Frith Street Gallery, London.

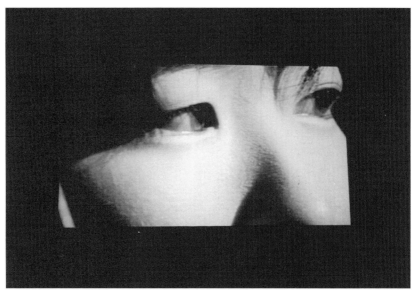

21

22

21 | Fiona Tan, video still (looking at), *Saint Sebastian* (2001). Courtesy of the artist, Galerie Paul Andriesse, Amsterdam, and Frith Street Gallery, London.

22 | Fiona Tan, video still (looking at), *Saint Sebastian* (2001). Courtesy of the artist, Galerie Paul Andriesse, Amsterdam, and Frith Street Gallery, London.

time with the image focused more on their faces. Whereas on one side of the screen we look with them, on the other side, we look at them—that is, we see them looking (fig. 21). One could say, then, that the two sides of the screen embody two different viewing positions in relation to the gazes of the women.

Yes, these women are shooting. We see them focusing on an object, but we do not see what they are focusing on, that is, shooting at. They stand in a row. One after another, they prepare themselves for their turn. We see them concentrating, an exertion that takes time. The images only show close-ups: of the upper part of women's bodies, of their faces, their hair, the pins in their hair, of their hands bending the bow and arrow. Although everything we see is extremely beautiful, it is not this beauty alone that strikes the eye. These close-ups emphasize that the concentration with which these women shoot their arrows is not limited to the act as such. They have dressed up with as much concentration as they deploy in their shooting—dress here is another sort of preparation for shooting bow and arrow.

The camera never takes distance from the women. Tan only shows close-ups. By doing this, she aggressively takes distance in yet another way from the tradition of Saint Sebastian representations, in which we always get to see his whole body. There, the viewer is put in a position to examine Saint Sebastian's body in whole or in part. We can visually colonize his body in pain and take pleasure from that. But showing only close-ups, Tan frustrates such a wandering and scrutinizing gaze. By showing only details without the whole, our look is directed away from the women as objectified beings, as beautiful bodies.

But the notion of the objectified image is challenged not only by the images presented to the viewers of Tan's video. It is also implied by the video installation's visual narrative. From the moment when women concentrate on their "shot" until they ultimately shoot and then stand and continue looking, their facial expressions barely change. As a viewer you almost look desperately in their expressions for signs or symptoms of disappointment or joy and victory (fig. 22). Each time, with each respective girl, it is impossible to make out whether it was a successful shot. There is hardly any difference between them: they all respond in the same way. Practically nothing in their faces or gestures indicates whether their shots were successful. It is as if their focusing and shooting had no goal. The success of their shooting does not seem to depend on hitting a specific object.

This suggestion is also strengthened by the sound track. The music iconically represents the tension that characterizes the concentration of the women. But there is never a release in the tension of the sound. It continues, even after the women have shot their arrows. The continuity in sound and facial expression suggests that the way the women look (and shoot) relies on a different paradigm

of vision from the one to which history has accustomed us. The duration of a constant (lack of) expression on their faces suggests that their looking and shooting is not object oriented but is involved in looking as an intransitive activity.

The kind of looking I am referring to has been effectively described by Roland Barthes in *Camera Lucida,* through reflection on the frontal look. He identifies this look in photographs in which someone confronts the viewer frontally. When the same thing happens in film the effect is very different. In film, when the look is directed to the camera, it becomes immediately embedded in the narrative sequence of images, and, thus, part and parcel of the illusionist world of film. In contrast, the frontal photographic look has something of a paradox about it that also applies to Tan's installation.

Barthes describes the nature of this paradox through a recognizable situation from public life. A boy enters a bar and surveys the people present with his eyes. Barthes realizes that the boy's look has rested on him for a few moments. Although the boy looked at him, Barthes is not certain if the boy has actually seen him, however. Here lies a paradox: How can we look without seeing? It is this paradox that confronts us in the photographic look. "One might say that the Photograph separates attention from perception, and yields up only the former, even if it is impossible without the latter; this is the aberrant thing, *noesis* without *noeme,* an action of thought without thought, an aim without a target" (1982, 111). The photographic look is reluctant in the sense that the attention of the look is "held back" by something inner. The look is simplysus-pended. Although the scopic situation in Tan's video installation has little to do with Barthes's frontal pose, his characterization of the photographic look seems appropriate to the way the women in her video hold back attention to the object of their gazes. This suspension of their gaze displaces our attention onto what is going on in the women—to what I would like to call their "inner vision."

In her documentary *Kingdom of Shadows,* Tan describes this aspect of what I called above her relational definition of the image: "By looking at photographs, my imagination throws its own shadows." The throwing of shadows is an act complementary to the shooting of images because to shoot an image means to expose the object to light. In *Scenario,* a recently published book on her work, Tan quotes a text by Esma Moukhtar to highlight the complementary nature of the subject and object of the look, in other words of viewer and image.

The meaning of an image always remains behind the scenes. What is in the picture takes its meaning by relying on what happens to the image behind the scenes. Whatever it is that the maker portrays is itself not visible. Behind the visible images is concealed a complex of completely personal interpretations and meanings. Even what the viewer sees and experiences is invisible. The viewer in turn imposes meanings on the image that cannot be

seen by anyone else. What is the image itself and what is our imagination–the image cannot answer that question. (2000, 120–21)

The image is portrayed as the meeting ground of two agents who are themselves invisible. The imagination is invisible not because it is hidden but because it itself has no "substance." It needs images in order to come into being, to become visible, and to be seen. Yet it cannot be conflated with the image.

It is precisely this distinction between image and imagination (between the shooting of images and the throwing of shadows), which is made visible—in its invisibility—in Tan's *Saint Sebastian*. The viewer is imbued with the concentrated gazes of the women. Those gazes do not direct us to the object to which the gaze is directed—not just because the object is located outside the frame of the image but also because these gazes endorse their own activity or imaginative quality.

{ IMAGES AWAKENING IMAGES }

The way images stimulate the imaginative dimension of the gaze is explored with yet different results in Tan's video/film installation *Lift* from the year 2000. This work suggests not only that the gaze throws its shadows on the image but also that different kinds of images evoke the throwing of different kinds of shadows. The installation consists of a video monitor in which we see moving color images of the feet of a person lifted from the ground (fig. 23). In the same space, there is a large projection of a figure lifted from the ground by a large number of big balloons (fig. 24). The images are in black and white. The figure floats against the background of leafless trees and the open sky, whereas the floating legs on the monitor only have solid ground as background. Neither of these images has sound.

The effect on the viewer of the large projection seems to be intensified by the open sky or by the fact that these images show almost no horizon. The viewer is no longer aware of the frame of the image: she is taken in by the image. The lack of sound and the black-and-white nature of the images contribute to the dreamlike effect. We have ended up inside a kind of visual vacuum. Strangely enough, our position "inside" the image leads us away from what we see in the images. It reminds us of our fantasies of being able to fly like a bird and of other images we have seen of flying or floating figures, like Winnie the Pooh who was taken into the air by a balloon or the mythical figure of Icarus who flew so high with his artificial wings that the heat of the sun melted the wax used to make them, and he plunged down. Whereas floating in the sky or flying like a bird is perhaps prototypical for the fantasmatic nature of the imagination, images that

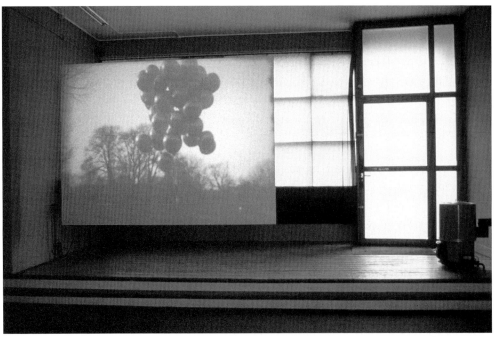

23

23 | Fiona Tan, video still *Lift*
(2000), film and video installation.
Courtesy of the artist, Galerie Paul
Andriesse, Amsterdam, and Frith
Street Gallery, London.

24 | Fiona Tan, video still *Lift*
(2000), film and video installation.
Courtesy of the artist, Galerie Paul
Andriesse, Amsterdam, and Frith
Street Gallery, London. 24

embody this fantasy seem to cause what they show: the viewer's gaze floats away and the viewer is reminded of past films and images seen.

The footage shown on the monitor has almost the opposite effect. The small format of the monitor and the color of the images stimulate a different kind of gaze. Although we see floating feet, we want to ground them, we want to know how it is possible that these feet are floating. Whereas the large frame of the projection is almost literally liberating because we are absorbed into another dimension, the small frame of the monitor makes us feel excluded from a vision to which we have no access. This does not mean that the shadows thrown by the viewer onto these images is less intense. But the nature of this shadow is qualitatively different: it is epistemological rather than fantastic, outer rather than inner vision.

Another installation, also with the title *Lift,* consists of three stills on three individual monitors. Tan used the same fantasmatic motif of the balloons for these stills. In the first still, we see a child in Western clothing in a park with a very big red balloon. In the second still we see two children, also in Western clothing, again with big red balloons. In the third still, however, we see an Indian boy with a red turban on his head. In his hand he holds something that could be the rope to which a balloon is attached. But the balloon is outside the frame of the still. In this series of images, the red turban seems to have the same function as the red balloons: they evoke the fantastic. However, in the case of the red turban, the domain of the fantasmatic is assigned to the place where it actually occurs: not in the air but in the head, the imagination.

In contrast with the first *Lift* installation, which consists of moving images, this installation consists of still images. The monitors are fixed to the wall like paintings or framed photographs. It is precisely the association with the photographic image that makes us aware of its difference from the still image on a monitor screen. The three stills of *Lift* lack the material substantiality that photographic stills seem to have. It is this lack of substantiality that enhances the fantasmatic quality of these images. And as in the other *Lift* installation, the images evoke in the viewer that which they are about.

{ AN ANTHROPOLOGY OF THE IMAGE }

For a long time the discipline of anthropology distinguished itself from other disciplines not just by its object but also, especially, by its methodology of so-called participant observation. Ethnographers had to do fieldwork—that is, they had to participate in the "other" culture that they wanted to observe. But this participation in another culture did not imply that they were also part of the ob-

served other. On the contrary, in the descriptions themselves the ethnographer remained invisible.

As argued earlier, Tan's use of archival ethnographic footage, as in *Facing Forward*—as well as in videos or films not discussed in this chapter, such as *Smoke Screen* (1997), *Cradle* (1998), and *Tuareg* (1999)—along her representation of a seemingly ethnographic topic in *Saint Sebastian* is far from arbitrary.[9] It is highly significant visual thought on the ontology and practice of the image. This kind of footage is paradigmatic for the humanist visual regime, which grasps the world through visualizing it while leaving the subject of vision out of grasp, that is, invisible. The visualization of the other in traditional anthropology is ultimately emblematic for a more general, objectivist conception of vision and the image. Tan adopts ethnographic footage in so many of her works in order to complicate and challenge this limited and imperialistic notion of the image. As if placing it on the other side of the depicted cloud—here, the historical appearance of archival footage—she proposes a different ontology of the image.

But her engagement with anthropology goes further than that. Not only does she use ethnographic footage and topics for her works, but she also practices anthropology by applying the methodology of participant observation. Her observed object is not the cultural other but the medium in which she herself works: the image. This is why works such as *Lift* or *Linnaeus' Flower Clock* can also be seen as a sort of ethnographic film or video. In these works, too, she practices the medium that is at the same time the object of her practice. She positions herself inside the scopic regime that she attempts to understand by showing it. Contradictory as it sounds, one could say that in analogy with anthropology's practice of visualizing the other, Tan visualizes the image.

The Representation of Space and the Space of Representation

Drawing, untitled (1987; fig. 25) by Dutch artist Marien Schouten evokes the spaces of landscape as well as those of architecture. The viewer is confronted with a contrast between the geometrical forms, the black and grey horizontal beams, and the gridlike structure in the center of the image versus the organic green-ish-brownish forms on both sides of the image. The organic forms look like the mountains that flank so many traditional history paintings as coulisses or that create the setting of a landscape painting. The grid, in contrast, evokes, first of all, twentieth-century works of art that have deployed the grid—for example, Agnes Martin's works. The grid counters illusionistic space, and it states the au-tonomy of the realm of art. In the words of Rosalind Krauss: "Flattened, geometrized, ordered, it is antinatural, antimimetic, antireal. It is what art looks like when it turns its back on nature" (1979, 51). But the grid also alludes to Renaissance paintings, which projected the gridlike structure within the painting in order to create linear perspective. Whereas in twentieth-century art the grid maps the surface of the painting itself, in Renaissance painting the pro-jected grid of perspective maps reality onto its representation.

Perspective as such is also evoked in Schouten's work by the receding of or-ganic forms at both sides. Renaissance perspective was, of course, explored or proudly practiced not only within the genre of landscape painting but also espe-cially within architectural painting. The tile floor, which creates the structure of a chessboard, also forms a grid, albeit now represented three-dimensionally. This quintessential motif most convincingly embodies the features of illusionist space as produced by linear perspective.[1]

25 | Marien Schouten, *Untitled* (1987), drawing, oil pastel/acryl/pencil on paper, 147 × 233 cm. Collection Becht, Naarden.

In chapter 1, I discussed Damisch's argument that while perspective may well be an attempt to open a window on the world, it also includes the position of the subject in the attempt to erase his presence. In this chapter I will give Damisch's argument a specific turn. I will make the case that, in the architectural paintings around which Damisch's argument turns, the implicit presence of the subject takes the form of a struggle: the painting keeps setting up obstacles that make the viewer more and more eager to look behind them. In landscape painting, in contrast, the relationship between the subject and perspectivally represented space is predicated on a relationship of attraction, or seduction. Here, the viewer is invited, solicited, to merge into space. Through the deployment of both grids and receding mountains, Schouten's drawing invites reflection on both generic traditions.

Associations with both landscape painting and architectural painting concern the representation of space. The question that arises, then, is whether, and how, we should negotiate the tradition of landscape painting and architectural painting in a reading of contemporary work like that by Marien Schouten. On a generalized level, what the two genres have in common is that they pursue the illusionistic depiction of space. I suggest, however, that landscape painting fore-

grounds a different concern with space than architectural painting does. I do not mean this in a thematic sense: of course a landscape is not the same as a building or an architectural structure or composition. I mean this in a theoretical sense, namely, the kind of spatial concerns that translate themselves into a depiction of landscape and the kind of spatial concerns that are more successfully foregrounded into a depiction of architecture. In the case of Schouten, where both traditions coexist, we can wonder what kind of conceptions of, or perhaps even reflections on, space underlie his evocations both of landscape and of architectural forms and structures.

In the Western tradition of painting, the representation of architecture and of landscape are minor genres. The genre of history painting, which represents biblical, mythical, or historical narratives, has always been valued more highly. Landscape or architecture often served as the background for the depiction of a story, but as ends in themselves they have been rather appreciated as enjoyable, not as important. The representation of landscape and of architecture has been subordinated to the higher demands of figuring history. But Schouten's work suggests a different history. There are moments or cases in Western art, I will argue, where the depiction of landscape or architecture becomes the privileged pictorial practice. When this happens, it implies more than a change of subject matter. I will interpret these moments as self-reflexive. The depiction of landscape or architecture is, then, not an end in itself as a representation of space, but it is the means by which the space of representation is explored, challenged, and exposed. By representing space, one makes programmatic statements about the kind of relationship between subject and space that is at stake when one makes an image.

The space of representation is certainly not a fixed entity. The history of art can even be seen as a sequence of changing conceptions of the space of representation. There have been periods in which representational space was defined as illusionistic space; in polemic reaction to this many twentieth-century artists have devoted their careers to fighting illusionism and have instead explored the flatness of the painted image. In works like Schouten's this polemic is conducted within the image. With the help of his and other contemporary works, I will show that changing ideas about the space of representation often manifest themselves in the form of the representation of spaces, in the past as well as in the present. Such representations of space, then, do not serve the program of the scientific, illusionistic objectivity that erases the subject; on the contrary, they reflect on the ideas in this ploy of representing space itself. Thus, they expose that illusionism and the stakes involved.

{ LANDSCAPE PAINTING AS EMBLEMATIC IMAGE }

In the tradition of seventeenth-century Dutch painting the depiction of landscape is a far less marginal genre than in, for instance, Italian Renaissance painting. It has often been remarked that the Dutch tradition distinguishes itself from Italian landscape painting by the nonidealized way in which it represents landscape or from nineteenth-century romantic landscape painting by the nonuniversal way in which it represents landscape.[2] The relatively high appreciation of Dutch landscape painting has, however, little to do with its lack of idealization but, rather, with the way landscape is seen as emblematic for the seventeenth-century conception of the space of representation. Landscape is no longer seen as a backdrop to history but as an entrance into it.

A growing appreciation of landscape painting manifests itself straightforwardly in Karel van Mander's *Schilder-Boeck* or *Book on Picturing,* published in 1604. This text is known today for its presentation of a history of Dutch and Flemish painting of the fifteenth and sixteenth centuries. But it also includes a theory of painting. The first book of the *Schilder-Boeck* contains the "Groundwork," a theoretical poem on the visual arts. The theoretical poem devotes a special chapter to landscape. This is remarkable in itself: there are no chapters devoted to still life, portraits, architectural painting, or history painting. This chapter has long been famous as an early defense of landscape.

But it has always been assumed that in the wake of his Italian colleague and predecessor Vasari, author of *Lives of the Most Excellent Painters, Sculptors and Architects,* Van Mander ends up subordinating landscape to the higher demands of figuring history (1973). But as Walter Melion has convincingly argued, van Mander instead identifies landscape as a specifically Netherlandish concern, on the one hand, while claiming it as a universal paradigm on the other. Landscape, then, sets the standard to which painters of other subjects aspire (1991, 97) If landscape is emblematic and functions as a kind of role model, it explains why Van Mander does not deal separately with other pictorial genres. Landscape is emblematic, Melion suggests, because in Van Mander's conception the optical impressions generated by landscape are the essential components of the well-ordered history: "He encourages the aspiring painter to position his foreground figures like coulisses: placed to the sides, they will function as a frame would, marking the zone beyond which the eyes look into the image. To ensure that the eyes will linger attentively, he advises the painter to devise a deep landscape setting into which the eyes may roam, and he adds that it is this panoramic vista, rather than figures proper, that centres the image" (7). This implies that landscape has been promoted from being mere backdrop to being the prime model for painters of any subject matter.

Van Mander makes the ordering of history dependent on the construction of landscape. The rhetorical effectivity of history painting, the appeal of the figures populating it, depends ultimately not on the way such figures are mobilized but on the insistence with which landscape mobilizes the eyes and seduces them into entering the picture. For Van Mander, the most important element of landscape is the view into the distance, which impels the beholder to enter the image: "See the forms of the distant landscape flow into the sky and seem to melt into the air, standing mountains seem to be clouds in motion, while from either side of the panel, fields, ditches, and furrows, whatever we see, recedes and converges, narrowing like the tiles of pavement. Take note of this and let it not oppress you for it will extend your backgrounds into the distance."[3] Van Mander defines landscape not as thematic subject matter but the result of distinctive procedures and optical concerns. The landscapist devotes himself primarily to achieving the optical effect of distance because this leads the beholder into the image. He discriminates among landscape types in terms of the optical itineraries they plot—that is, in terms of different wanderings of the viewer into the image. Landscape mobilizes the eyes and conducts them to engage with the image in a way other genres do not.

Van Mander's comments on landscape are very idiosyncratic within the tradition of art-theoretical writing of the fifteenth and sixteenth centuries. The unexpected importance of landscape in his comments seems to arise from his preoccupation with the nature of pictorial representation as such. According to Van Mander, the nature of images consists of the power to convince us that we are seeing something not actually present to the eye. This implies that Van Mander defines pictorial representation according to a rhetoric of realistic illusionism. Landscape "speaks" this rhetoric of illusionism in an almost "natural" way. It seduces the viewer into the image. It invites the viewer to follow the orderings of the landscape.

This notion of landscape is ultimately a notion of representation. When Van Mander describes the elements of a landscape, he describes at the same moment the eye traveling on the surface of the painting. Landscape, then, becomes a metaphor for a mode of looking, a mode of looking that draws the eye into the painting and makes the beholder forget that the space is representational: "The eyes [should] gladly graze in Pictura's beautiful gardens, searching many places to refresh themselves, led by pleasure and desire, and hungry for more to see, they will peer over and under, like guests [at a banquet] tasting many dishes" (Melion 1991, 9).

History painting, in contrast, does not speak the rhetoric of illusionism but a rhetoric of address. The viewer is not being convinced that she is seeing something actually present to the eyes; rather, she is addressed by the image. The

viewer is subjected to the persuasive address enacted by figures in the painting. Appropriate responses or passions are projected by painted spectators and communicated to the responsive viewer. History painting is, one could say, shaped or codified within a different conception of representation. History painting manifests itself as a mode of address, which, again as a metaphor of its own modality, is explicitly shown, held out to the viewer. But the rhetoric of illusionism does not address the viewer directly or invite her to respond; it compels the viewer in a more indirect, oblique way to look attentively. After having led the viewer into the illusionistic world of representation, landscape compels the viewer to behold and to discern from within the depicted space. This seems to be the reason why, for Van Mander, landscape painting is paradigmatic for visual representation as such.

Significantly, Van Mander shows his preference for a rhetoric of illusionism over a rhetoric of address most clearly when he describes a painting that belongs to the genre of history painting. In the section devoted to the "life of Hans Bol" he describes the *Fall of Icarus* by this painter as follows:

It depicts a rocky promontory surrounded by water and crowned by a fortress, executed surpassingly well, pleasingly and meticulously overgrown with moss, the various colours of which were securely rendered: as was the curious and remarkably graceful old fortress, which appeared to grow from rock. The distant landscape was also very well rendered, as was the water mirroring the promontory, in whose shadowed waves one saw floating the plumes from Icarus' wings, fallen when the wax melted. The foreground was beautiful, too, as was all the landscape: seated here was a shepherd with his flocks, and a bit farther on a farmer behind his plough, both of whom looked up, astonished to see such flight, just as the text recounts. (Melion 1991, 183–84)

As Melion points out, it is the landscape, not the story, that commands attention: "We are called to gaze up at the island fortress, then out into the distance, and finally down at the sea. To emphasize that beholding is his primary concern, Van Mander focuses not on Daedalus and Icarus, but rather on the shepherd and the ploughman, who are themselves caught in the act of beholding" (184).

It is remarkable that the features attributed to landscape by Van Mander are usually attributed to architectural painting. He himself compares the well-ordered landscape with an architectural composition: "From either side of the panel, fields, ditches, and furrows, whatever we see, recedes and converges, narrowing like the tiles of pavement" (Melion 1991, 12). His description of how a well-ordered landscape should look enacts, in fact, the ideals, or the point, of linear perspective. His ideal landscape setting emphasizes depth again and again.

Every spot in a landscape should have its beyond, so that the eye will never rest but, rather, travel further into the image.

Landscape paintings are, for him, perspective landscapes. This notion of landscape explains, for instance, why in the idiom of seventeenth-century Dutch, the generic qualifier "a perspective" could refer to architectural painting as well as to a landscape painting.[4] But the relation between viewer and landscape is more "friendly" than in architectural painting, where perspective and buildings play hide-and-seek, and the viewer is tantalized and frustrated at once. In landscape painting, access to the depth of the represented space is not hampered but, instead, made "endlessly" appealing.

{ ELIMINATING ILLUSIONISTIC SPACE }

If Van Mander's pursuit only concerns the ideal of the illusion of depth because it is by means of depth that the eyes will enter the image, is it striking that he only deals explicitly with landscape painting? For, in itself, architectural painting succeeds in producing the effect of depth much more consistently and in much more detail and refinement than does landscape painting. Yet there is another reason why landscape serves his notion of representational space better than the depiction of architecture would. In order to understand this, I will discuss the work of Jan Dibbets, a contemporary artist who has challenged the pursuit of illusionistic space and who has proposed a different notion of representational space in its place.

In Dibbets's work, architecture is the privileged realm within which the artist dismantles illusionistic space and replaces it by another notion of representational space. This makes his work a good case through which to raise the question of on what basis, or in which terms, illusionistic space has been decontsructed, and how these terms differ from the terms in which Van Mander privileged landscape.

Between 1967 and 1969, Dibbets made about forty works in a series called *Perspective Corrections;* and—highly relevant for the topic of this chapter—the first versions are done in the realm of landscape, while the later versions are in the realm of architecture. The early works were made on grass, using white rope to "correct" the spatial distortions caused by a limited perspective on space (fig. 26) A large number of them existed in two forms: as drawings of the constructions combined with small photographs of the construction and as enlarged photographs transferred to canvas. Although these works conveyed their conceptual point, they were also confusing in two respects: first, because the lawn did not foreground but, rather, diminished that which defines photographic represen-

26 | Jan Dibbets, *Perspective Correction (Four Horizontal Lines)* (1968), black-and-white photograph on photo-
graphic canvas, 110 × 110 cm. Museum Boijmans Van Beuningen, Rotterdam. Reproduction. © Jan Dibbets, c/o
Beeldrecht Amsterdam 2003. © Jan Dibbets/Artists Rights Society, New York.

tation—its linear perspective—and, second, because the white rope was more
than a line that "corrected" linear perspective, it was also a rope.

Therefore, most critics see the later *Perspective Corrections* as the most success-
ful versions. They were made on the wall of Dibbets's studio (fig. 27). The best
known and probably most successful one is the photograph of a square on the
wall of the studio. It is a small square, drawn on a white wall, "so light that it
seems to float" (Fuchs 1987, 51). Fuchs's analysis of what is at stake in the *Perspec-
tive Corrections* is very much to the point: "In constructing the *Perspective Correc-
tions* something happened to the spatial structure of the resulting image. In the
photograph, the geometrical form laid out on the lawn or drawn on the wall
changed into a different shape on the *surface* of the photographic image. The

ground supporting the original shape was carried along, it seems, in the process of visual transformation and became frontal too, like the 'corrected' shape. The illusionistic space, which is the natural space of photography, is thus eliminated: it is as if space is being pushed forward, almost out of the image" (51). Fuchs's words are well chosen: it is not only the space of the lawn or of Dibbets's studio that is "pushed out of the image" but a specific notion of the space of representation is pushed out with it as well. We see Dibbets transforming illusionistic space into the surface of the picture plane. We do not see just the result of it; rather, we see it happening before our eyes. This is especially true for the works in the studio because they leave the illusionistic photographic space intact. There, we see the illusionistic space in addition to the picture's ambiguous surface, and we realize that the spatial depth and frontal surface create a tension.

27 | Jan Dibbets, *Perspective Correction (My Studio I,1- Square on Wall)* (1969) black-and-white photograph on photographic canvas, 110 × 110 cm. Private collection. Reproduction. © Jan Dibbets, c/o Beeldrecht Amsterdam 2003. © Jan Dibbets/Artists Rights Society, New York.

Fuchs's analysis of Dibbets's successful use of architectural space for the deconstruction of illusionistic space takes place on the basis of very specific terms. The pictorial space that Dibbets's work and Fuchs's discourse explores and constructs is the flat surface of the picture plane. There is no place, or activity, for the viewer in this spatial realm. The beholder does not figure in the narrative of visual transformation told by Fuchs. The opposite is the case in Van Mander's discourse, in which he uses the space of landscape for promoting illusionistic space. The main character of Van Mander's narrative of the visual experience is the beholder of the image. The so-called *verschieten,* or distances, are of such a crucial importance because they exert an almost magnetic pull over the eyes; they engage viewers by compelling them to "plow" into the image (Melion 1991, 8). All of Van Mander's discourse seems to be fueled by the ultimate goal of absorbing the viewer into the image. In contrast, Fuchs's discourse seems to be fueled by almost the opposite goal: that of proposing the surface of the picture plane as an independent ontological realm, over against which the viewer is positioned, but into which he or she can never penetrate or travel. Fuchs's discourse represses the role of the viewer. But it is ultimately the viewer's role to feel, and in that sense realize, the tension that is at stake in Dibbet's *Perspective Corrections.*[5]

Of course, Dibbets's *Perspective Corrections* are not the first works of art that dismantle spatial depth by foregrounding the picture surface. These works fit into a modernist tradition initiated by artists such as Cézanne, Mondrian, and Picasso. Picasso for instance, started to structure the surface of the canvas in a new way. There was no horizon, no background; the surface was simply divided between the space of the painted figures and the space that surrounded them. His *Les Demoiselles d'Avignon,* for instance, shows no space surrounding the figures. Picasso rendered the image surface through a highly developed dialectic of line and plane rather than of color, rhythm, or background. Picasso was not, however, merely dismantling the depth of the picture surface alone but the objects or figures depicted on them as well. He depicts the multiple aspects of the thing or figure, its three-dimensionality, simultaneously, at the level of the painted surface.

As Henri Lefebvre points out, this process is quite paradoxical: the third dimension (depth) is at once reduced to the painted surface, and restored by virtue of this simultaneity of the three-dimensionality of the multiple aspects of the thing or figure (1991, 301). But this restored three-dimensionality now takes place elsewhere: not in the painting but on the painting's surface.

Dibbets's works explicitly relate, almost constantly, to the tradition of architectural painting. This is less obvious in the cases of Cézanne, Picasso, and Mondrian. But I would nevertheless like to argue that even their works have outspo-

ken architectural qualities. Whatever they paint, they construct pictorial objects as compositions of two- or three-dimensional forms rather than as embedded in a spatial context or foregrounded by light. What these artists have in common, therefore, is not only that they reformulate representational space within the two-dimensionality of the picture surface. They also need, or end up employing, architecture, or architectural qualities, to do this. Furthermore, the viewer, who was such a central character in Van Mander's promotion of illusionist space, has disappeared from the stage.

{ FALLING INTO THE PAINTING }

The opposite seems to be at stake in the works of Canadian artist Eleanor Bond. She has become known through her depiction of fictional landscapes and futuristic urban environments. Visually, the works are large-scale paintings that usually depict settings from a bird's-eye view. But even when Bond depicts urban centers and built forms, her work always has the quality of landscape painting. Her paintings seem to be determined by exactly those qualities that are so consistently lacking in the work of Cézanne, Picasso, Mondrian, or Dibbets. She pays much attention to texture, color nuances, and light. In my reading of her work, I will focus on her series of eight large-scale paintings titled *Social Centres,* of 1990 (fig. 28).

Whereas Dibbets's work creates a tension by the absorption of illusionist depth into the picture surface, Bond's work creates a tension by means of scale and perspective. The bird's-eye perspective in these paintings has an unsettling effect on the viewer. Standing before one of her canvases, one feels as if falling forward into the space of the painting. The painting's perspective situates the viewer high in the air. She literally has no ground under her feet. The compulsion to enter the painting's space is more than a visual effect. One experiences it viscerally or bodily, like the feeling of vertigo. This experience of falling into the painting, however, is produced not only by the bird's-eye perspective and the size of the paintings. As Anne Brydon has pointed out, these paintings never include horizons that could give the beholder's eye some stability (1994). The compositions are dominated by spiraling lines, which generate a feeling of dynamic motion. The intense colors and dispersed patters of light and dark also produce a sense of forward movement.[6]

But there is more. These formal features are not alone in having this unbalancing and unsettling effect on the viewer. The identity of these urban centers contributes as well. Again and again, anthropomorphized forms can be recognized in them (fig. 29). We see a hand-shaped lake, a mountain in the form of a

28

29

28 | Elenor Bond, *Social Centers* (1990). Courtesy of the artist.

29 | Elenor Bond, *Social Centers* (1990). Courtesy of the artist.

head, an island in the form of a guitar player or an eye. These anthropomorphized forms break down the opposition between nature and culture or between nature and society. When we see these settings as landscapes, they turn out be very artificial, but when we see them as urban settings, they turn out to be highly "human" or "natural."

Together, the different strategies pointed out so far result in the problem of situating oneself as beholder. Clearly, the viewer—his or her role and positioning—has an important function in this analysis of Bond's work. One could wonder, therefore, whether this implies that Bond's representation of space is a return to the kind of space of representation as advocated by Van Mander. To put it differently, is Van Mander's beholder, whose eye travels into the depth of the illusionistic space, the same kind of beholder implied or activated by Bond's paintings? That would make Bond's work very traditional, a repetition of a historical genre and its implications. But there is a crucial difference. Van Mander's beholder is just an eye without a body. The viewer is reduced to the function of looking, a looking that is always in total control of the field of vision. This looking controls by virtue of being detached, not only from the field of vision but also from the eye as bodily sense organ related to the rest of the body.

Van Mander's viewer is endowed with a masterful gaze. This conclusion is inevitable, for instance, in the magnificent vast panoramas of Philips Koninck (fig. 30). The high perspective in these works has an effect opposite to the bird's-eye perspective in Bond's vast panoramas. The high perspective gives the viewer an overview that masters what it covers. The overview provides mastery because the viewer is positioned in such a way that he or she has figuratively, or perhaps literally, ground under his or her feet. By having a stable position, the viewer can forget herself, her body, and focus on the field of vision.

In Bond's case, the aerial views constitute no stable position for the beholder, which is why the perception of her paintings is more than a visual experience. It is also bodily or emotional. This has radical consequences for the kind of space of representation involved in the works. The space of representation expands into the "living" space of the beholder. It is the space of the body and the space between viewer and image that becomes a crucial element of the representational space.

So far, I have distinguished three kinds of representational space, which can be acted out or activated in representation: first, the space in or behind the picture surface, the so-called depth of illusionistic space; second, the two-dimensional space of the picture surface itself; and third, the "lived" space of the beholder, which includes her body, as well as the space in between the image and the viewer. These three spaces each pertain to different ontologies: they are determined by their own laws, orders, and processes.

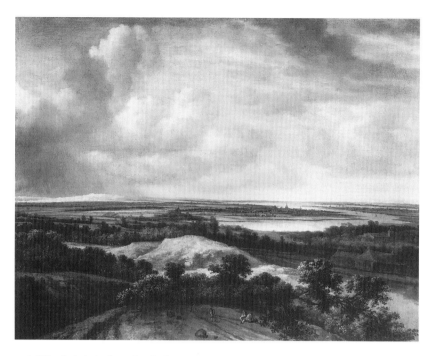

30 | Philips Koninck, *Landscape* (1664), oil on canvas, 95 × 119 cm. Museum Boijmans Van Beuningen, Rotterdam.

At the same time, I have been talking about representations of different kinds of space: landscape and architectural or urban space. The question now is the following: Is there a correlation between these two dimensions, between the representation of a specific space—landscape, architecture—and a specific space of representation—the viewer's space, the picture plane, illusionistic space? I would like to suggest that when artists set out to explore the two-dimensionality of the picture surface, they end up in the realm of architecture. This is why even Cézanne's still lifes and landscapes look constructed like architecture. This is why Picasso's human figures, built up as they are out of flat shapes, look like a composition of architectural forms and volumes. This is why architecture has been a constant point of reference in the work of Dibbets. And Damisch's analysis of urban perspective paintings, which I discussed in chapter 1, suggests what the challenge is.

I would like to suggest that when artists set out to explore the space between viewer and image, they end up in the realm of landscape. This is the reason why Van Mander describes history painting as if it were landscape painting. This is the reason why Eleanor Bond cannot avoid deconstructing the dichotomy between nature and culture when depicting urban settings.

{ BODILY SIGHT }

Let me test this idea on Marien Schouten. I began this chapter by pointing out some contrasted forms in one of his drawings from 1987: the organic mountain-like forms and the geometrical forms of the grid and the beam. These forms come back again and again in Schouten's vocabulary, doubtlessly because they evoke the tradition of landscape painting and that of architectural representation at the same time. Realizing to what kind of art historical traditions these forms refer is important because you thereby realize what kind of issues are at stake. Of course, these historical dimensions of Schouten's work do not provide an answer to the question of Schouten's own position in these issues—whether he reiterates or exposes these traditions. To answer that question, we have to see how these forms, with their historical allusions, function within his works.

Much has been written about Schouten's use of grids; much less, however, has been written about his use of organic, natural forms. For example, Jan van Adrichem has argued that the grid in Schouten' work is not an unambiguous structure with a fixed meaning or function. I agree with him, but what, then, are the different meanings of the grid enacted in Schouten's work, especially in terms of representational space? Van Adrichem defines the grid as "an abstract-rational space-indicating, space-limiting and space-dividing function" (1993, 158). Right. But what kind of spaces are being indicated, limited, and divided by the grid? This is an important question because Karel van Mander assigned, in fact, exactly the same functions to the forms of landscape.

For instance, Van Mander claims that by limiting and dividing the space by means of a rock, a mountain, or some trees, the work entices the viewer to want to know what is behind those forms, and thus he will be seduced to travel into the image. It seems that when Schouten applies grids in his works—and I say in, not on or in front of—the space that is indicated, divided, and limited is the two-dimensional space of the picture surface. Schouten, however, usually contrasts these grids with organic forms that evoke mountains, far horizons, or other landscape elements. These evocations are the result not only of the forms of these elements but also of their earthlike colors and the visible brush stroke that creates texture and suggests depth on a microlevel.

One recognizes, now, the same two representational spaces that are at stake in Dibbets's *Perspective Corrections.* But there is a difference. In the case of Dibbets, the illusionistic depth of the photograph turns out to be absorbed by the flatness of the picture surface, whereas Schouten's work never offers such a resolution. There is an ongoing tension, an irresolvable conflict between these two notions of space.

In the *Untitled Drawing* from 1989, one also sees some forms in or on the

31 | Marien Schouten, *Drawing with Wooden Slats* (1988), varnish/lacquer/pencil on paper (133 × 222.5 × 13.5 cm). Bonnefantenmuseum, Maastricht.

grids indicated just by their contours. They lack color as well as texture; they are just contours. Strikingly, these forms are not in tension with the grid in the way that the mountainlike forms at both sides are. The grid functions now like a support for a design, as grids do in architectural drawings. But Schouten has also made works with wooden grids applied to their surface (e.g., *Drawing with Oval Wooden Grid* [1989], *Drawing with Wooden Grid* [1988], *Drawing with Wooden Slats* [1988]; fig. 31).

The status of the grids in these works is quite paradoxical. Are these grids part of the image or in front of it? Do they belong to our space, or to the space of the picture surface? Are they framed by the picture frame or are they part of the frame? Again, there is an irresolvable tension, but this time not between illusionist space and the picture surface but between real, concrete space (the space of the viewer) and the one of the image proper. This second level is ambiguous in itself, depending on whether we read it as an allusion to illusionist space or as a flat surface.

However, not only the status of the grids but also their function is paradoxical. They hide the image by covering it, but they also highlight the image by indicating or outlining the space that is behind it. This paradoxical function is, of

course, also active in the traditional seventeenth-century Dutch motif of the painted drapery or curtain that partly hides the image of which it is part. For example, Gerard Houckgeest's *Interior of the Old Church, Delft* (1654; fig. 32) uses this device. As a viewer you do not know whether these views are being opened, revealed to you by the removal of the drapery, or whether you should feel frustrated because you cannot see everything. Is this a moment of public revelation of something secret, or is the constructed viewer in possession of a voyeuristic gaze? Whichever way we read this device, it is important to notice that, in both

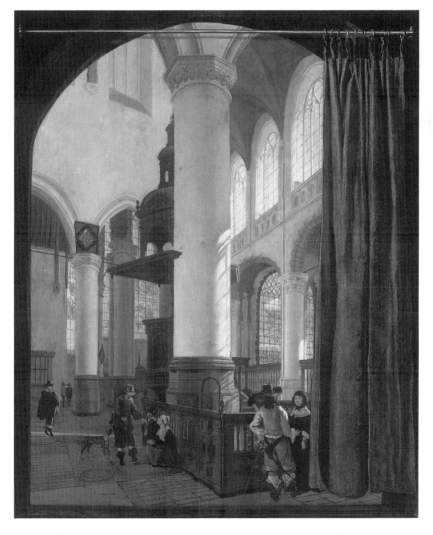

32 | Gerard Houckgeest, *Interior of the Old Church, Delft* (1654), oil on panel, 49 × 41 cm. Rijksmuseum, Amsterdam.

cases, the space of the viewer is reflected on in the work. It is taken into consideration, integrated into the space of representation.

That this motif of drapery is also played out in many of Schouten's works comes as no surprise. Or to see this differently, when we read his work through this tradition it changes gears. Often, the organic forms that until now I have read as mountainlike forms can equally well be read as curtains. The role assigned to mountains by Van Mander is exactly the one of curtains in front of paintings or of curtains before the stage of a theater. Through the gesture of blocking your sight by something, an artist makes you want to know what is behind that which blocks your sight. Thus, you are seduced into the visual field.

The relation between past and present works according to the concept of "influence" as we have learned to use it: looking at past art helps us understand contemporary art. But this relation is not a one-way street. I will now reverse it and show how the present exposes the past, makes problems in it visible by an engagement with past art that exposes, rather than follows, its ideological implications.[7]

Whereas Schouten started out by depicting these blocking/revealing devices in the image, he soon applied them elsewhere as well, within realms that are ontologically different. In 1986, for instance, he made a work that consists of a framed drawing and a wall painting, which is mounted at a right angle to the wall on which the drawing hangs (fig. 33). The wall painting is an abstracted representation of a drapery. In contrast to the seventeenth-century device, this curtain is in the same, real architectural space in which the viewer is situated. But like the historical device, the curtain is not real but a representation.

What the seventeenth-century motif and Schouten's use of it have in common is that the work itself reflects on the act of viewing. The difference, however, can be articulated as follows. The drapery depicted in the painting refers indirectly to the beholder as an abstract function. In Schouten's case, the self-reflexive gesture of the work takes place in the same ontological space as the one in which the viewer is located. This space is real and concrete. It implies a different reflection on viewing. The act of beholding is more than an abstract function: it has become an activity, which can no longer be limited to the function of sight as such. Sight now becomes bodily, something performed by a sense organ, that is part of a body, a body that is by definition determined by its specific location in space. This is a crucial difference that, retrospectively, exposes a major limitation of the tradition that Van Mander so enthusiastically promotes. Now, it is the contemporary artist that comments on his predecessors.

The implication of the body, its being positioned, is precisely what those works that extend into real space foreground when wooden shelves are fixed onto the picture surface, not frontally, but by their narrow side (fig. 34) The

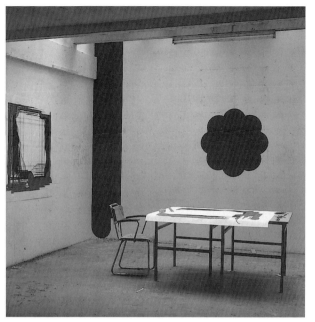

33

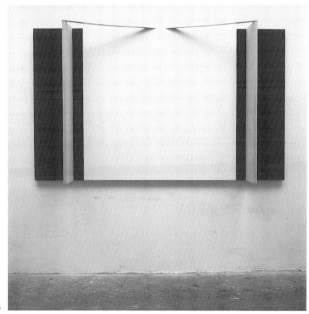

34

33 | Marien Schouten, studio view: *Wall Painting* (1985), acrylic, 350 × 58 cm, Museum Boijmans Van Beuningen, Rotterdam; and *Drawing* (1986), oil pastel/pencil on paper, 120 × 150 cm.

34 | Marien Schouten, *Painting with Wooden Boards* (1989), wax/pencil on linen, zinc strips, 200 × 118 × 34 cm. Bonnefantenmuseum, Maastricht.

viewer's access to the visual field constituted by these works depends, in the most physical way, on where the viewer is positioned: to the right of the work, in front of it, or to the left of it. The shelves always make part of the visual field invisible. No position providing mastery over the whole image is possible. Contrast these works, for instance, with the vast panoramas of Philips Koninck to which I alluded earlier.

But, one could remark now, this way of presenting the act of viewing as something that takes place in time, and as something that always depends on the position the viewer has in relation to an object, is not at all new. Already in the sixties, artists like Robert Morris focused their work precisely on this issue.[8] This is true, but in Schouten's works we see the addition of a different concern. He does not just show that the viewer is positioned in space and that this real space is one of the dimensions of the space of representation. At the same time he explores different ways in which the viewer, not only as an abstract function but also as a real person, can be engaged with the visual field. The distinction that I have deployed so far, the one between architectural space and the space of landscape, will help me explain this.

In 1991, Schouten radicalized his efforts to integrate the real space of the viewer into his works by making installations that included gridlike fences placed in the middle of the exhibition space.[9] These fences are unambiguously architectural elements (fig. 35). As objects in an exhibition space, they are radical statements. Usually, you can freely wander through a gallery or a museum, but these fences block the walking circuit in the most literal and physical way. In their radicality, these architectural grids suggest a crucial difference between architectural space and the realm of landscape.

As I pointed out before, when reading Van Mander's text and Schouten's mountains/draperies, these natural forms relate to the viewer in a highly paradoxical way. They invite the viewer into the image at precisely the same moment that they block the beholder's view. By hiding something, they promise a revelation as reward. The blockage of our view is not there to prevent vision but to direct our vision. The architectural grids, however, only frustrate our view. There is no way around the fences. That these fences evoke prisons is, of course, not irrelevant. Our view is limited and we are confronted with the awareness of this limitation. In contrast to landscapes, the grids constitute the prison house of vision.[10]

One could now formulate Schouten's artistic project as follows. He explores the nature of representational space as a tension among illusionist three-dimensional space, the two-dimensional space of the picture surface, and the space of the real viewer, again three-dimensional. And he explores the nature of representational space as a mode of engagement that space itself provokes. The space of

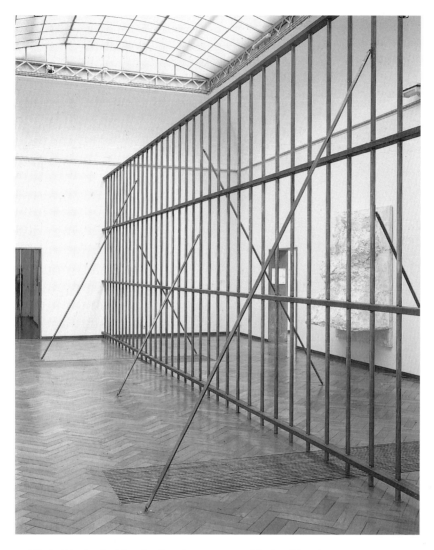

35 | Marien Schouten, *Steel Fence* (1996), steel, 420 × 1,590 cm. Collection of the artist.

landscape seems to be inviting, seducing, promising, whereas architectural space stops you, asks for respect, defines space in terms of territory, its own and yours.

This distinction is not a distinction between good and bad, between stimulating vision and frustrating it. They are both effective ways of engaging vision but according to different principles. If you like, we can use a psychological framework to explain these different principles. Architectural space engages vision by

raising obstacles. And obstacles encourage the desire to conquer them, to do something when it is forbidden, to try something when it is impossible, to intrude on a space that is not yours and has to be respected as secret or somebody else's. In contrast, the space of landscape engages vision by seducing you or inviting you. Both can be effective, but the effects differ.

Let us now go back to the works with wooden shelves in front of them. We can read them in relation to the architectural tradition or as abstracted landscapes, comparable to the abstracted curtain painted on the museum or studio wall. Earlier, I suggested that artists who focus on the space of the beholder in relation to the image end up in the realm of landscape, whereas those artists who explore the nature of the picture surface will feel more at home in the architectural realm and idiom. The gridlike fences placed in the middle of the exhibition space seem to counter this hypothesis. Unambiguously architectural, they can only be read as reflections on the space of the beholder. Importantly for the thesis underlying this book—that art thinks in history—the object here resists what I am trying to do with it. If I want to continue defending my hypothesis, I have to turn not only the fences but also the wooden shelves into abstracted landscapes, but that seems to be too farfetched. Instead, I will try to resolve this tension between a historically grounded theory and a concretely apparent counterexample by reading the latter as a theoretical object that has a point to make in this classical theoretical debate.

Certain works that Schouten started to make in 1995 will enable me to do this, namely, his so-called bronze paintings (fig. 36). These works look as radical as the gridlike fences. They are obviously programmatic. To begin with, these paintings are made out of bronze, and this material aspect stresses a lack of penetrability. Two elements, however, offer the viewer easier access. At the outset, in the wake of Van Mander, two mountainlike forms frame the painting like coulisses, thus hovering between nature and theater, that apex of artificiliality. The eye follows their three-dimensional slopes until we arrive at the picture surface. Van Mander's device of seduction has been transposed in the most literal way from the space of illusionism into the space of the beholder. This element works in the same way, nevertheless, to take care of the eye.

The other element consists of the now familiar shelf attached to the painting by its narrow side. The shelf does not lead the eye; instead, it forms an obstacle to it. We have problems looking underneath. We must go down on our knees to see the part of the image that is under the shelf. This makes us realize again that the act of looking is bodily rather than abstract. Two modes of engaging vision into the visual field seem to be combined here in one painting. The first is the seducing mode with its recourse to the realm of landscape. The second is the

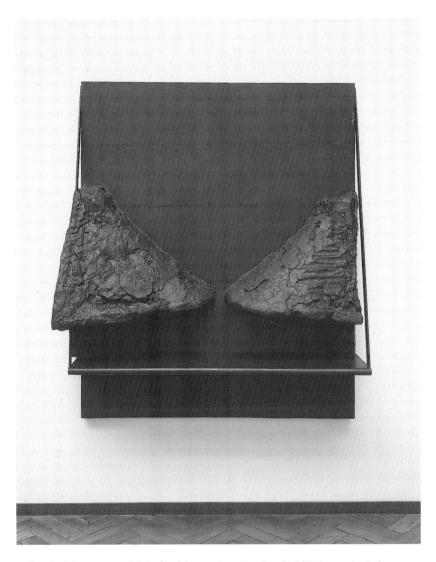

36 | Marien Schouten, *Bronze Painting* (1995), bronze, 187 × 158 × 46 cm. Stedelijk Museum, Amsterdam.

mode that engages by creating obstacles and territories. This is the mode that has recourse to the realm of architecture.

Schouten's more recent ceramic installation *Slang* ("snake" [2001]; fig. 37) takes the intertwinement of these two itineraries to its limit. The installation consists of a room with curving, folding walls. Literally, it is a piece of architecture, for you have to go inside it to see it. But at the same time it is endowed with

37 | Marien Schouten, *Snake* (2001). Collection Stichting De Pont, Tilburg.

qualities that turn the installation into a landscape. It seduces you into it, makes you follow its meandering path. You enter at one side, and after having passed through the space, you can leave at the other side. The walls are covered with dark green ceramic tiles in innumerable shades. The tiles are piled up like roof tiles or like scales. As a result, parts of the tiles are exposed, parts are hidden because covered by other tiles. The glazing of the tiles is very uneven. Sometimes

it reflects back our gaze, at other times the absorbing quality of the green color is strengthened by the lack of glazing. Hence, wavering between different modes of vision is solicited not only by the macrostructure of the installation but also by the parts of which it consists. But the tension between landscape and architecture is never resolved. On the contrary, the interplay between the modes of vision these genres solicit, form a rhythm that exposes the irreconcilability of landscape and architecture.

But where do we find ourselves at the end of these two different itineraries of which Schouten proposed an integration? In both cases, at the picture surface. There is not much to see there. The same was true, though, for Van Mander's itineraries through illusionistic space. In the paintings he described again and again, we end up at the ultimate horizon where earth and sky dissolve into a hazy nothingness. There is not much to see there either. What we have seen, however, at the moment that we arrive at that point, is a vision. A vision of vision.

The Homosocial Gaze

Souvent les femmes ne nous plaisent qu'à cause du contrepoids d'hommes à qui nous avons à les disputer, bien que nous souffrions à mourir d'avoir à les leur disputer; ce contrepoids supprimé, le charme de la femme tombe.—Marcel Proust, *A la recherche du temps perdu* (3:413)

{ INTERMALE LOOKING }

In the wake of the exposures discussed in the first part of this study, I will here look at the result of such exposures. They create the need and desire for fantastic revisions of a status quo revealed to be unsatisfactory, sometimes even unbearable. One important situation that is so firmly historically anchored that it seems extremely difficult to change is the social structure indicated by the term "homosocial." In this chapter I will explore the specific nature of homosocial relations through the notions of the gaze and the glance. I will propose some reflections on *intermale* looking. The distinction between gaze and glance has been introduced by Norman Bryson (1983) in a discussion of modes of looking at painting. For him, the gaze is the look that ahistoricizes and disembodies itself and objectifies or takes hold of the contemplated object. The glance, in contrast, is the involved look where the viewer, aware of and bodily participating in the process of looking, interacts with the painting and does not need, therefore, to deny the work of representation. Mieke Bal, elaborating on Bryson's distinction says the following about the glance: "The awareness of one's own engagement in the act of looking entails the awareness that what one sees is a representation, not an objective reality, not the 'real thing'" (1991, 142).[1] The gaze is a reading attitude that conflates model and figure in representation, an attitude that is encouraged by "transparent" realism, effacing the traces of the labor of representation. The

glance, in contrast, is the mode that emphasizes the viewer's own position as viewer and is aware of the representational status of the object of looking.

At first sight this distinction between gaze and glance does not seem inherently relevant for a reading of intermale looking. Bal and Bryson are discussing modes of looking at (visual) representations. It is not self-evident to see intermale looking as a case of looking at representations. Hence, I will argue for such a conceptualization of intermale looking through a discussion of the social bond between men. This bond is effectively based on the exchange of images of men. Hence representation is at the heart of it. This bond is not directly sexual in nature, nor are the modes of looking that shape it homosexual. The homosocial bond does, however, delimit and determine the relationship between men and women. With Eve Sedgwick I will call that particular bond homosocial.

First I will briefly evoke those theories on which Sedgwick has based her concept of the homosocial bond, that of the anthropologist Lévi-Strauss and the literary scholar René Girard. Then I will examine the novel *The Comfort of Strangers* (1981) by the British novelist Ian McEwan, which will enable me to demonstrate the nature and consequences of this bond in their full complexity. This novel not only presents a sharp analysis of what happens "between men," but significantly, it does so by way of visual motifs, such as looking, spying, mirrors, and photographs. I contend that this overlayering of the social relations with visuality is inherent to those relations, not coincidental. The question I will therefore address is: What is the point of all the picture taking and mirror looking in the novel in connection to the social relations between the male characters? *How* do they look? It is necessary to ask this last question not only because motifs of looking structure the novel so consistently but also because I contend that the nature of homosocial relations can be understood most keenly through an understanding of intermale looking, a process in which representation structures subjectivity.

In McEwan's novel one of the male protagonists, called Robert, is spying on and following another man, called Colin. Robert secretly takes pictures of Colin. In these situations of watching, Robert is not looking at a painting, a representation, but at another man. But the point I will try to make is that Robert's initial mode of looking at Colin turns Colin, precisely, into a representation. Colin is a live representation of a position within a system in which male subjectivity is constituted. This is why Bryson's distinction between gaze and glance are useful as concepts to analyze the particular modes of homosocial looking as powerful forms of social agency and, by extension, as configurations of the homosocial cultural order as such. This culture is represented in the novel in such an extremely destructive way that the need to revise it is inscribed in the novel. Thus,

it generates the thought that the cultural order of homosociality must be rewritten in radically different terms.

{ THE GIFT OF WOMEN }

In *The Elementary Structures of Kinship,* Lévi-Strauss speculates about the beginning of human societies. To do this, he examines the general structures of kinship relations. Two notions are central in his analysis: the gift and the incest taboo. These two notions together lead to an analysis of the practice of the exchange of women between men. According to Lévi-Strauss, the gift of women is of crucial importance for the emergence of culture. For the result of such a gift is much more fundamental than that of other kinds of gifts. By giving women, a relationship is created that is not just of mutuality but also of kinship. The men between whom the transaction takes place become relatives, and their offspring will even be blood relatives. Lévi-Strauss emphasizes the difference from other gifts by a quote from J. Best: "Two people may meet in friendship and exchange gifts and yet quarrel and fight in later times, but intermarriage connects them in a permanent manner" ([1949] 1969, 481).[2]

Within this structure of exchange the distribution of roles seems fixed. Women are the gifts; men are the partners between whom an exchange takes place. The social organization that is thus taking shape is an organization among groups of men within which women are only objects. Lévi-Strauss claims that even in cultures where women can choose the men they marry, they do not necessarily form an alternative organization: "This remains true even when the girl's feelings are taken into consideration, as, moreover, is usually the case. In acquiescing to the proposed union, she precipitates or allows the exchange to take place; she cannot alter its nature" (115). The consequences of this view are far-reaching. For it would imply that the organization on the basis of the exchange of women is still valid, even within contemporary Western societies. My analysis of McEwan's novel *The Comfort of Strangers* will present a statement on this issue.

The second important element in the transition from nature to culture is the incest taboo. The exchange of women provides a concrete elaboration of this taboo, which allegedly created the starting point of culture. If this is indeed the case, this elaboration sheds a disturbing light on the relationships of man to man and of man to woman. The heterosexual relationship of man to woman is then embedded within the relationship of man to man. The man-woman relation, result of the exchange of women between men, is a means to create ho-

mosocial relationships. The emergence of homosocial relationships is then the starting point of culture.[3]

In his study on the novel, *Mensonge romantique et vérité romanesque* (1961), René Girard depicts a less positive image of the relationships between men. His conclusion is based on European fairy tales and sagas about erotic triangular love relationships, and subsequently he applies it to the novel. In the dominant European tradition those triangles consist of male rivals competing for a female beloved. Girard concludes that the motor behind these triangles consists of a relation of rivalry between two active members of the triangle. The bond between these two rivals is at least as strong as the one between lover and beloved. Girard also discusses many examples where the choice of a beloved is determined by the fact that she was already selected by another person who is experienced as a rival. Girard even contends that the relationship between the two rivals is stronger and more defining of behavior and experience than the bond between lover and beloved.

Girard's theory shares with Lévi-Strauss's the notion that the relationship between men and women is embedded in the homosocial one between men. The heterosexual relationship shapes the bond between men, a bond that in the end is much more important than the one between men and women. The nature of this homosocial relationship is, however, different for Lévi-Strauss and Girard. For Lévi-Strauss it is an idyllic bond, the starting point of culture, whereas for Girard it consists of rivalry and competition. The difference between the two views can be understood in terms of Freud's theory of the Oedipus complex and can be explained in terms of the phases of that complex. Girard, then, theorizes the moment of crisis, the oedipal crisis of rivalry between father and son, whereas Lévi-Strauss deals with the situation of adaptation thereafter, when the son has renounced the mother, identified with the father, and, quietly and good-naturedly collaborating with the father, awaits his turn.

Both Girard and Lévi-Strauss base their conclusions on material that is not necessarily identical to the situation in contemporary Western cultures. Lévi-Strauss examines structures of relationship in so-called primitive cultures, while Girard limits his analysis at first to tales stemming from premodern popular culture, which he then transfers to the novel (which he thereby labels as fundamentally romantic).[4] Similar to Damisch's discussion of Kant, Freud, and a Watteau painting in close connection to the classical myth of the judgment of Paris (see chap. 2), I will use their theories as thoughts dealing with the same issue as those that I encounter in McEwan's *The Comfort of Strangers*. This does not imply that this novel thinks this issue in the same way or that it comes to the same conclusions. But only in close connection to each other can the specificity of this novel's thought be assessed.

Reading this contemporary Western novel, I will ask how the homosocial bond is characterized there and how it stands regarding the heterosexual relationship. What, in other words, is the function of the homosocial within the heterosexual, or, the other way around, what is the function of the heterosexual within the homosocial? Hence, this argument is not about homosexuality but about the foundations of heterosexuality. And, as I will argue, the relation between the homosocial and the heterosexual is grounded in an experience of similitude and difference, which is best understood by means of visuality: ultimately, the connection of a vision.

{ SEXUAL AMBIGUITIES }

McEwan's novel is about an English couple, Colin and Mary, who are vacationing in a picturesque Italian town with much water, many bridges, and, as a result, many tourists. The town is never mentioned; the descriptions do not lead up to an identification of the place, but one does recognize Venice. When, late at night, Colin and Mary try to find a restaurant, they get lost. During their wandering they meet the Italian Robert who leads them to a night café. After questioning them about their relationship, Robert is expected to talk about his own situation, a marriage. "When Mary asked how he met his wife, Robert said it was impossible to explain that without first describing his sisters and his mother, and these in turn, could be explained only in terms of his father" (McEwan 1981, 30). After Robert's narrative of his family history, everybody heads toward home, but Colin and Mary get lost again and spend the night in the streets. In the morning, Robert finds them in a state of exhaustion and takes them to his apartment. They sleep their fill, and afterward they meet Robert's wife Caroline. As a first unsettling motif of vision, Caroline confesses that she has watched them during their sleep. Robert resumes his narrative of father and grandfather for Colin's sake. Unexpectedly, Colin is punched in the stomach when he makes an ironic remark about Robert's veneration of his ancestors. On the days following this encounter, Colin and Mary hardly leave their hotel room. They sleep, make love and eat, again and again.

After a visit to the Lido they pass the palazzo of Robert and Caroline, who notice and reinvite them. Robert takes Colin to his bar where he has to settle some business; the women stay behind. Caroline tells Mary about her disability: she has become an invalid because of Robert's sadistic love making. Her back has been permanently damaged. Subsequently, she shows Mary the bedroom. Mary is totally flabbergasted and panicked when she is confronted by another visual event: the bedroom walls are filled with photographs of Colin. Robert must have

secretly taken these pictures during the couple's wanderings through the city. But she cannot react; Caroline has drugged her tea.

When the men come home, Colin wants to call in a doctor to look after Mary. Caroline and Robert refuse. Colin, already panicking because of Mary's sleepy state, begins to realize that Robert and Caroline want something from him, probably something sexual. He agrees, on the condition that Mary is helped first. When Caroline starts to caress him, he punches at her. The blow wounds her. She then smears the blood on Colin's lips. At that, Robert starts to kiss Colin on the mouth and cuts his throat. Over the dying body of Colin, Robert and Caroline make savage love. Mary, half unconscious and unable to intervene, has been forced to watch.

In what sense is this a novel about homosociality? And why is it not more obvious to interpret Robert's fascination for Colin as homosexual? Throughout the novel, this issue seems confused. Robert is clearly not interested in Mary, even if she is called a beauty. He is exclusively interested in Colin. He takes pictures of him only, and whenever Mary is by chance included in the image, he cuts her out. Already during their first visit to Robert and Caroline, Mary has seen a picture of Colin taken by Robert. When she tells this to Colin, she suggests that Robert might be erotically interested in him: "Perhaps," Mary said, "he thinks you have a nice face" (102) There are other moments in the novel that seem to confirm that interpretation.

The bar owned by Robert is visited by men only; these men are described as identical: "A number of young men dressed similarly to Robert, sat on high stools at the bar, and several more were arranged in identical postures.... Everyone appeared to be smoking, or putting out his cigarette with swift, decisive jabs.... Since they all wore tight clothes, they had to hold their cigarette in one hand, the lighter and pack in the other. The song they were all listening to, for no one was talking, was loud and chirpily sentimental" (28–29). At their second meeting, Robert takes Colin again to this bar. The itinerary to reach it is described as follows: "They were taking yet another unfamiliar route, along streets relatively free of tourists and souvenir shops, a quarter from which women too seemed to have been excluded, for everywhere, in the frequent bars and street cafés, at the strategic street-corners or canal bridges, in the one or two pinball arcades they passed, were men of all ages, mostly in shirtsleeve, chatting in small groups, though here and there individuals dozed with newspapers on their laps. Small boys stood on the peripheries, their arms folded importantly like their fathers and brothers" (108). Reading this passage, two conclusions present themselves. Either this is a description of a homosexual pick-up area, or this strict separation between men and women is typically Mediterranean.

The text does not give a clue. On their way to the bar, Robert has several brief conversations in Italian with the men he runs into. On arriving at the bar he asks Colin if he has understood the subject of those conversations. Colin's answer is negative. Robert then responds as follows: "Robert smiled again in simple delight. 'Everyone we met, I told them that you are my lover, that Caroline is very jealous, and that we are coming here to drink and forget about her'" (110). It is possible to read this remark as an indirect confession of homosexual desire. But this interpretation is too quick. Robert does not really express his desires. The effect of the remark, however, is obvious: he is trying to drive Colin into a corner, to put him in his place. I will return to this below.

In the final confrontation between Robert, Colin, and Caroline, it is again possible to read clues of homosexual desire: "Caroline transferred more of her blood on the end of her finger till Colin's lips were completely and accurately rouged. Then Robert, pressing his forearm against the top of Colin's chest, kissed him deeply on the mouth, and as he did so, Caroline ran her hand over Robert's back" (129). This passage does suggest that both Caroline and Robert are in love with Colin. That is why, one assumes, they hang his pictures in their bedroom. Husband and wife collaborate here in their violent conquest because they have a shared object of erotic desire. Yet I will ultimately contradict the notion that Colin is in the least an object of homosexual desire for Robert. Robert is in fact not at all kissing another man. Colin does not function as object of desire but as catalyst for his heterosexual desire whose object is Caroline.

Yet the lack of clarity in this matter must not be dissolved; for the question whether Robert's relationship to Colin is homosexual or homosocial is not only a crucial one for our purposes; it is also the question that turns this novel into a visual mystery. What is it, exactly, that Robert sees when he looks at another man, how is it that he looks, what is the nature of his gaze? This question determines his identity as a man, hence his subjectivity.

{ THE COMFORT OF A STRANGER }

Before returning to the crux of my argument, the nature of the homosocial in terms of looking-relations, I will now first make the same detour as does Robert. In order to understand his relationships to Caroline and to Colin, I must first present his relationship to his father, his mother, and his sisters; a full system of relations is already in place and at stake. This family history is literally and figuratively the frame of this novel. In the film based on the novel by Paul Schrader, that is the case even more concretely. The film begins with a voice-over: we hear

Robert talking about his father. In the middle of the film he tells the same story to Colin and Mary, and the film ends with Robert's voice talking about his father at the police station, during the hearing.

Robert's father was a diplomat, a pure specimen of patriarchy both within and outside his family. His wife and four daughters, his son Robert, and even the ambassador for whom he worked were all afraid of him. According to Robert, he was his father's favorite:

He took my napkin from my lap and tucked it into the front of my shirt. "Look!" he said." Here is the next head of the family. You must remember to keep on the good side of Robert!" Then he made me settle the arguments, and all the time his hand was resting on me here, squeezing my neck between his fingers. My father would say, "Robert, may the girls wear silk stockings like their Mama?" And I ten years old, would say very loudly, "No Papa." "May they go to the theatre without their Mama?" "Absolutely not, Papa." "Robert, may they have their friend to stay?" "Never Papa!" (33)

The father gives his ten-year old son the feeling of being a member of an exclusive club. This is how the father manages to rule over the rest of his environment. Robert denounces the childish bad tricks of his sisters to his father, for "I believed he knew everything, like God. He was testing me to find out if I was worthy enough to tell the truth. So there was no point in lying. I told him everything" (35), Of course, his sisters hated him and wanted to take revenge. One day, when the parents were away, the sisters presented Robert with a gift: two bottles of lemonade, chocolate, marshmallows and cream cake. His father had absolutely forbidden him to ever eat candy or chocolate, for those things give one a weak personality, like that of girls.

Robert was unable to resist the temptation and ate everything. When he falls sick, needs to throw up and gets diarrhea, the sisters lock him up in the father's study. He vomits and defecates all over the room. His father's reaction is thus: "'Robert, have you been eating chocolate!' And I said, 'Yes Papa but . . .' And that was enough for him. Later my mother came to see me in my bedroom, and in the morning a psychiatrist came and said there had been a trauma. But for my father it was enough that I had eaten chocolate. He beat me every night for three days and for many months he did not speak kindly to me" (39). The relationship between Robert and his mother is in a sense the opposite of that with his father. If the latter relationship is characterized by fear and deference because of the father's absolute authority and the hierarchy that sustains it, the relationship with his mother is based on unconditional love and warmth. Until he was ten years old, Robert slept in his mother's bed whenever his father was away. The sisters saw here another opportunity for revenge. When the Canadian ambassador

came to visit the family with his wife and his daughter Caroline, the following scenario unfolded:

Suddenly Eva said, "Miss Caroline, do you sleep with your mother?" And Caroline said, "No, do you?" Then Eva: "No, but Robert does."

I went deep, deep red, and was ready to run from the room, but Caroline turned to smile at me and said, "I think that is really awfully sweet," and from that time on I was in love with her, and I no longer slept in my mother's bed. Six years later I met Caroline again, and two years after that we were married. (41)

The place that Caroline will occupy in Robert's life can best be characterized with the novel's title, "the comfort of a stranger."

Robert is imprisoned in the relationship (of struggle) with his father, the ideal but feared reference point for his own identity. Deference and anxiety define Robert's experience of his father. In addition, he is involved in struggle with his sisters; contempt, but also fear, defines the experience of that relationship. In comparing himself to his father, he is constantly afraid of not resembling him enough; in comparing himself to his sisters, he fears too much resemblance, fears being like a woman. Robert's identity is shaped between these two extremes. Afraid of not being manly enough, he must distinguish himself from the opposite pole. His identity is in suspension: not enough like the one, he is constantly threatened with being too much like the other. This is emphatically not a matter of object choice, but of a lack of subjectivity. It must be remembered that this experience of self and the lack thereof is the result of an imposed identification with the father.

The mother appears to stand outside this struggle. She loves her son unconditionally. Yet she is unable to offer a solution for Robert's struggle, precisely because she belongs to the respected father. Robert only sleeps with her when the father is away from home. Caroline, the Canadian girl, finds him "awfully sweet" just like that, just like his mother. She becomes his resting place and companion in his impossible struggle to build himself a masculine identity like his father's. Robert falls in love with Caroline because she is without conditions—because, for her, he need not prove himself because he is his own truth—as he was for his mother.

However, when they fail to have children and he turns out to be sterile, their marriage takes a different turn. Robert can forget his ambition to be a father, a patriarch. He sinks into the marsh of the other pole, his sisters', the nonelected: the nonmasculine. Now he struggles no longer for the position of the Father but, more defensively, against the inferiority of nonmasculinity. And Caroline is no longer just like his mother; she is, with her sex and generational position, also

like his sisters. That is why he cannot but despise her, humiliate and hate her; that is why, as of that moment, his love turns into extreme sadism.

Talking to Mary, Caroline recounts her marriage in the following terms: "Robert began to really hurt me. He used a whip. He beat me with his fists as he made love to me. I was terrified, but the terror and the pleasure were all one. Instead of saying loving things to my ear, he whispered pure hatred, and though I was sick with humiliation, I was thrilled to the point of passing out. I didn't doubt Robert's hatred for me. It wasn't theatre. He made love to me out of deep loathing, and I couldn't resist. I loved being punished" (117). Sexuality and violence are here completely intertwined. Robert's sexual desire for his wife cannot be distinguished any longer from his contempt for, and hatred of, women, in their quality of nonmen. And this intertwinement of sexual desire and violence will further determine Robert's homosocial bonds with men.

The intertwinement of sexuality and violence is emphatically not presented as a universal fact—as Bataille did, for example.[5] The intricacy is the product of a specific organizational principle, most adequately described as the patriarchal order. Whereas Robert and Caroline are representatives of this order, Colin and Mary embody an alternative order or, rather, the negation of that order. The novel stages the conflict between the patriarchal order and the tentative one that negates it. This conflict is represented spatially and visually. The whole city is filled with posters of a feminist pressure group that demand that rapists be castrated. Mary explicitly underwrites that demand. She herself has been a member of a women's theater group, she raises her two children by herself, and her relationship with Colin can be termed modern, based on mutual autonomy. The sadomasochistic relationship between Robert and Caroline stands in sharp contrast with theirs, based as it is on violent subordination. The extremity of the represented positions makes impossible any attempt to "naturalize" them. Hence, the representation itself invokes its own rewriting.

{ THE CAMERA AND THE MIRROR }

The conflict between the two orders is shaped in a much more complex way, however, by the elaborate weaving through the novel of visual agency, in the manipulation of camera and mirror, each standing for a way of looking. About Venice, the city where Mary and Colin are strangers, it is said that "two-thirds of the adult males carried cameras" (49). Robert himself, who is not a tourist, is nevertheless constantly walking around with a camera: "Over his shoulder he carried a camera" (26). Almost everyone in this novel carries a camera. Mary and

Colin are the exceptions to this rule, which is remarkable, given the fact that they are tourists.

When Colin begins to realize that Robert has been following him with a camera, he looks around to see if Robert is somewhere near. He then sees so many cameras that their owners are reduced to negligible, meaningless items in the background: "There were cameras everywhere, suspended like aquarium fish against a watery background of limbs and clothes, but Robert, of course, was not there" (102). Whereas the patriarchal order seems to be embodied by the camera and the taking of pictures, the order based on the negation of the patriarchal order is signified through the visual motif of the mirror. Mary and Colin find themselves quite often in front of a mirror. Realistically speaking, this simply means that they pay more attention to their looks ("Colin stood in front of the mirror, listening, and for no particular reason he began to shave for the second time that day" [11]). But at the same time the mirror motif represents the nature of their relationship and a different relation between the sexes: "They often said they found it difficult to remember that the other was a separate person. When they looked at each other they looked into a misted mirror. When they talked of the politics of sex, which they did sometimes, they did not talk of themselves. It was precisely this collusion that made them vulnerable and sensitive to each other, easily hurt by the discovery that their needs and interests were distinct" (17). When we analyze the mode of looking that is at stake here in terms of Bryson's distinction between gaze and glance, the collusion between Colin and Mary is the result of their looking according to the logic of the glance. Their involved looks dissolve the clear-cut difference between the subject and object of their looks. The object of the look functions as a mirror, which means that subject and object are mingled and become mutually constitutive. The mirror functions here as the embodiment of a specific mode of looking: the glance.[6]

The camera, the taking of photographs embodies, then, the other mode of looking: the gaze. In this novel, the taking of pictures comes to stand for the objectification and disembodiment of the contemplated object in the most literal and lethal sense. This meaning of the taking of pictures is in the same vein to the "shooting of images" I discussed in relation to Fiona Tan's video installation *Saint Sebastian*. Robert's taking of pictures of Colin disembodies him, takes the life out of him. Colin is turned into a representation, with deadly effect.[7]

In some respects, the order in which Colin and Mary stand is diametrically opposed to the patriarchal order of Robert and Caroline. This does not mean, however, that it is idealized. If Mary and Colin are mirrors to each other, this situation entails the cancellation of sexual difference.[8] In Robert's order, in contrast, the difference between man and woman is hierarchical and absolute. At

the same time, the equation of the sexes in light of the mirror suspends the properties of each sex, and that suspension appears to diminish sexual desire. The frequent lovemaking of Colin and Mary is not described as passionate but as pleasant.

The difference between photo and mirror as standing for the difference between the patriarchal order and the negation of it is also palpable in narratological terms. Colin, who is after all the main character of the story, hardly has an identity outside of his relationship with Mary. We know nothing of his past, for example. In contrast with Robert, he never acts as focalisor of his own past. We get to know much more about the pasts of Mary and Caroline. He is not given an opportunity to tell his story, but neither does he wish to do so.[9]

This is not the case for Robert. When, at their first encounter, Robert interrogates them and thereby yields to them the narrating position, Colin whispers to Mary: "We don't have to explain ourselves, you know" (26). In contrast, Robert talks all the time about his past, and in addition, he has fixed his identity through an exposition of photos of his father and grandfather. Colin's identity is represented exclusively through the way he behaves in the present, the way he talks, responds, acts, and thinks in relation to Mary.

As a man, Colin is not a representative of the patriarchal order. That becomes clear, for example, when Mary focalizes him sleeping naked on the bed. She takes pleasure in his beauty, but the terms in which she describes him stand in systematic contrast to some of the conventional views of masculinity: "His arms were crossed foetally over his chest and his slender, hairless legs set a little apart, the feet abnormally small like a child's, pointing inwards. . . . His buttocks were small and firm, like a child's. . . . Colin's eyebrows were thick pencil lines. . . . His hair was unnaturally fine, like a baby's, and black, and fell in curls on to his slender, womanly neck" (58–59). The description of Colin's body and face takes more than a page. It is entirely couched in terms of a baby, of femininity, or of the artificial beauty of sculpture. There is never any mention of terms that describe him as conventionally masculine.[10]

Standing outside the patriarchal order, Mary and Colin have enough distance to have insight into its basic principles. When, at the end of the novel, Mary has to identify Colin's body, she mentally explains to him why he was murdered: "She was in the mood for explanation, she was going to speak to Colin, She was going to recount Caroline's story, as closely as she could remember it, and then she was going to explain it all to him, tell him her theory, tentative at this stage, of course, which explained how the imagination, the sexual imagination, men's ancient dreams of hurting, and women's of being hurt, embodied and declared a powerful single organizing principle, which distorted all relations, all truth" (134). The proximity in this crucial passage of the nouns "story,"

"theory," and "imagination," three key concepts in the present analysis, is, so to speak, telling. Although Mary and Colin do not live in this order, narratively they become lost in it—with lethal consequences. This wandering into the patriarchal order is again represented in primarily spatial terms. Venice with its historical grandeur stands for that order. They wander in that city like strangers, and more and more they get lost. At the moment that Robert guides them through Venice they get entangled in the pitfalls of that order. We notice this, for example, after their first visit to Robert and Caroline's apartment. There, the text suggests that sex and violence get entangled for them, too: when they leave the palazzo, we read the following: "As they descended the first flight of stairs, they heard a sharp sound that, as Mary said later, could as easily have been an object dropped as a face slapped" (80) This event closes chapter 6. Chapter 7 opens with this information: "During the next four days Colin and Mary did not leave the hotel. . . . Walking back from the apartment to the hotel, they had held hands all the way; that night they had slept in the same bed. They woke surprised to find themselves in the same bed. Their lovemaking surprised them too, for the great, enveloping pleasure, the sharp, almost painful, thrills were sensations, they said that evening on the balcony, they remembered from seven years before, when they had first met" (81). Although the connection between the end of chapter 6 and the opening of chapter 7 remains implicit, a causal connection is suggested between the encounter with Robert, the sharp noise, perhaps a slap in Caroline's face, and the four days of sexual pleasure. The implicit message is that violence brings pleasure.

When Mary defines the organizing principle of the patriarchal order as "men's ancient dreams of hurting, and women's of being hurt," eroticism and violence are presented as an inextricable knot within which no difference between cause and consequence can be noticed any more. It stops being a narrative process to become a static situation within which positions are not delimited and exist as a mixture of masculine and feminine positions. When Caroline tells about her marriage, however, she does so in terms of development and change, of a growing entanglement. Robert begins to use violence at a certain point in time—not at an arbitrary moment but when he learns that he is sterile and, therefore, definitively unable to become a father. At first Caroline is afraid, terrified, of this development; only later does she learn to take masochistic pleasure from the violence. My interest here is not in Caroline's development but Robert's. His heterosexual desire for Caroline only becomes sadistic later; it entails the entanglement of sex and violence in a second round.[11]

I will now turn to how eroticism and violence interact in Robert's homosocial relation to Colin. I have already argued that Colin is not the object of homosexual desire for Robert. Yet Robert constantly calls forth a homoerotic tension.

From where does this tension arise, and what is its function? The epigraph that McEwan uses for the novel helps to answer these questions. The epigraph consists of three lines of poetry from the feminist poet Adrienne Rich:

how we dwelt in two worlds
the daughters and the mothers
in the kingdom of the sons[12]

The syntactical and formal structure of these verses emphasizes the embedding of the world of mothers and daughters within the kingdom of the sons that is their semantic content. Moreover, it is striking that Rich mentions mothers but not fathers, as if she wants to say that the kingdom of the sons contains no fathers because the sons are still up to the task of proving their fatherhood, in a continuous struggle, an endeavor they never entirely succeed in. Never does a son reach the moment that he can say: "I made it, I am a father." Masculine identity remains the stake of struggle and must be proven time and again.

Rich's lines confirm my earlier assumption that Robert and Caroline's marriage is not a goal in itself but a function in a family history, in the development of a subject. Thus a second meaning begins to take shape for the title, which at first seems to refer to the help Robert provides the two strangers when they are lost and hungry. Now the relation is reversed. If Robert's subjectivity is shaped on a sliding scale between idealized man (the father) and non-man, then his heterosexual love object, Caroline, is the comfort that a stranger can bring within this struggle. Because women stand outside the opposition men—non-men—they can be the means through which the man can prove his manhood or his fatherhood. Within this struggle, Caroline is just a means, not a goal.

Robert's representation of the world is totally occupied by his ego ideals, his father and his grandfather: "My father and his father understood themselves clearly. They were men, and they were proud of their sex. Women understood them too. . . . There was no confusion. . . . Now men doubt themselves, they hate themselves, even more than they hate each other. Women treat men like children, because they can't take them seriously" (75–76). Robert says these things in a conversation with Colin, who responds ironically. The subordination of women in Robert's world order is not chosen by the women out of deference and respect for the men but because they were subordinated. "Women did as they were told," says Colin. In response to Robert's nostalgic memories of the heyday of patriarchy, Colin says: "Your grandfather's day had suffragettes. And I don't understand what bothers you. Men still govern the world" (76).

The difference between Robert and Colin is enormous, and the reader is soon aware of it. Naturally, Robert sees Colin in a different light than the reader

does. Seeing him stroll through the alleys of Venice in the company of Mary, Colin at first represented Robert's ego ideal. There was the man he would have liked to be. He does not see Colin as a beautiful man but as a representation of a position within the hierarchical system that constitutes male identity. The position, which Colin represents according to Robert's gaze, is a high position, higher than the one he occupies himself.[13]

Robert's relation to Colin is initiated by a visual experience: he sees Colin walking in the streets of Venice. His response to this experience is also visual. It is the reason why he secretly takes all those pictures of Colin, which he subsequently shows to Caroline who also becomes fascinated by Colin. The issue of their fascination is, however, radically different from one another's. Whereas Colin is for Caroline an object of desire, for Robert he represents the ideal with which he wants to merge. And this difference between the desire to unite yourself to someone and the desire to become like something or someone also defines the difference between vision according to the photograph, or gaze, and vision according to the mirror, or glance. The taking of pictures is the taking possession of the other. Taking a picture is then an attempt to appropriate an object visually. In the mirror, however, the subject and object of the look unify. One loses oneself in the object of the look when one sees the other as a mirror image.

At this point it becomes important to see the differences and the connections between Colin as (Robert's) visual creation and as the character, a real person in the novel's fabula. When he has been made a representation, he is totally objectified but not real; hence, his representational status is absolute. One would expect the glance, that mode of looking that emphasizes representation, to be brought to bear on such an "image." Quite the opposite, Robert's response to Colin as representation ignores that unreality and "forgets" the unreal status of his (image of) Colin. This leads to a crucial paradox. Robert's denial of the representational quality of the image he has himself made enables him to practice the gaze, that mode of looking that neglects the representational status in favor of transparent realism. Thus, his self-made Colin becomes a "real" model. Signifier and signified are conflated; the representation and that which it represents can no longer be distinguished. Whereas he wants to appropriate the position of Colin-as-image—what he stands for—the act of appropriation consists of disembodying the representation: he begins with *taking* pictures of Colin, and ultimately he kills Colin. Destroying the representation of Colin, Robert tries to capture its content.[14]

The difference in the nature of Robert's and Caroline's desires for Colin becomes clear in the way they look at the photos. When Caroline meets Colin live, after knowing him only in pictures, she feels as if she is stepping into a mirror. For her, Colin is the object of sexual desire, and the pictures of him are mirrors

with which and in which she wants to unite herself. For Robert, the attraction is different. The passage that describes Robert for the first time demonstrates the difference between the two men. The comparison between Robert and Colin in the first sentence suggests that Mary, not Colin, focalizes Robert: "He was shorter than Colin, but his arms were exceptionally long and muscular. His hands too were large, the backs covered with matted hair. He wore a tight fitting black shirt, of an artificial, semi-transparent material, unbuttoned in a neat V almost to his waist. On a chain round his neck hung a gold imitation razor blade which lay slightly askew on the thick pelt of chest hair. Over his shoulder he carried a camera. A cloying sweet scent of aftershave filled the narrow street" (26). Robert not only disposes of a whole range of cliché signs of organic masculinity, such as muscled, long arms, much body hair, especially breast hair; he also displays those signs. His already transparent shirt is in addition open to the waist and he is surrounded by the smell of aftershave. His presence shall not be overlooked. The description of Colin discussed above opposes this one in great detail. But if Robert wants to score as highly as possible on the sliding scale of true masculinity, he has a lack that warrants his choice of Colin as ego ideal: "He was shorter than Colin." Yet one could also argue that Robert's fascination for Colin stems from the fact that for him Colin is a true man without displaying any of the signs of traditional masculinity. Thus Colin turns masculinity into a mystery, a sphinxlike problem that must be unraveled at all cost.

But, importantly, Robert is not only shorter than Colin, he is also older. Colin has enough experience of the intermale world to sense the relevance of age within homosocial relations. Colin displays his sensitivity to this issue not in a confrontation with Robert but, earlier on, when he witnesses from his hotel room a confrontation between an old man and a group of younger men. He watches an old man trying to take a picture of his wife against the backdrop of a terrace on which a number of young men are drinking. The old man, "with thin, trembling thighs" and "unsteady legs," wants these young men as background decoration, not as characters on the same level as his wife. The young men, however, turn to the camera and raise their glasses. The old man gets irritated and "tried to usher them back on the path of their unselfconscious existence" (15).

This street scene is clearly extraordinary to Colin. He tells Mary about it, but in doing so he exaggerates all its elements, out of fear that Mary will not believe him "or because he did not believe himself." He described the elderly gentleman as "incredibly old and feeble," his wife was "batty beyond belief," the men at the table were "bovine morons," and he made the husband give out "an incredible roar of fury" (16). The exaggeration Colin feels compelled to perform is itself important. It is a *mise-en-abyme,* a direction for reading that holds for the novel as a whole.[15] The novel, too, is an exaggeration, necessary in order to demonstrate

and make the readers believe. In order to get a clear insight into the mechanism Colin watches in operation between the old man, the young men, and the wife through whom it is structured, he must represent it with exaggeration, magnify it. Similarly, McEwan "exaggerates" when he makes Robert's striving for power end in murder. This turns the novel into an allegory. It is as such, as allegory, that it begins to rewrite the history of gender relations.

But if this passage can be taken to function as a *mise-en-abyme,* the visual theme that underlies the scene may also be taken as such. The old man *takes* a picture, appropriates his wife, and, in the act, circumscribes the young men's existence to mere figuration and decoration. They are not allowed to be partners to his wife, for that would make them partners to himself, too. And such partnership, in turn, would make all the men comparable. It would start the competition that, older than them, the old man can only lose. The little scene shows the visual underpinning of a situation of comparison as a structuration of social intercourse. It shows that homosocial relations are defined by the logic of the gaze.

Robert's deference to Colin subsequently turns into jealousy. This change is the logical consequence of the patriarchal organization, the sliding scale that shapes masculine subjectivity. Since positions on this scale emerge through comparison, they are by definition exclusive; from the standpoint of one subject, each position can only be occupied by one man. Masculine identity is measured by the position other men occupy on the scale, either higher or lower than the measuring subject. At the moment that Robert admires Colin, the latter occupies for him the position on the scale that he himself would like to hold. Thus begins intermale competition. To become a man, some man must be unmanned. This patriarchal rule seems to be symbolized by the golden razor Robert wears around his neck. The razor, a masculine attribute, will be used during the final scene of the film to cut the wrists of another man. In taking Colin's life, his manhood is cut off as well.

But before definitively unmanning Colin, Robert alludes to this need in various ways. When Colin does not show enough respect for the museum Robert has erected for his ancestors, he receives a punch in the stomach.

Robert stood up too. The geometric lines of his face had deepened and his smile was glassy, fixed. Colin had turned back momentarily to set down his empty glass on the arm of his chair, and as he straightened Robert struck him in the stomach with his fist, a relaxed, easy blow that, had it not instantly expelled all the air from Colin's lungs, might have been playful. Colin jack-knifed to the floor at Robert's feet where he writhed, and made laughing noises in his throat as he fought for air. Robert took the empty glasses to the table. When he returned he helped Colin to his feet, and made him bend at the waist and straighten several times. (77)

When Robert leaves the room after this incident, he first turns around and winks at Colin. In this passage Robert reverses the positions on the sliding scale of masculinity. Colin literally sinks down at Robert's feet.

What is most striking, however, is the fact that all of this happens within an atmosphere of comradeship, during drinks, with a wink. In his aggression, Robert does not want to sever the homosocial bond; he only wishes to reverse the hierarchically ordered positions of which that bond consists for him. If the punch in Colin's stomach endangered the bond, the risk would be unbearable: Colin would stop providing a measuring scale for Robert's manhood. This is why the struggle must be fought out within an atmosphere of camaraderie. In order to be a man, Robert sorely needs Colin—at first, to be able to shape an ideal of masculinity for himself and, subsequently, to elevate himself (literally) over that ideal—over Colin. But he needs Colin's comradeship, so that the latter can recognize Robert's elevation. Without other men, above or below him, Robert cannot be a man. This statement must be taken in all its ambiguity. The need of that verticality and that struggle implies violence—the violence that provides the intensity that will be erotically charged.

In a following passage, Robert's elevation over Colin and Colin's degradation take shape in yet another way. Robert tries to humiliate Colin by saying that he told the men they encountered on the way to the bar that Colin was his lover and that his wife was very jealous. As I mentioned before, I do not think this is an indirect declaration of love. Robert rather makes use of the taboo on homosexuality within the homosocial community. He makes use of homophobia to shape his homosocial relationship with Colin. Eve Sedgwick has argued precisely this about homophobia in *Between Men* (1985). Homophobia—its horrible consequences for gay men notwithstanding, which Sedgwick elaborates further in her later *The Epistemology of the Closet* (1990)—is not so much directed against homosexuals; it is in the first place a means of channeling homosocial bonds. Sedgwick defines homophobia as a mechanism that must regulate the behavior of many by the specific oppression of a few (1985, 88).

A connection between homosocial bonds and homosexual feelings does exist, but this connection is much more complex than is usually assumed. Sedgwick phrases it as follows: "For a man to be a man's man is separated only by an invisible, carefully blurred, always-already-crossed line from being 'interested in men'" (1985, 89). This formulation entails the notion that homophobic homosocial men are always already sexually relating to men. At first sight, the consequence seems to be that every man is slightly homosexual. That may be true, but it explains nothing. Sedgwick's statement describes a situation, the production of which I seek to understand, with McEwan's help. The intensity of the involvement with other men that the homosocial struggle entails is so threatening for

homosocial men because it threatens to get entangled with homosexual desire, the very desire that the homosocial homophobia is meant to exorcize.

{ BEING ON TOP }

In Robert's homosocial world, violence and sexual desire stand against each other in reversed symmetry to the relation between them in his heterosexual relationship with Caroline. I have already argued that his sexual desire, already in place, entailed violence in his marriage in a subsequent phase. Now we see, conversely, that the intensity of a violent competitive homosocial relationship gets entangled with homosexual desire. This entanglement is represented in McEwan's novel by extremely subtle recurring hints of an allusion to, or threat of, homosexuality. One is never sure whether situations can be interpreted as homoerotic. And that is precisely the point: because there is, within a homosocial relation, a constant "threat" of homoeroticism, such a threat must be violently exorcized. Because the distinction between "to be a man's man" and "to be interested in men" is so subtle and in danger of disappearing, it must be reconfirmed time and again, forcefully.

The murder of Colin allegorizes, in aggrandized and dreadful but symbolic form, one of such reconfirmations. The climactic passage describes a meaningful sequence of actions. The murder, the unmanning of another man, is presented here as a condition for being a man. Robert and Caroline begin to make passionate love over the dying Colin. Mary, half unconscious by the drug Caroline has put in her tea, is forced to witness this hours-long lovemaking scene. Again, the concrete details produce the precise meaning. She must be half unconscious, so that she cannot act. Yet she must not be totally unconscious because she must watch and see. As a witness to Robert's masculinity, she must bear testimony and acknowledge his position on top. Just as passive as the old man's wife whose picture was being *taken* with the young men as passive as she, Mary must photograph in her eyes the superiority of Robert: "All through the night that followed she dreamed of moans and whispers, and sudden shouts, of figures locked and turning at her feet, churning through the little pond [of Colin's blood], calling out for joy" (130). Mary's "dreaming" in this passage gives expression to her half unconscious state in which she witnesses Robert's and Caroline's lovemaking. The importance of vision, of the homosocial gaze, becomes acutely clear in this final passage. The homosocially based masculine identity needed for heterosexual arousal must be seen, witnessed, or it cannot be.

The order in which these actions are placed in the sequence has a radical meaning. The implication is that Robert can only be sexually aroused with his

wife, be a man to her, when he first humiliates—here, kills—another man. Heterosexual male desire is thereby placed in dependency on homosocial relations; these are thereby defined as inherently violent and competitive. Homosocial violence is represented as the motor that operates male heterosexual desire.

This gives additional meaning to a moment in the scene I have already mentioned. When Colin feels threatened and strikes back, Caroline is wounded. As we have seen, she smears her blood on Colin's lips: "Caroline transferred more of her blood on the end of her finger till Colin's lips were completely and accurately rouged. Then Robert, pressing his forearm against the top of Colin's chest, kissed him deeply on the mouth, and as he did so, Caroline ran her hand over Robert's back" (128–29). This little scene is again symbolically charged. Colin's lips are painted red. It seems he must be visually turned into a woman before he can adequately be murdered. Precisely because Colin was initially Robert's ego ideal, he must now be transformed. Colin is not to be murdered in his quality of ideal man but in the form of a humiliated non-man. Thus he is feminized. At the moment Colin has turned into the image of disabled masculinity his murder is justified. Colin's earlier interpretation of the old man who tried to usher the young men into decorative background without agency when taking his wife's picture seems to apply here to Robert's behavior of which he, Colin, is now the victim. The photographer, Robert, tries to usher him back into unselfconscious existence.

But then, Robert drinks his victim's blood with his kiss. Through that symbolic act Robert turns into a vampire, like Dracula. Dracula, in Western cultural history, is a figure in whom sexual desire and anxiety are mixed. Christopher Craft has argued that Dracula's desire is not heterosexual but homoerotic (1989). Even if his victims are women, they are not the stakes of his actions. At the end of Stoker's novel, Dracula confesses that his female victims are just a phase in the completion of his goal: "My revenge is just begun! I spread it over the centuries, and time is on my side. Your girls that you all love are mine already; and *through them you and others shall yet be mine*" (Craft 1989, 365; emphasis by Craft). Craft argues that Dracula's sexual object choice is homosexual, but in Robert's case I oppose such an interpretation. Perhaps there is enough reason to interpret Dracula as a closeted gay, but from the perspective of my reading it might be more revealing, more radical, to interpret his ultimate interest in his female victims' partners as homosocial desire. In spite of the difference between Craft's view and mine, however, there is a striking similarity between the two interpretations. In both cases women are only a provisional phase, a usable means within a "higher" desire, whether the latter desire is the wish to be a man's man or to be involved with men. Homosocial violence as the motor of male heterosexual desire: this is how I would like to define, with McEwan, the patriarchal order.

Within McEwan's allegory, this homosocial violence is literal and lethal violence. But his visual motifs locate the violence of the homosocial realm in the unseen: in a mode of looking. The violence originates in the gaze that disembodies and objectifies its objects.

This homosocial violence as motor of male heterosexual desire must be seen in order to be acknowledged. Mary, reduced to eyes only, must register it: "Caroline was settling Mary in one of the two remaining wooden chairs, arranging it *so that she sat facing the man*" (124; my emphasis). Too bad, for Robert and the order he stands for, that in the end this is not what she does. Instead, she becomes the interpreter of the vision she has seen, thus retrieving the agency that was taken away from her. Within the allegorical reading of the novel, she becomes the embodiment of the ideal reader, a seer, seeing through a system that can thereby become an object of critique, ready for a drastic rewriting.

Men without Balls

{ SATYRS AND GENDER }

After witnessing the devastation wrecked by traditional masculinity—if only, thank heavens, allegorically—I hope to interest my readers now in an equally allegorical rewriting of historical masculinity on a more positive, almost utopian note. Rams or ramlike beings play a central role in the films and videos of American artist Matthew Barney. For instance, in *Drawing Restraint 7* (1993), we see two figures who are half-ram, half-human (fig. 38). Their torsos are male, but they wear horns on their heads, have goats' beards, and the lower part of their bodies are those of a ram. The classical motif of the satyr seems to have been animated in this video. In Western culture, rams or satyrs symbolize the devil or, more prosaically, an excess of male sexuality or potency. But strikingly, Barney's rams have no male genitals, whereas the satyr conventionally wears them XL. There is yet a third satyr in *Drawing Restraint 7.* His horns, however, are underdeveloped, he lacks hair on his head and the lower part of his body, and he has an intestine-like appendage where one would expect a tail, as though his bowels have migrated to the outside of his body (fig. 39). Because of his lack of hair, the fact that the ram has no genitals is even more noticeable.

In the video *Cremaster 4* (1994), we meet with a satyr who looks like a dandy. He has the pointed, hanging ears of a sheep, red hair, and a cream-colored costume, with waistcoat, tie, tiepin, and two-toned brogues (fig. 40). His red hair is combed to form two little circles on his forehead, indicating, perhaps, potential places for horns. He also has two holes on the top of his head, out of which, it seems, two others still have to grow. Taps fixed to the bottoms of his shoes seem to turn his feet into substitute hooves. In this video we also find a real ram, which belongs to a species known as the Loughton sheep and is found only on

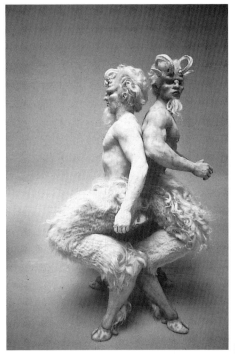

38

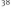

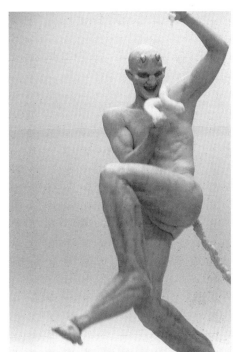

38 | Matthew Barney, video still (two satyrs),
Drawing Restraint 7 (1993). © 1993 Matthew
Barney. Courtesy of Barbara Gladstone
Gallery, New York.

39 | Matthew Barney, video still (kid satyr),
Drawing Restraint 7 (1993). © 1993 Matthew
Barney. Courtesy of Barbara Gladstone
Gallery, New York.

39

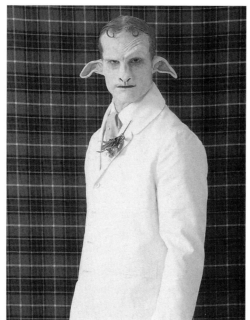

40

41

40 | Matthew Barney, production still
(dandy satyr), *Cremaster 4* (1994).
© 1994 Matthew Barney. Photo: Michael
James O'Brien. Courtesy of Barbara
Gladstone Gallery, New York.

41 | Matthew Barney, production still
(Loughton sheep), *Cremaster 4* (1994).
© 1994 Matthew Barney. Photo: Michael
James O'Brien. Courtesy of Barbara
Gladstone Gallery, New York.

the Isle of Man, a small island located between Ireland and England—and the location for this video. The real ram has two pairs of horns: one pair is directed upward, the other pair downward (fig. 41). The satyr-dandy, who is played by Barney himself, is called the "Loughton Candidate." The Loughton Candidate clearly radiates less masculinity than the Loughton ram. His horns are only symbolically indicated, and his polished style of clothing, moreover, makes him rather effeminate. This does not mean, however, that the suggestion or connotation of sexuality is absent. On the contrary, this Candidate Ram still symbolizes sexuality, but a sexuality that cannot be characterized as unambiguously male or female.

The title of the *Cremaster* cycle suggests that, in one way or another, these videos deal with the issue of masculinity. "Cremaster" is the anatomical name of the muscle that raises and lowers the testicles in response to stimuli such as cold or fear. Moreover, Barney's sculptural works also give rise to assumptions that his work problematizes masculinity. Many of his sculptural objects seem to come directly from the gym, a place that is conventionally seen as masculine, because masculinity is built there in the most literal sense of the word. These objects, for instance, look like barbells; however, they are not hard, not made of steel, but of emphatically soft materials like frozen Vaseline.

But Barney's satyrlike figures enable us to sharpen this view of his work. His work does not deal with masculinity in general but, more specifically, with the relation between masculinity and the body or masculinity and sexuality. Before I discuss the kind of relations that Barney establishes (or refuses to establish) between bodily expression and gender identity, it is necessary to connect to recent developments in gay culture as well as in gender studies. In gay culture as a "practice," as well as in the latter field of study, the conviction has spread that gender identity and sexuality can be lived and thought without automatic connection to each other. Barney's artworks on masculinity and the body can best be understood against the background of these recent ideas concerning gender and sexuality, specifically as lived in gay culture.

{ THE GENDER-GENERATES-SEXUALITY PLOT }

In the past two decades, a disruption has taken place in the dominant conception of homosexuality. For more than a century, popular as well as scholarly thought had assumed that homosexuality was a case of literally "misplaced" heterosexuality. A homosexual man, for example, could be anatomized as "a woman's soul enclosed in a man's body," a lesbian as a "man's soul in a woman's body." This simple formulation has far-reaching consequences. It implies at the

very least that heterosexuality is the authentic sexuality of which homosexuality is an inversion. It also conceptualizes both heterosexuality and homosexuality in terms of the binarism of sexual difference. Sexual orientation is not explained in terms of bodily desire but in terms of the gendered soul (masculine or feminine) enclosed in a sexed body (male or female). This means that sexuality is derived from the gendered soul or mind: first, we have a gendered identity; next, in its wake, a sexual orientation. When the gendered mind is incarnated in the corresponding body, it results in authentic, that is, heterosexual sexuality. When the gendered mind incarnates in a noncorresponding body, an inversion has taken place: homosexual nonauthentic object-choice is the result of the becoming of sexual desire.

But this conception of homosexuality as inversion, and in general, of sexuality as a derivative of the gendered soul, has come under pressure in the past two decades by a new self-presentation of homosexual and heterosexual men and women. Dennis Altman describes this new self-presentation in his book *The Homosexualization of America* as follows: "By the beginning of the eighties a new type of homosexual man had become visible in most large American cities and could also be found, to a somewhat lesser extent, in most other Western urban centers. No longer characterized by an effeminate style, the new homosexual displayed his sexuality by a theatrically masculine appearance: denim, leather, and the ubiquitous key rings dangling from the belt. The long-haired androgynous look of the early seventies was now found among straights, and the super-macho image of the Village People disco group seemed to typify the new style perfectly" (1982, 1) The same is true for lesbians. While previously lesbians had been typified as masculine-identified women, in the eighties, feminine-identified lesbians appeared in public culture and disrupted the classical idea of the butch as model of the lesbian.

In her seminal study, *Male Subjectivity at the Margin* (1992), Kaja Silverman has argued, however, that the practice and show of macho homosexuality does not necessarily mean an extirpation of the "woman within." This is so because, as Jacques Lacan has remarked in "The Significance of the Phallus" (1977), virile display as such always seems feminine. Silverman explains this effect by arguing that, in Western culture, exhibitionism is fully associated with women. She illustrates her point by quoting Don Mager's description of the so-called Castro Street–clone look (1985), a look that includes such masculine signifiers as leather, denim, work boots, and military clothes: "Jeans are worn snugly . . . to emphasize and tease, hiding yet revealing the genital/buns/thigh areas. This is traditional to female clothes usage. Materials may be rugged and weathered, speaking to masculine tradition, but they are worn in rigidly precise, almost tailored ways—thus speaking to feminine traditions of dressing one's self up in

clothes as a presentation, as opposed to throwing clothes on oneself as a practical necessity" (Silverman 1992, 346). As Silverman remarks, this hypermasculine uniform serves ironically to "unman" its wearer. One might say that the macho homosexual man masquerades not so much as a man but as a woman masquerading as a man.

One could claim that this homosexuality-as-macho-masquerade fails to overcome the idea of a woman's soul enclosed in a man's body. The feminine touch is still present, although disguised by a masculine look. There is, however, a fundamental difference between this understanding of the masquerade and the traditional view of homosexuality. Femininity, a feminine soul or mind, no longer "explains" male homosexuality as its source or cause. Femininity is no longer the cause but the effect of a masquerade. Femininity is not the subject of identification ("the feminine soul enclosed") but a signifier or mark that distinguishes male-identified homosexual men from male-identified heterosexual men. This differentiation is necessary because, "worn without the feminine 'accent,' there is no longer anything to distinguish the clothing of the homosexual man from his heterosexual counterpart" (Silverman 1992, 346). This suggests that this role of femininity in macho homosexuality has little to do with the "true nature" of the homosexual man but with a practical and political goal, which is realized as a performative effect. For, "when feminized, the homosexual body faces contempt; yet untheatrically masculinized, it simply disappears" (Watney 1987, 78–79).

As Silverman (1992) points out, the homosexual representational practice just described, which has become so dominant in recent years, had, however, already been acknowledged as one of the many forms of homosexuality by Sigmund Freud in the theoretical and therapeutic context of psychoanalysis. In his "Psychogenesis of a Case of Homosexuality in a Woman," he refutes the idea that homosexuality is a case of a man's soul in a woman's body or the reverse. He recognizes the possibility of a masculine identification coexisting with the desire for a masculine love object and of a feminine identification coexisting with the desire for a feminine love object:

A man with predominantly male characteristics and also masculine in his erotic life may still be inverted in respect to his object, loving only men instead of women. A man in whose character feminine attributes obviously predominate, who may, indeed, behave in love like a woman, might be expected, from this feminine attitude, to choose a man for his love-object; but he may nevertheless be heterosexual, and show no more inversion in respect to his object than an average normal man. The same is true of women; here also mental sexual character and object-choice do not necessarily coincide. The mystery of homosexuality is therefore by no means so simple as it is commonly depicted . . . "a feminine mind, bound

therefore to love a man, but unhappily attached to a masculine body; a masculine mind, ir-resistibly attracted by women, but alas! imprisoned in a feminine body." ([1920] 1955, 170)

Freud's pluralization of possible scenarios breaks down the binarism of feminin-ity versus masculinity that heterosexuality is assumed to maintain and homo-sexuality to invert. Another consequence is that it becomes impossible to "ex-plain" sexual orientation by someone's gendered soul or mind. There is no longer a simple determining, coercive link between gendered identity and sex-ual object-choice.

Silverman has shown not only that Freud complicates thinking about homo-sexuality by disrupting the causal link to gendered identity but also that he fur-ther complicates it by developing several models of male homosexuality. Within his psychoanalytic theory, there is not one but at least three different archetypes of the male homosexual subject.[1] The first one is based on a desire for the father and identification with the mother. This is the situation in the so-called nega-tive Oedipus complex that is the phase that precedes the positive Oedipus com-plex in childhood. The boy then starts to desire the mother instead of the father and identifies with the father instead of the mother. However, the negative Oedi-pus complex is not only a psychic paradigm for universalizing infantile homo-sexuality; it is also, at the same time, a model of one possible form of adult male homosexuality in Freud's work.

The second model, which Silverman (1992) calls the Greek model, is a model of narcissistic object-choice. It is based on identification with the father and de-sire for what the subject once was. In this scenario, the mother nevertheless plays an indirect role. In childhood (in the negative Oedipus complex phase), the little boy plays out his feminine identification, while in maturity he plays out his masculine identification. The adult man might therefore be said, in loving the youth, to love a femininity that was once his own.

The third model, which Silverman calls the Leonardo model, concerns a con-stant oscillation between a repressed desire for and identification with the mother, on the one hand, and a desire for and identification with what the sub-ject once was, on the other. In this model, one wields the penis only from the maternal position. By incorporating the mother, the homosexual male subject is able to make good her anatomical "deficiency." In effect, he provides the miss-ing organ through his own body. The Leonardo model not only defies the rule of paternal succession, but it situates the father altogether outside the fields of de-sire and identification. In this model the penis functions not as a marker of sym-bolic privileges and the law but, rather, as an erotically resonant organ.

I do not want to suggest that with these three models the last word has been said about male homosexuality. It is, however, of radical theoretical importance

as well as political importance to notice that the monolithic model of homosexuality (male and female) has been exchanged for several forms of homosexuality, some male identified, some female identified. The fact is that it is no longer possible to assume that sexual orientation originates in a gendered identity. Freud's triangular models give no precedence to an identification with the gendered identities of the father or mother, which would thereby result in a specific sexual desire. Desire and identification cannot be disentangled in time; rather, they cohere as mutually dependent.

But opening up the relation between gender and sexual desire does not absolutely necessitate falling back on psychoanalytic theory. Contemporary practices of homosexual and lesbian styles imply something similar through their self-conscious deconstruction of the dependence of sexual desire on gender identity. The pluralization of homosexual styles in the past two decades has shown there to be various constructions of gender identity and can therefore be conceived of as a "theory" in its own right. In times when masculinity was the only visible marker of lesbianism and femininity of male homosexuality, these gender identities could easily be seen as the origin or cause of same-sex object-choice. But now it seems that the opposite is the case: one's homosexual or heterosexual desires no longer have any automatic consequence for how one expresses these desires, by means of male or female identification. This, of course, does not mean that one can choose one's gender freely. The performative view of gender and sexuality does not imply a radical fabrication of a gendered and sexualized self. In the words of Judith Butler: "It is a compulsory repetition of prior and subjectivating norms, ones that cannot be thrown off at will but that work, animate and constrain the gendered subject, and that are also the resources from which resistance, subversion, displacement are forged" (1993, 21). Gender identity, then, is no longer seen as the source of homosexual or heterosexual desire (i.e., dependent on whether the gender identity is incarnated in a corresponding body or not) but as an effect of identification, constructed in specific historical and cultural contexts, and in interaction with sexual desire.[2]

{ BARNEY'S BODIES }

Along with recent gender theory, gay and lesbian cultures of the past two or three decades have disconnected sexual object-choice from gender identity, which for so long had been automatically and naturally linked. These contemporary practices and theories necessitate us to start thinking in terms of forms of gendered sexualities and sexualized genders. This challenge has, however, not been brought to bear on Barney's work. So far, this work has been discussed in

terms of "the body": that is, a body without sexual desire, and even without biological sex. According to these readings, his work does not relate at all to the contemporary pluralization of forms of masculinity, femininity, hetero- or homosexuality but, rather, to its opposite: the universalization of gender identities and sexual object-choices into one generalized body, called the next sex.[3]

The limitations of the body are alleged to be challenged in Barney's works. According to Norman Bryson, the characters in Barney's video pursue power and control over bodily desires (1995). Michael Onfray argues that in *Cremaster 4,* the Isle of Man is populated with mutants out of which a new Adam can grow who, in a Nietzschean way, will give form to new conditions of life (1995, 56). In this reading, Adam does not embody the first man in the sense of the first human being of the male sex; rather, Adam is a synecdoche for the first human being. And Neville Wakefield quotes Norman O. Brown to argue that Barney counters gender differentiation by means of sadomasochistic rituals: "an endless, a vicious cycle; in which the subject and object are confused; active and passive, male and female roles are exchanged, in the desire and pursuit of the whole, the combined object" (1995, 16). I will argue, however, the opposite: that Barney's view of the body is gender specific. Barney's disturbing bodies have to be understood against the background of, and in resistance to, dominant fictions of masculinity in which masculine identity, on the one hand, and sexuality, on the other, are indissolubly interconnected.

In these dominant fictions of masculinity, the penis (a body part) is conflated with the phallus (a privileged symbol). This implies, among other things, that the qualities embodied in the phallus, like control, stability, productivity and activity are also ascribed to those human beings who possess a penis. Moreover, these qualities define masculinity. But this conflation of penis and phallus is hard to sustain in the living practice of the male body. The self-willed behavior of the penis does not always confirm the qualities of the phallus. Penises are rather unstable and uncontrollable, and one cannot always rely on their productivity. These qualities, which have to form or give content to dominant constructions of masculinity, are not compressed in the penis; rather, they are problematized or denied by the penis in an embarrassing way.

The independent life of the penis, and the insecurity to which it can give rise in men, can be seen as a major motivation behind bodybuilding. Phallic desire, which turns the penis into its showcase for stability and control, is displaced onto the rest of the body. The inflated and pumped-up body of the bodybuilder functions as a metaphoric substitute for the impossible, unreachable, stable, and impressive penis. What the rest of the body gains from this rhetorical displacement consists of the fact that the control that men never, or only unsuccessfully, have over their penises can be displayed through the rest of the body.[4]

As a radical expression of traditional masculinity, bodybuilding demonstrates yet another aspect of the relationship between masculinity and the body. In the homosocial culture of the gym, it is a compliment to call somebody a machine, a beast, a monster, a colossus, or a "fucking Greek statue." The best way to compliment somebody is to use expressions that turn a man into a building: "The well-shaped man should resemble a building, and not just any building, but a *fucking* Greek temple. Or better yet, make that a *fucking* Greek column, made of muscle hard as marble. Okay with a head atop the column. A capital (caput-al) muscle head" (Ian 1996, 191). The highest ideal is to be like a building devoid of interior space. All space should be transformed into muscle. The ideal male body has no interiority. It is hard and massive. It also has no apertures because apertures challenge the sealing off, the closedness of the male body, the demarcation between inside and outside: "For to be penetrated, to have an interior, is to be 'woman.' We know this from prison movies; we know this from Plato; we know this from Catherine MacKinnon" (Ian 1996, 191). The taboo on interiority can also be taken figuratively: there is also a taboo on inner feelings, an inner life, because attention to feelings, emotions, and subjectivity is traditionally seen as typically female.

Barney's sculptural objects are so disturbing because they challenge the ideal of the well-defined, massive male body. Again and again his objects are objects that stem from stereotypically male spaces. They belong to the gym. They are attributes with which men conventionally construct their masculinity. As attributes, they are metonymies of masculinity. But at the same time, these attributes are metaphors for this type of masculinity because they possess the very qualities of hardness and massiveness that their use is intended to produce in the (male) body. This is why they are ultimately metonymically motivated metaphors of masculinity.[5]

Barney's attributes, however, are not hard as steel but soft as butter. They are made of materials like frozen petroleum jelly, which prevents his objects from embodying the promise of a massive, hard body (fig. 42). They seem to fall apart, to melt, to loosen their boundaries. They rather evoke situations in which it is not at all clear what is inside and what is outside the body.

In his videos, furthermore, he makes it especially difficult for the viewer to attribute masculinity to solid and massive bodies.[6] As Norman Bryson has remarked, Barney's videos no longer evoke the atmosphere of a gym but that of a laboratory in which all kinds of bodily transformations are being performed. For example, the legs of the rams in *Drawing Restraint* are lengthened, which makes it look as if these rams walk on real hooves instead of human feet. The bodies that are built up out of the prostheses never produce the illusion of "whole," "natural" bodies (fig. 43). The prostheses remain recognizable as prostheses. For

42

43

42 | Matthew Barney, *Unit BOLUS* (detail) (1991), cast petroleum jelly, eight-pound dumbbell, stainless steel, electronic freezing device, 28 ? 18 ? 10 inches (71.1 × 45.7 × 25.4 cm). Courtesy of Barbara Gladstone Gallery, New York.

43 | Matthew Barney, video still (satyr with long legs), *Drawing Restraint 7* (1993). © 1993 Matthew Barney. Courtesy of Barbara Gladstone Gallery, New York.

the viewer, this causes an awful tension. According to Bryson, watching the fight of the two hairy satyrs on the back seat of the limousine is so difficult because of the constant threat that the mutated bodies will lose their limbs in the fight: at any moment their horns, feet, or tails might become detached from the body (30).

Ironically, the culmination of the performance of a bodybuilder can cause the same kind of anxiety. When a bodybuilder "pumps himself up" in front of a jury, his massive body usually shows its Janus face: suddenly, we only see a collection of muscle groupings that no longer belong to a "whole," unified body. The body seems to fall apart. This sudden appearance of the built-up body's Janus face, however, is presumably unintentional, whereas Barney's rams systematically confront us with this flip-side of the ideal male body.

Moreover, in Barney's videos the bodies also contain striking apertures. There are four motor drivers who figure in *Cremaster 4*, two who wear yellow leather suits and two who wear blue ones. Leather is quite an ambiguous material: it is hard and solid as well as soft and flexible. It has connotations with femininity as well as masculinity. Each leather suit has four slits out of which gluey, glandular substances extrude (fig. 44). These bodies enveloped in leather are neither closed off nor massive.

Strikingly, this video shows us many more openings and apertures. The satyr seems to have holes in his head out of which horns will grow. Also, the mouths and anuses of the figures are foregrounded. Barney presents the Isle of Man as a kind of body with many apertures through which the satyr enters the island's interior. This passage is coated in Vaseline, and Barney's passage through it is another athletic feat (fig. 45). It looks, then, as if he were in a kind of intestine-like space of another body. Again and again, openings and holes represent the body's apertures, places of transit through which the body can be penetrated or through which the body can extrude itself. The name "Island of Man" is, of course, ambiguous. It can be read as "the Island of Humanity, as Theodora Vischer does (1996, 22). But because of the proliferation of connotations referring to masculinity, it is perhaps more appropriate to consider the alternative, more specific meaning: the island of the male sex.

{ IN PURSUIT OF THE IN UTERO PHASE }

So far, we can conclude that Barney's work dissolves the distinction between inside and outside in several ways. In continuity with this dissolution, he also seems to refuse another distinction: the one between masculine (outside) and feminine (inside). Again and again, we see hybrid beings that are not, or not yet,

44

45

44 | Matthew Barney, production
still (leather suit with openings),
Cremaster 4 (1994). © 1994 Matthew
Barney. Photo: Michael James
O'Brien. Courtesy of Barbara Glad-
stone Gallery, New York.

45 | Matthew Barney, production
still (satyr-dandy within the Island
of Man), *Cremaster 4* (1994). © 1994
Matthew Barney. Photo: Michael
James O'Brien. Courtesy of Barbara
Gladstone Gallery, New York.

or not sufficiently, differentiated into man and/or woman. In *Cremaster 1,* however, Barney clearly does not present the differentiation into man and woman as an end goal that is pursued but not yet reached. In this video all the actions on the level of plot try to prevent this differentiation from taking place. The video's theme consists of the so-called in utero phase, the phase that precedes the formation of the ovary or the testicles and in which the fetus is still sexless.

According to the description of this video by Richard Flood, the main character of this video is a woman, called Marti, who tries to remain sexually undifferentiated by keeping herself hidden in a split personality, dividing herself between two space shuttles (fig. 46). These space shuttles try to reach their destination—that is, they try to bring about the differentiation into ovary and testicles. The main character does everything to prevent this and to remain sexually undifferentiated. At first glance, the women who populate this video are super feminine, especially in terms of the clothes they wear. In that respect, we don't recognize any undifferentiated sexuality at all. But the kind of femininity that is represented is the femininity of the fifties, especially of that decade's movies. Their make-up and Farah Diba (last empress of Iran) hairstyles look utterly constructed. These women are plain, polished, hard, and impenetrable.

On the basis of this video, one could argue that in Barney's work the refusal of traditional masculinity as a hard and massive body is not in fact at stake, since the main character here is a woman rather than a man. Does this imply that Barney's work is about a free, undifferentiated experience of the body that refuses any gender construction at all, of masculinity as well as of femininity? Not at all. The point is, instead, that differentiation as such, and thus also resistance to differentiation, is not gender neutral. The anxieties and desires that motivate bodybuilding show that the ambition or desire to differentiate, to close off, to distinguish, serves a very specific kind of masculinity. Resistance to this circumscription, to differentiation is, therefore, a resistance to this construction of masculinity. Resistance to differentiation does not challenge dominant fictions of femininity because, according to those fictions, women are already open, yielding, and pliable. And in contrast with masculinity, femininity is considered to be the product of masquerade.

Barney, for a long time a sportsman and athlete himself, displaces the importance of sports from the competitive confrontation to the practice of preparation. This seems to be another way of refusing differentiation, this time not of the body but between bodies. In an interview he explained this as follows: "I think I was always trying to create some kind of threshold between the space of preparation and training and competitive space. And that threshold ran through this story that began to develop between Houdini and Otto.[7] On that foundation level it was about avoiding competitive space and making a medita-

tion on the endless practice of preparation where those narratives are so much richer" (Sans 1995, 28). The narrative of preparation is for Barney so much richer because it circles around a potential space, around possibilities, that have not been clearly formed and articulated. The narrative of competitiveness compels one to differentiate—from the other but also from oneself.

This is why Barney's work is men's work: it tries to construct or reconstruct masculinity by means of hybrid bodies that lose themselves rather than solidify themselves. He proposes, or explores, a kind of experience of the male body, a sexuality characterized by movement and hybridity. In Barney's work, the body has become a location in which unpredictable transformations or mutations can take place. Barney's body is a body without center, or, in the philosopher Gilles Deleuze's terms, a body without organs.[8] Such a body is not new at all from the perspective of dominant fictions of femininity. But from the perspective of dominant fictions of masculinity, such a body is unheard of and disturbing.

When Barney was questioned about the role of gender in his work, he gave an answer that in the criticism on his work is often used as the proof that his work does not deal specifically with gender identities (masculinity or femininity): "It's like I was saying about this drawing of the reproductive system in the fetus before the point where sexuality is differentiated. Gender has been at least one of the foundations for building this narrative. I am less interested in the *external* debate about gender, which I don't think my work is about. It's more about the *endless possibilities this organism can take on,* the fact that it can occupy a field that is designated as feminine or masculine or androgynous, but I am not more interested in one than another" (Sans 28; my emphasis). Barney contrasts here the external debate about gender, which seems to refer to internalized gender roles, with an assessment of gender in relation to the possibilities of the body.[9] He refuses the idea that a gender identity is determined by the gendered body, that there is an automatic link between gender and body. But he is more radical than those who claim only the constructedness of gender. He explores the constructability of the body, a project that has, of course, ultimately enormous ramifications for gender but especially for masculinity.

Within the dominant fiction of masculinity the penis in erection is the image par excellence of hypermasculinity. Barney, however, has exchanged this image for the cremaster, the muscle that pulls up the testicles. *Cremaster 4* even closes with a view of testicles in isolation (fig. 47). It seems as if at any moment they can be raised by the cremaster. From now on, masculinity has to be constructed in a pregenital manner. This implies that the qualities ascribed to the penis on the basis of the confusion between penis and phallus are no longer permissible as building blocks of masculinity. This raises the question of what building blocks remain.

46

47

46 | Matthew Barney, production still (Marti), *Cremaster 1* (1995–96). © 1995–96 Matthew Barney. Photo: Michael James O'Brien. Courtesy of Barbara Gladstone Gallery, New York.

47 | Matthew Barney, production still (testicles), *Cremaster 4* (1994). © 1994 Matthew Barney. Photo: Peter Strietmann. Courtesy of Barbara Gladstone Gallery, New York.

{ TRAVESTY }

Although Barney's works present themselves foremost as laboratories in which bodily transformations are being performed, part of the result of how some of the mutants look is created by dress. The dandy-like satyr in *Cremaster 4,* for instance, depends not only on some bodily transformations but also on a meticulous form of travesty for how he looks. In the same video there are three "fairies." When we see them naked they are very masculine: they have the looks of bodybuilders. But they have their hair put up in a strikingly feminine way and from time to time they wear romantic yellow dresses (fig. 48). This is an even more conventional case of travesty, of cross-dressing that is.

The fantastic effects of travesty have a lot in common with the predifferentiated phase Barney pursues by means of bodily transformations. In her *Vested Interests: Cross-Dressing and Cultural Anxiety* (1992), Marjorie Garber takes the fairytale of Little Red Riding Hood as emblematic for the attraction—and uncanniness—of travesty. Children are fascinated by the wolf in bed because by dressing up in grandmother's clothes, the formerly masculine wolf has acquired a gender identity that is unclear. It is this troubled identity that generates fascination as well as anxiety. In the fairytale, much emphasis is put on the difference between how the female human and the male animal look and sound. When the black wolf wears the white nightgown and cap of their grandmother, "he" must be her. There is no mistake possible anymore. Or is there?

The fact that a male black wolf can look like a female human, that the differences between them can be made invisible, turns this story into a representation of something, which, according to Garber, can be seen as a kind of primal scene. This primal scene is the reverse of the primal scene in Freud's psychoanalytic theory, in which it stands for children witnessing their parents making love. Without any understanding of sex, children read this scene as an act of violence done by one parent to the other. The primal scene of travesty enacted in Little Red Riding Hood confronts children with an eroticism that blurs or cancels the differences between father and mother, man and woman. It concerns an eroticism that presents these differences as utterly exchangeable and constructible. Gender, travesty seems to suggest, concerns distinctions that can be fumbled at, changed, deconstructed. This is a fascinating and frightening insight for little children who are at an age when they have just learned the bodily difference between father and mother and between brother and sister.

Travesty implicates a conception of gender as unfixed, as changeable. In Barney's work, travesty reconfirms and strengthens his resistance to gender and sexual identity by means of bodily transformation. It is, one can say, a practice complementary to the resistance from within the body.

48 | Matthew Barney, production still (fairies in yellow dresses), *Cremaster 4* (1994). © 1994 Matthew Barney. Photo: Michael James O'Brien. Courtesy of Barbara Gladstone Gallery, New York.

{ SEXUALITY IN FLUX }

So far, I have used the words "body" and "sexuality" interchangeably. Although sexuality always implies the body, the body also manifests itself outside the realm of sexuality, for instance, while sleeping or eating. Barney's work, however, does not concern the body in general but, more specifically, its connection to sexuality. He has said that the notion of the body is too limited because the word "body" suggests an entity that is enclosed in itself. Barney's work foregrounds, instead, the exchanges and interactions of powers, energies, substances, and movements, of expansions and contractions, of reversals and multiplications, of attractions and repulsions. It is precisely the realm of sexuality where the body transgresses its own boundaries in these manners.

That sexuality and the body are the central issues of Barney's work becomes clear in an allegorical and exemplary way in a scene from *Cremaster 4*. In this video, three fairies appear. They have their orange hair put up in a strikingly feminine way. Sometimes they wear romantic yellow dresses, other times they wear white overalls. Their figures are very masculine, and when we see them naked they appear to have the muscles of bodybuilders (fig. 49). We also see their genitals. This organ is emphatically undifferentiated: it is a fold too undif-

49

50

49 | Matthew Barney, production still (naked fairies), *Cremaster 4* (1994). © 1994 Matthew Barney.
Photo: Michael James O'Brien. Courtesy of Barbara Gladstone Gallery, New York.

50 | Matthew Barney, production still (genital with tubes), *Cremaster 4* (1994). © 1994 Matthew Barney.
Photo: Michael James O'Brien. Courtesy of Barbara Gladstone Gallery, New York.

ferentiated to be a penis and too protruding to be a mons veneris (fig. 50). Four motor drivers connect these genitals by means of tubes attached to their motorcycles. It is unclear whether energy is supplied to the motorcycles or whether the machines rev up the genitals. What is evident, however, is that this scene represents the stream of energy. It is about the increase and decrease of energy and tension; energy is captured, transformed, used, and reconverted in a logic of flux (Onfray 55). In whatever way we describe this scene, the sexual connotations proliferate.

Earlier I described the recent developments in gender studies and in gay and lesbian studies and, also, in gay and lesbian practices. I argued that gender identity and sexuality are increasingly lived and studied as separate entities. Barney's work is a clear example of this development. But he goes even further. Not only does he refuse a mechanical relationship between sexuality and gender but he also seems to pursue an undifferentiated identity of gender as well as of sexuality. Masculinity is no longer constructed or shaped by means of the qualities that are ascribed to the male genitals, and he also seems to refuse a clear object-choice when sexuality is at stake. The sexuality of his figures isn't hetero-, homo-, or bisexual and cannot be reduced to what the male member is able to perform.

The sexually undifferentiated creatures that populate Barney's fictional world have a childlike, toylike quality about them. The fairytale ambiance frees us all from adult concerns, so that alternative possibilities can be explored. Utterly different in tone from McEwan's rewriting of conventional masculinities against which this artist wages his battle, Barney creates a free place for free play, an island that can become a visual laboratory for new unheard-of possibilities. Imagined possibilities, that is. The need for such a light-handed overwriting of traditions is just as necessary for the gendered fixations of femininity. I will now turn to an example of how such rewriting can become un-fixing.

7 ⟩ Facing Defacement

This was more than a woman, this was a masterpiece!—Honoré de Balzac, *Sarrasine*

These forms of projection of the body reveal the paradoxical status of the body as both mode and object of knowing, and of the self constituted outside its physical being by its image.
—Susan Stewart, *On Longing*

{ AT FIRST SIGHT }

Marlene Dumas's *Models* (1994; fig. 51), a series of one hundred drawings, consists of portraits, that is, faces. Faces come to us one by one. It is our desire to relate to others, to establish an I-you relationship that constitutes our self, that disables us and thus prevents us from seeing many people at the same time. Even in the case of a group, or a group portrait, our eyes move from one face to another. For groups are always composed, that is, they have a center, a foreground, a background, margins. They create outsiders and insiders. Our look is directed from one face to another; the relation we establish with all those individual faces depends on the ways our look is disciplined by the composition of the group. I use the word "composition" in this case in its double meaning, pointing at the various constituents, as well as the hierarchical orderings that put those parts in their place.

Models, which is neither a single portrait nor a group portrait, but a group of single portraits, challenges our disciplined manner of reading faces in a variety of ways. It lacks composition in the second sense just mentioned, for it lacks hierarchy. The work consists of one hundred ink drawings of portraits of women. One sheet shows the head of a snake. Inclined to relate this snake to the mythi-

51 | Marlene Dumas, *Models* (1994), 100 drawings, each 62 × 50 cm., mixed media on paper. Van Abbe Museum, Eindhoven.

cal figure of Eve, I assume that woman is here again represented, albeit now in-directly, symbolically. One's first impression is that all these women form one family, that they are the manifestations of one identity: womanhood.

On closer viewing, however, it becomes very difficult to recognize a group identity in this group of portraits. Some of the portraits show androgynous or even male figures. The gender identity of these women, then, is not so clear. The suggestion that they are all women is implied in the title, *Models.* The model is associated with femininity, although male models do exist. This is so because in Western culture exhibitionism and masquerade, which models have made their profession, are seen as feminine. In Dumas's oeuvre titles, are not insignificant, neither superimposed nor confining but complicating signs that stop attempts to simplify or to go for an interpretation too hastily. Therefore, respecting the title, I will for the moment treat the depicted figures as women.[1]

The figures are also not uniform in terms of racial identity; some are white, some are black. One could perhaps think that this group of portraits gives expression to the humanist idea of "the family of man." In their diversity all these women have something in common, because in their diversity they belong to the same human race. However, even this reading is hard to sustain when we become aware of the fact that we are not so much identifying women in these portraits but images or representations of them.

I recognize, for instance, Rembrandt's *Bathsheba,* Vermeer's *Woman with the Pearl,* Paloma Picasso in one of her perfume ads, Anita Ekberg in *La Dolce vita,* Brigitte Bardot, a female head from a Man Ray photograph, the world-famous model Claudia Schiffer, and images from the book *Portraits of the Insane: The Case of Dr. Diamond.* I can also recognize the artist Sandra Kriel, the writer Simone de Beauvoir, the choreographer Pina Bausch, the singer Billie Holiday. I recognize these women because I have seen pictures of them; I recognize pictures. They are a mix of cultural agents, models in the narrow sense of the term. They are emblems and victims, successes and failures, named individuals and anonymous people. *Models* does not consist of representations of women alone but of representations of representations of women. And the represented representations are, again, diverse. They belong to high as well as to low culture, to elite as well as to popular and mass culture.

This reading, based on a cursory look, suggests that Dumas's group of portraits explores the relationship between representation and female identity or subjectivity. This is not surprising because Dumas has consistently examined the relations between the human figure in representation and the kind of subjectivity—or the lack of it—in which those representations result. In chapter 2, I discussed how her single portraits, her group portraits of 1985–87, and her subsequent groups of portraits provide insights illuminating one another within the

same project. I defined her project as an exploration of different kinds of portraiture and the notions of subjectivity produced by this specific pictorial genre. The group of portraits *Models* should be seen in continuity with these works. But in this chapter I will focus more strongly on these portraits as an intervention in the culture of the model, not limited to exposing it.

{ MODELING MODELS }

Models addresses yet another aspect of the relationship between representation and subjectivity. Its title adds a dimension to it that makes this work central in Dumas's oeuvre to date. The title creates a tension between individual subjectivity and its absence or even denial. We are in the presence of portraits, that pictorial genre that, as I discussed in chapter 2, is traditionally invested with notions of the presence of unique individual identity. The individual in portraiture, however, is usually not considered the model but, rather, its sitter. Models, by contrast, tend to be anonymous. Not their inner individual personality but their outer form, their bodies and poses, are depicted in representation. Models have no particular face because they have no individuality.

The painting *Model* (1995; fig. 52) emblematizes this feature of models. Done in what is for Dumas a strikingly uncharacteristic smooth paint stroke, it depicts the figure in bold assured lines, thus creating flat surfaces. The model consists of surfaces. She lacks any suggestions of depth. This superficiality is emphasized by her eyes or, rather, the empty shells that betoken the absence of eyes. A model, this work seems to say, has no real face, only a facade. The painting *The Cover-Up* (1994; fig. 53), representing a little girl covering her face with her skirt, illuminates *Model* and, by extension, *Models,* by showing how the child, still having subjectivity, tries to protect herself from the culture that makes models at the price of defacement. In an ironic twist, her action turns out the wrong way. She protects her face, but at the cost of exposing her body. Culture is stronger than she is. The dialogue between the two paintings suggests that cover girl is cover-up.[2] Models have no real face, only a facade. I will return later to this mutually exclusive relation between face and facade.

Dumas's *Models,* however, does provocatively show us faces instead of bodies and postures. The implication of this paradoxical portrayal of models can be articulated in confrontation with yet another work. The group of portraits titled *Rejects* can be understood in opposition to *Models.* It is precisely this opposition that makes us aware of the ambiguity of the concept of "model." The two works, as well as their titles, are fundamentally different. While *Models* consists of a fixed number of drawings within a fixed place in the work as a whole, *Rejects* (fig.

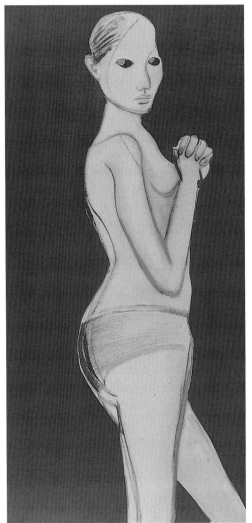 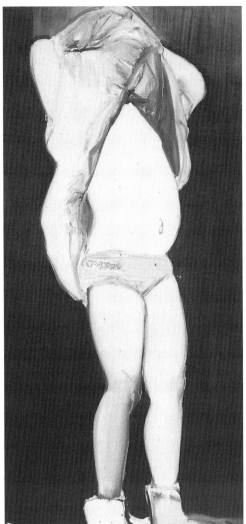

52

53

52 | Marlene Dumas, *Model* (1995), oil on canvas, 200 × 100 cm. Courtesy Jack Tilton Gallery, New York.

53 | Marlene Dumas, *The Cover-Up* (1994), 200 × 100 cm. Private collection.

54) is an organic or, better, a dynamic work. Each time it is exhibited it consists of a changing number of drawings, which do not have a fixed place. New drawings constantly appear in this work, while others disappear. One could say that the composition of "rejects" is governed by disorder, whereas that of "models" presents order. This disorder is not just a lack of order but its actual destruction, as a willful dis-ordering that will become particularly meaningful in the context of the grotesque, on which more below.

But differences do not end here. The editing of the series *Rejects* is also a feature of each of its components. The ink drawings of *Models* are "plain" or "pure" representations of representations of women, whereas *Rejects* are worked on, "edited," or distorted. The "rejects" are treated as raw material on which work has been done. The eyes, for instance, have been distorted by adding colors to them or by scratching or cutting them out. As a result, the kind of subjectivity that is expressed in the depicted figures is radically different. In this analysis, *Rejects* thus functions as a supplement to *Models,* radicalizing the way *Models* hampers the smooth, objectifying gaze that "takes in" what it sees.

When we take the titles of the two works into consideration, and the way those titles are each other's opposite, we become aware of a fundamental ambiguity in both works. In the context of the visual arts, the word "model" first of all refers to the person from whom the image is drawn or painted. In an artistic context, the word "reject" refers first of all to another ontological level, that is, to representation. A reject is a rejected drawing or painting. But as seen against

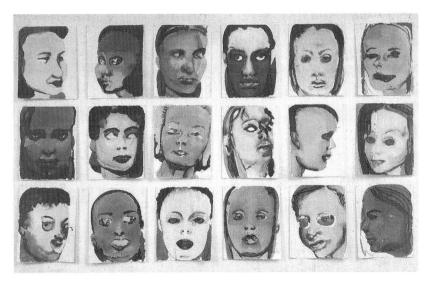

54 | Marlene Dumas, *Rejects* (1994–), work in progress, detail

Models' opposite, other meanings can be evoked. "Reject" means in this way a rejected person, represented because she exemplifies the opposite of the features of the artist's model. Thus the title *Rejects* draws attention to an important dimension of the idea of "model." "Model," then, means not only the model from whom the image is drawn but also an ideal. The representation thus presents an ideal form, a figure of beauty. The drawings offer ideal standards instead of figures drawn from models. The title *Black Drawings* contains the same kind of ambiguity: it can mean drawings of black people as well as drawings in black, made with black ink.

The nature of this ambiguity is fundamentally the same as the ambiguity of mimesis, one of the central concepts of the Western aesthetic tradition and, according to many, the basic principle of realist representation. In effect, "model" is mimesis's ambiguity. This term is often wrongly translated as imitation. But Aristotle's *Poetics,* which is the source of the concept of mimesis as it is currently used, employs the term already in an ambiguous sense. The accusative that accompanies it can indicate the "model" as well as the "copy," the preexisting object and the resulting creation.[3] If we take this ambiguity into consideration, mimesis implies much more than passive copying or rendering. Mimesis is creative, and the re-presentation becomes a "presence" in and of itself. As a means of understanding the ambiguity in Dumas's groups of portraits, this concept suggests that her work *Models* involves much more than an ironic celebration of mass culture's motifs in high art. Claudia Schiffer and Naomi Campbell do not just replace Warhol's Marilyn Monroe.

This work places itself in relation to that aesthetic tradition that identifies woman with beauty and beauty with woman and rewrites that tradition. While acknowledging the lasting power of this tradition, Dumas's meaning is located in the way she contrasts her work to this tradition. Thus, the work comes to embody an ambitious intervention in the history of art. In *Models,* the beautiful or ideal representation is not modeled on the cliché of the female body. There are no bodies in these drawings, only faces. Woman, her body or beauty, is not under discussion, it is her face that is the exclusive focus of representation.

But Dumas's intervention goes further than that. To understand how radical this work is, the opposition or tension between the models and the rejects needs to be pursued further. It can be enlarged by placing it within the strong cultural oppositions of the ideal and the grotesque. In a suggestive essay of cultural analysis, Susan Stewart has argued that representations of the human figure tend toward these two extremes: "There is only convention in the 'realistic' depiction of the body. The body depicted always tends towards exaggeration, either in the convention of the grotesque or in the convention of the ideal. There are few images less interesting than an exact anatomical drawing of the human

form" (1984, 115). The difference between the grotesque and the ideal can be explained as a difference in the perspective from which the body is experienced. According to Stewart, grotesque realism is emblematic of the body's knowledge of itself. This is a knowledge of pieces and parts, of disassociated limbs and an absent center. In contrast, the realism of the ideal is emblematic of the body's knowledge of the other. This is a knowledge of facades, of two dimensions.

The relevance of Stewart's view for Dumas's oeuvre is striking. Dumas's work can be seen as an exploration of the tension between the body as a spectacle seen from a distance and the body as lived reality, that is, between the ideal and the grotesque. There is such a tension because the experience of our own body and the sight of the body of somebody else can never be reconciled. In fact, this tension is already present in the body as such because the body is at once a container and that which it contains. This paradox explains our fascination for the boundaries of our body, the cuts and gaps on the body's surface as Lacan has called them. These cuts or gaps are, for example, the slit formed by the eyelids, the lips, the anus, the tip of the penis, the vagina, in short, the erotic zones of the body. All those places are (again) ambiguous because they are the places where the interior of the body is turned inside out. Boundaries have disappeared.[4]

As Stewart put it, we want to know what is the body and what is not. This question seems to motivate all of Dumas's works, but then it is complicated by the added concern for the location of subjectivity in that body. It especially informs *Models* and *Rejects*. In *Rejects* she effectuates the grotesque body by exaggerating those elements that connect inside to outside or where, as in the eyes, the interior surfaces on the outside. This results in disorder. These works betray the knowledge of a bodily experience that shatters, distorts, and is in constant flux. It is an experience that refuses closure. The lived experience of sexuality is emblematic for this grotesque knowledge of the body in pieces and parts. The only situation in which the body of the other is experienced as one's own—that is, in parts—is in the embrace. Because a key aspect of sexuality is the grotesque knowledge of the body, representations that address or are informed by such a knowledge are rendered truly erotic. Such representations are, in fact, the only imaginable cases of erotic art.[5]

Dumas has explored the effect of the embrace as shattering the spectacle of the other literally as well as figuratively. In her works *Porno as collage* (1993), *Porno blues* (1993), *No more oneliners* (1993), *Kissing* (1994), she provocatively depicts situations of an erotic nature but that traditionally have evoked the voyeur and the pornographer. In pornography and voyeurism, the body is kept at a distance, reduced to surface, and kept closed. Dumas's mode of representation transforms this pornographic practice into the experience of the embrace and lived sexual-

ity. The flowing ink has created an image that frustrates the focused and distanced view of the pornographer. Our view is opaque: we see shattered limbs and get lost in poses that entangle the two bodies. Watching these sexual acts we are not in the external, safe position of the voyeur but, rather, in the shattering and disordering situation of the embrace. The pornographic spectacle of sex is turned into something antispectacular. We see it from the inside.

The group of portraits titled *Underground* (1994–95), made with her young daughter Helena for the Biennale in Venice, performs the grotesque effects of the embrace in a figurative way. This work, which consists of twenty-four drawings, does not depict pornographic situations but, instead, shows portraits. Helena has made all kinds of additions in color to her mother's black drawings. This joint or collective practice has the same shattering effect as the lived experience of the embrace. The production of the work itself is now an embrace, an embrace of mother and daughter. This experiment gives a radically unexpected meaning to the pursuit of representing lived bodily experiences. What we, as viewers, see is again not an ordered, distanced spectacle—an "other"—but a "work" (not a product). A dynamic work that thematizes in its production the readiness or even desire to dissolve the boundary between self and other.

By allowing an invasion of individual artistry, Dumas as an artist "goes underground." But she renounces not only her unique status as an artist: by letting in a child, she even puts at risk the very concept of artist. And since it is her own daughter, this act of renunciation can only be seen as an act of love. Thus the collaborative embrace of producing the subjects of *Underground* highlights the aspects of *Models* that questions subjectivity as an opposition of individual autonomy and sheer exteriority.

{ THE TAMING OF THE FREAK }

From this perspective *Underground* is a breakthrough in a problematic that Dumas has explored in her earlier work. The grotesque may be the quintessential expression of eroticism, but—perhaps because of that—it raises anxiety. Dumas addresses that anxiety by way of what I would like to call a "fascination for the freak." The idea of the freak is related to that of the grotesque body. Eroticism and grotesquerie both represent the problems of the boundary between self and other. Where they differ is in the response to those issues of boundary. In the grotesque body the dissolution of those boundaries is actively and eagerly enjoyed. By contrast, in the fascination for freaks, such a dissolution of boundaries produces no positive excitement but an anxiety and abhorrence. Stewart explains: "Often referred to as a 'freak of nature,' the freak, it must be empha-

sized, is a freak of culture. His or her anomalous status is articulated by the process of the spectacle as it distances the viewer, and thereby it normalizes the viewer as it marks the freak as an aberration" (109).

The freak has had a clear place in the museum of curiosities, in the circus or at fairs where so-called freaks of nature like dwarves, bearded women, "Siamese" twins were put on display. The attraction is fueled by an abhorrence of the freak's body as a metaphor for our impotence to accept the body of the cultural other. This cultural construction of alterity in terms of abhorrence is most painfully visible in the display of Saartjie Baartman, the famous so-called Hottentot Venus, the black woman with excessively ample buttocks, among the freaks. The body of the cultural other has to be naturalized and domesticated in a process we might consider to be characteristic of colonization in general. In Stewart's terms: "For all colonization involves the taming of the beast by bestial methods and hence both the conversion and projection of the animal and the human, difference and identity. On display, the freak represents the naming of the frontier and the assurance that the wilderness, the outside, is now territory" (109). The only way to understand this political and representational mechanism of domesticating and colonizing the other by means of display is by doing it with the difference of self-reflexivity.

In our postcolonial and postpatriarchal times, Dumas has displayed freaks, provocatively and shamelessly, in many of her works. She has displayed the "display of freaks" literally in works such as *The Human Tripod* (1988; fig. 55) and *Albino* (1986). By shifting a visual practice from the domain of the amusement industry to that of sophisticated reflection and aesthetic pleasure, the freak of *The Human Tripod,* for example, confronts the viewer with the unnatural and aggressive modes of looking that the latter can, therefore, no longer take for granted. In their freakish deviation, such figures denaturalize looking in a fundamental way. Therefore, those works do not repeat the domesticating practice but challenge it through displacement; they rewrite it.

It is now directly and confrontationally done within the context of high art, not popular culture, a domain that is too "serious" for our embarrassing fascination for aberrations and curiosities. Dumas's figure of *The Human Tripod* is a freak because he has a "third leg." The third leg, hyperbolic metaphor of the primary attribute of maleness, is presented frontally. At the same time, the figure's hand rests between two legs in a position of masturbation. But because there is no middle between three legs, the object the hand presumably touches is decentered. The freak is a freak, then, because of a self-aggrandizing fantasy; acting "normally," the hyperbolic item is neither grand nor central.

But Dumas's predilection for freaks is even more subversive in those works that represent them only obliquely; in works like *Man without Sexual Organs (3 Sys-*

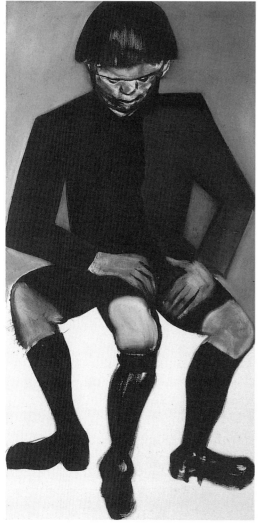

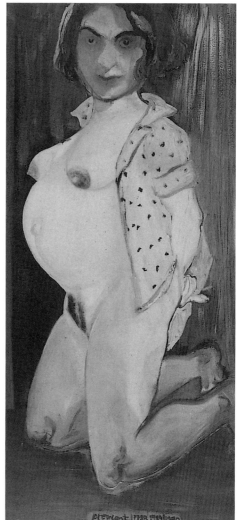

55

56

55 | Marlene Dumas, *The Human Tripod* (1988), 180 × 90 cm, oil on canvas. Centraal Museum, Utrecht.

56 | Marlene Dumas, *Pregnant Image* (1988–90), oil on canvas, 180 × 90 cm. Private collection, New York.

tems), *The First People (I-IV* [1991]), *Pregnant Image* (1988–90), *Warhol's Child* (1991), *See No Evil* (1991). These works subvert the "taming" of the body of the cultural other by bestowing freakish features on the body of the cultural self. These images do not display the bodies of those who are assumed to be other. It is "we," ourselves, who we are seeing as freaks. *Pregnant Image,* for example (fig. 56), shows nothing less "normal" than a pregnant woman, but the representation is blatantly made freakish, a monstrous belly that can only be a representation, an imaginary view of pregnancy as "other." Thus it is ultimately the image of pregnancy that is freakish—hence this precisely appropriate title. Dumas dissolves the boundary between the normality of the self and the aberration of the other by showing the "other within," the freak within ourselves. The frontier between culture and wildness is no longer assured.

The "freakish" side of Dumas's work can be seen as a destabilization of a representational practice that has an investment in safeguarding the self through the projection of disorder and excess onto the cultural other. And of course, this investment is colonial as well as sexist. But once Dumas started to make her groups of portraits, a new dimension came about in her work. These works, compared with earlier works, are less absorbed by questioning, criticizing, and destabilizing a politically charged practice of representation, although they do that too. It is, however, more striking that these works take pleasure in the impossibility of drawing boundaries and of fixing identities. They wallow in abundance, excess, disorder, and pluralization. They celebrate diversion in identity crises and revel in the grotesque alternative that her earlier critique of the freak evoked.

{ BEAUTY AND THE BEAST }

This view of Dumas's groups of portraits takes into consideration only one aspect of these works, that is, the implosion of the notion of identity into a pluralization of images. Thus formulated, it does not as yet enable us to acknowledge the differences between a work like *Models* and works like *Rejects* or *Underground.* To understand this difference I would now like to concentrate on the opposite of the reject, the grotesque, and the freak. I would like to consider now the implications of the other side of the concept of model. As stated earlier, this concept is ambiguous in the same way as the concept that is closely related to it, mimesis. Its object can indicate the preexisting object from which the representation was made but also the resulting creation.

But the term "model" has an additional aspect. It is a further specification of the accusative of mimesis. A model is not just any preexisting object or just any

resulting creation. In both meanings of the term it involves an ideal of perfection. This implies that an ideal of perfection—beauty—can be found in preexisting objects, in megamodels to use Dumas's own term, or it can be achieved through artistic labor, in the work of representation. Art historians have taken this ambiguity to heart. They have persistently conflated the two meanings of "beauty."

An example informing this issue can be found in the article "Ideal and Type in Italian Renaissance Painting," where Ernst Gombrich discusses a famous letter by Raphael of 1514, addressed to the diplomat and man of letters Baldassare Castiglione. In this letter Raphael responds elegantly to a compliment about a fresco he had just completed in the Villa Farnesina in Rome. It is clear from this letter that Raphael does not believe in the possibility that real women can be perfect models. For he writes:

As for the Galatea, I should consider myself a great master if only half of the many compliments your Lordship wrote to me were deserved. However, I recognize in your words the love you bear me, and would say in order to paint one beautiful woman I'd have to see several beautiful women, always on the condition that I had your Lordship at my side in making the choice. But since there is a shortage both of good judges and of beautiful women, I make use of a certain idea that comes into my mind. Whether it carries any excellence of art I do not know, but I work hard to achieve it. (1986, 89–90)

It could be argued that Raphael expresses here a Platonist aesthetics. The perfection of beauty cannot be found in real women but only in a metaphysical idea. To achieve excellence in painting, one should imitate this idea. This is possible because, before the soul entered the body and was wedded to matter, the soul was granted the sight of the idea of beauty. This reading implies that our knowledge of the ideal is based on memory and not on the perception of reality or of "models." When Raphael uses models for his paintings, it is not because they embody the perfection of female beauty. His models are not the ideals of perfection worth imitating. They are only a starting point in the process of remembering the metaphysical idea of beauty. It is exactly their imperfection that reminds the painter—by way of contrast—of beauty's perfection.

But Gombrich does not agree with such a Platonist reading of Raphael's letter. He reads it, as we might expect, according to the thesis that he developed in his book *Art and Illusion* (1968). His thesis can be summarized with the formula "schema and correction" or "schema and modification." In making an image, the artist first needs to establish a structure, a shape that he can subsequently approximate to reality. This means that the artist always takes the inherited type as a starting point. Those types or schemata can be modified but not discarded.

If we accept Gombrich's thesis, it implies that Raphael derived his successful image not from a Platonic, metaphysical idea of beauty but, rather, from a type of female beauty that he owed to tradition. This type was essentially a composite. Raphael's letter indicates a kind of beauty contest whose winner is no single woman but the combination of a feature or limb of many.[6] In such a composite, one can imagine that it does not even matter whether all contributors are women. In later academic practice, where women were banned not only as students but even as models, male models were used to imagine females. Breasts were simply added and penises deleted. Such practices are entirely consistent with the imaginary search for perfection that Raphael describes in his letter. Platonic essence and bodily fracture are easily integrated into a notion of the ideal that is open to the definition of beauty as the male body with a difference.[7]

Gombrich's view of mimesis has been more than influential. It is pervasive in art history departments today. His thesis is seductive because it seems to imply a major break with the antihistoricism of the natural, realistic attitude. For the painter does not, according to Gombrich, gaze on the world with innocent or naive vision and then set out to record with his brush what his gaze has disclosed. Norman Bryson has characterized Gombrich's position tersely: "Between brush and eye intervenes the whole legacy of schemata forged by the painter's particular artistic tradition" (1983, 21). What the painter does is the same as what the Popperian scientist does: he tests these schemata against experimental observation of reality. The artist's image will not be a perfect copy in terms of transcendent Truth or Beauty. It will be a provisional improvement on the existing corpus of hypotheses or schemata, improved precisely because tested through falsification against the world.

I have dwelled on Gombrich's theory because at first sight there is a parallel between his ideas and Dumas's art practice. Dumas will never draw or paint from reality or directly from a model. According to her, to copy reality is a senseless pursuit because reality itself will always be more interesting or more "perfect" than its copies. She once said that in a way she had more affinity with abstract expressionism than with naive realism.[8] Consistent with this denunciation of drawing from life or from models, she always works from photographs. But with that insistence on the fabricated nature of ideals of beauty, her work takes on the history of that fabrication and "forgets" to pursue the beauty that history aimed for. Her willful forgetfulness results from a reminder of that which the great artists of the past "forgot": the mechanisms that obliterated subjecthood in the process of achieving beauty.

But the similarity between Gombrich and Dumas only opens the gap between them. While Gombrich's thesis that artists work on the legacy of schemata seems to be performed in the most literal way by Dumas, her starting

point and object of inquiry is the realm of representation, not that of reality. Her work titled *Models* is an explicit case of this practice. By using images of women out of diverse domains she addresses the modeling effect of these representations. It is the difference between Gombrich and Dumas that makes clear what is at stake in *Models* and how this work offers a critique of art history as a discipline, as well as of the history of art as a practice. It is also this difference that reveals the ideological investment of Gombrich's conception of art history.

Gombrich's theory takes distance from the Platonic tradition. According to this tradition, the project of art is a moral-aesthetic one. The artist should try to attain the absolute standard of the idea of beauty. Instead, Gombrich turns art into a scientific project. The history of art is progressive; it pursues the improvement of schemata through testing against the perception of reality. His ideal of perfection is, however, not metaphysical. It is reality. Gombrich and Platonism have in common that their ideals of perfection are absolute and static.

There is only one perfection in the place beyond the heavens where the Platonic ideas have their being. The same can be said about Gombrich's reality. In his account there is always an ulterior and veridical world that exceeds the limited, provisional world picture built from schema and hypothesis (Bryson 1983, 33). This is precisely the reason why Gombrich's effort to break with antihistoricism has failed. From this perspective, his theory is no more than a secularized version of Platonism. The static absolute has been transposed from the metaphysical world of ideas to something called reality.

The static and absolute status of perfection represents an ideology of exclusion. Perfection is always singular or unique. Hence, it leaves no room for difference and plurality. Dumas's *Models* seems to poke fun at this feature of perfection by representing a hundred models. She turns the serious project of achieving the standard set by the absolute Model (whether we call it Beauty or Reality) into something like a catalog from a modeling agency. But Dumas's deconstruction of art history's models of absolute perfection goes further still than this pluralization of the singularity of perfection. She exposes and rewrites the Western representational politics of representing women within the paradigm of the model in the sense of the ideal. Susan Stewart, whose ideas we have already encountered, has explained what the parameters are of this paradigm. According to her, the realism of the ideal is emblematic of the body's knowledge of the other. And as we have seen, this is a knowledge of facades, of two dimensions, that belongs to the domain of the voyeur and the pornographer.

This knowledge of facades is formalistic par excellence. It fetishizes the perfection of detail. This characterizes precisely Gombrich's theory of art history. With the eye of a professional voyeur and pornographer he completely ignores subjectivity and meaning in the "types and schemata of feminine beauty" that

he discovers in Raphael's and Michelangelo's representations of women. The pursuit he ascribes to the artist is a strictly formalist one, which is the correction of schemata through the perception of reality. And of course the only art tradition that he recognizes as art is the Western one, and that is precisely the one that conflates woman with the perfection of art and art with the perfection of the female body.

Stewart's differentiation of the grotesque and the ideal implies that the idealization of the female body in Western art is but one face of the Janus head of the representation of the body. The other face is the pornographic. Both practices treat women as facades. The title of Dumas's work *Models* invokes both these traditions, which come together in the figure of the cover girl, for example, Claudia Schiffer or Naomi Campbell. Their bodies present the contemporary ideals of perfect beauty.

But after having evoked these traditions, which are only apparently opposed, Dumas gives us no access to them. She refuses to show the model's means of existence: her body. Instead, Dumas insists on only the face. This makes it hard to watch models as facades because it is in the face that one's subjectivity expresses itself most directly. Furthermore, she juxtaposes the faces of cover girls with those of women who stand on the wrong side of ideal beauty. These are women who are mentally ill. And in order to emphasize the constructed quality of the ideal of beauty, she adds to her collection faces that previous artists have "made external": the lasting beauties of Rembrandt and Vermeer. By that addition, she reverts to the conflation of the two meanings of mimesis's object, which makes "model" and "copy" indistinguishable.

One can say now that Dumas has rewritten subjectivity into the representation of models, and by doing so she challenges both the pornographer and the Gombrichian art historian. In addition, many of the represented "models" confront us with their gaze. An undisturbed voyeuristic look at or over them is made difficult. They watch us while we watch them. This critique of Gombrichianism as pornography is the emphatic subject of *Snow White and the Broken Arm* (1988; fig. 57). This work compels an allegorical reading of it as a theory of art. Behind the woman in the glass case that caused her demise through display, the seven dwarves look on as voyeuristic art historians who presume to gauge her deviance from reality.[9]

Dumas critiques the museum as peepshow, a concern also central in *The Ritual* (1988–91; fig. 58). In the foreground lies a disordered heap of Polaroid photos, reminiscent of the torture by photography in Marlene Gorris's film *Broken Mirrors* (1984). But Snow White strikes back: she directs her camera at the viewers, who are in danger of being caught and made into objects of voyeurism in their own turn. She breaks herself free from being a formal facade. The arm guilty of

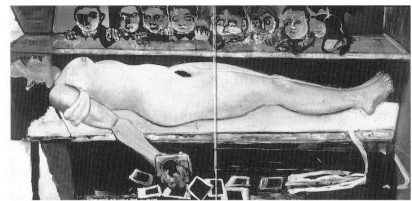

57

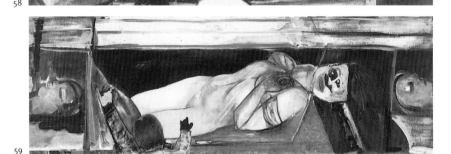

58

59

57 | Marlene Dumas, *Snow White and the Broken Arm* (1988), 140 × 300 cm, oil on canvas.
Haags Gemeentemuseum, The Hague.

58 | Marlene Dumas, *The Ritual* (1988–91), 140 × 300 cm, oil on canvas. Courtesy Stampa, Basel.

59 | Marlene Dumas, *Snow White in the Wrong Story* (1988), 100 × 300 cm, oil on canvas.
Collection J & M Eyck, Wijlre.

breaking the rules of the gentlemen's agreement of Gombrichianism is broken. This broken arm frustrates the dwarfs' pursuit of perfection and beauty, thus breaking the glass case—the model's mirror.

The relation between *Snow White* and *Models* is emphasized in two other paintings about Snow White. Each addresses another aspect of the view of beauty based on decomposing models. *Snow White in the Wrong Story* (1988; fig. 59) represents the art critic from the back and dwarfed. He is alone and pulls away a curtain. The gesture, as well as his solitude, casts him as a voyeur and his smallness signifies voyeurism as infantile. But what is disclosed by his gesture— the reason that his story (of art) is wrong—is three corpses of women: the story of the pornographic view of beauty turns into the story of Bluebeard. This is yet another version of Raphael's search for the women who can represent perfection together—on the condition of being cut up.

In *Snow White and the Next Generation* (1988; fig. 60), Dumas endorses the universalism of the view of beauty in an ironic way. Now the dwarves/critics are seen from the back and crouch in the foreground. They, too, are little, in a literalization of the idea of "the next generation," but they are already imitating the behavior of their fathers. They have naughtily taken their pants off; as children, they are not inhibited in their expression of eroticism. Snow White, however, is not so well off. She is clearly dead, and her pose reminds one of the famous anatomical lessons of the history of art. The pose of her body is similar to the one in *Waiting (for Meaning)* from 1988 (fig. 61). She thus embodies the lack of meaning this formalistic approach of art proclaims. She is beauty's model condemned to remain an empty vessel for men's desires. As long as art history and criticism remain formalistic in their pursuit of perfection, Snow White will have to keep waiting for meaning, a model forever "miss-interpreted."[10]

{ MODELING THE VIEWER }

Modeling, as an activity, is a transitive verb. Modeling is acting upon an object that is shaped according to an ideal: a model. This, I submit, is the most important, the constructive phase of Dumas's narrative of *Models,* where she moves from exposing to rewriting history. It is the one that receives its most specific representation in the *Magdalene* series she made for the 1995 Biennale in Venice (fig. 62).

Mary Magdalene, a saint, is also a model; and she used to be a whore. She is the quintessential whore, the one who abjured her profession and became a saint and, thus, a religious model. Her life story embodies the cultural ideal of penitence. But the abjuration of her body and sexuality is made contradictory in

60

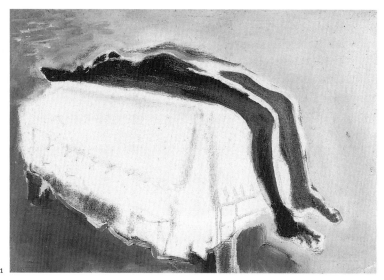

61

60 | Marlene Dumas, *Snow White and the Next Generation* (1988), 140 × 200 cm, oil on canvas. Centraal Museum, Utrecht.

61 | Marlene Dumas, *Waiting (for Meaning)* (1988), 50 × 70 cm, oil on canvas. Kunsthalle zu Kiel, Kiel.

62 | Marlene Dumas, view of studio with part of the *Magdalena* series (1995), 300 × 100 cm and 200 × 100 cm, oil on canvas.

63 | Marlene Dumas, *Magdalena: A Queen of Spades* (1995), 300 × 100 cm, oil on canvas. Stedelijk Museum, Amsterdam.

representation. She wiped Jesus' feet clean with her long hair. This gesture, which expresses her repentance, is at the same time charged with sexuality. It is this paradox that is emphasized in the representation of Magdalene in the history of art. She is usually represented with beautiful long hair, which makes her into a model of female sexuality. But her saintliness is based on the denial of that same sexuality.

In the Magdalene paintings of artists like Caravaggio and Georges de la Tour, we see this renunciation of her sexuality expressed as a turning away from the viewer. She repents and is therefore no longer secretly interested in somebody's voyeuristic look. Or so it seems. More commonly, the history of art teaches us otherwise. Magdalene figures in the same way as all those canonical models of women who represent sinful sexuality or its abjuration: Susanna, Bathsheba, Judith, Delilah. These female figures tend to condone, or even collude in, their sexual abuse by surreptitiously encouraging it visually. They look at the viewer enticingly or are painted to look back secretly while "officially" turning away. This history of sexual engagement by vision is the subject of Dumas's *Magdalenes*.[11]

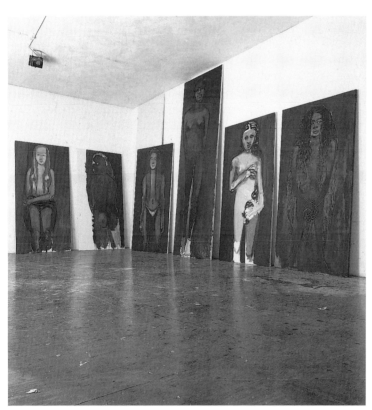

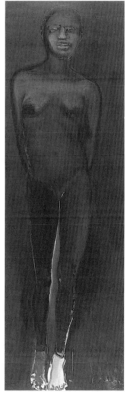

62 63

But we now have these Magdalenes who look you straight in the eyes. These looks are self-confident and never enticing. Some are angry, some irritated. They are never neutral. By looking back at the viewer, these figures are members of the tradition of Olympia, Manet's reclining female nude who/that scandalized the Parisian public in 1865 by looking irritatedly at the intruders who interrupted her private space. Dumas's Magdalenes, importantly, stand; they do not recline. Thus they are full subjects, adopting a pose as well as a gaze that inscribe their dignity and authority.

There are two groups of Magdalenes, giant ones (fig. 63) and slightly smaller than life-size ones. The former locate the viewer's gaze at the crotch; the latter locate it at the face. This difference further articulates the tension with which *Models* plays: between body and face, between women and subjects. This binary structure is totally disrupted, as it must be, because the system blatantly fails to work. The smaller ones—at first sight easy to "take in," to appropriate visually—possess such striking eyes that you don't dare do so. The larger ones, which force you to look at their crotches, tower above you and dominate you. In either case, the "wrong" way of looking is provoked but then precluded.

This journey through Dumas's stages, or stations, of sexually specified looking ends with her insistence that it is simply not acceptable, ethically speaking, that looking can kill. The viewer, trained by a long history of art with Raphael or Gombrich as his teachers, arrives at her confrontation with the impossibility of looking according to this traditional model. Dumas's reassigning subjectivity to women by returning a face to models (as in *Models*) and a body to faces (as in the *Magdalenes*) forces the viewer to reflect on the question of why this was necessary. Thus, the project at whose center *Models* stands comes to a satisfying, albeit provisional, closure. Magdalene's renunciation becomes the viewer's repentance.

<table>
<tr><td>**8**</td><td>Caught by Images</td></tr>
</table>

. . . except what I saw with my wide-open eyes.—Tadeusz Borowski, *This Way for the Gas, Ladies and Gentlemen*.

{ A VISION THAT DOES NOT SEE }

"Someday you be walking down the road and you hear something or see something going on. So clear. And you think it's you making it up. A thought picture. But no, it's when you bump into a rememory that belongs to somebody else" (36). Toni Morrison, in her novel *Beloved* (1987a), here writes about the importance and reality of what she calls "rememories," and what students of the Holocaust call, with a contradictory term, "traumatic memories." The key word here is "pictures." In an interview, Morrison the writer insists on the visual quality of these images: "What makes it fiction is the nature of the imaginative act: my reliance on the image—on the remains—in addition to recollection, to yield up a kind of truth. By 'image,' of course, I don't mean 'symbol'; I simply mean 'picture' and the feelings that accompany the picture" ("Site of Memory," 1987b, 111). It is my conviction that current interest in specifically visual art related to the Holocaust finds in these statements by Morrison its raison d'être: both its explanation and its theoretical justification. Morrison is a writer, not a visual artist. Yet she insists on the founding, grounding function of specifically visual images in the "re-membering," the healing activity of memory that present-day culture, facing the disappearance of the eyewitness, is struggling to articulate and implement. Paradoxically, it is most clearly and convincingly through creative written texts, commonly called "fiction," that this visuality and its truthfulness can be assessed. This assessment is necessary to come to terms with his-

tory—to "work it through." This chapter, then, is about the "'picture' and the feelings that accompany the picture."

Joan B., one of the Holocaust survivors whose testimony was videotaped by the Fortunoff Video Archive for Holocaust Testimonies at Yale University in New Haven, Conn., recounts the following. She worked in the kitchen of a labor camp. When one of the inmates was about to give birth, the camp commandant gave the order to boil water: "Boil water. But the water wasn't to help with the act of giving birth. He drowned the newborn baby in the boiling water." The appalled interviewer asks, "Did you see that?" "Oh, yes, I did," the witness imperturbably replies. "Did you say anything?" the dialogue continues. "No I didn't." Later Joan B. offers the following comment: "I had a friend . . . who said that now when we are here, you have to look straight ahead as if we have [blinders] on like a race horse . . . and become selfish. I just lived, looked, but I didn't feel a thing."[1]

Although Joan B. has seen what has happened to the newborn baby, her act of looking seems to involve no more than the recording of a visual impression. One of the epistemological implications of seeing, namely, apprehension, to discern mentally, to attain comprehension or grasp, seems to be lacking in her act of seeing. That which was visually distinguishable has been imprinted on her memory like an immutable photograph, but the traces of that visual imprint seem never to have been emotionally experienced, let alone worked through. She recounts an event that is no more than a visual recording. In her narration of it, the event seems not to have had any emotional or ethical dimensions.

Joan B.'s testimony is emblematic of the profound way in which the Holocaust has disrupted conventional notions of seeing in the visual domain in Western culture. Since the Enlightenment, observation of the visual world has enjoyed a privileged epistemological status: it is a precondition and guarantee of knowledge and understanding. Being an "eyewitness" automatically implies that one apprehends and comprehends the observed situation or event.

This link between seeing and comprehension, however, has been radically disrupted in the experiences of Holocaust victims.[2] And as Morrison aptly reminds us, thinking about such traumatic experiences also revivifies the memory of slavery. As I will argue, it is because of this disruption that "to see" and the description of visual imprints have such a central role in the testimonies of Holocaust survivors. But these eyewitnesses' testimonies of visual imprints concern events that cannot be processed in the same manner as those recounted in the eyewitness account in a police report. In Holocaust testimonies the visual functions more like the unmodified return of what happened instead of as a mode of access to or penetration into what happened and instead of being the raw material to be processed into understanding. Even after all this time, that first step has still not been made. Yet the image is there; it refuses to budge.

Perhaps it is because of this strong yet problematic nature of vision in the face of a disaster of the magnitude of the Holocaust that so much intense debate concentrates today on visual art that represents it. Films such as *La vita è bella* and, before it, *Schindler's List* are criticized in terms of the "authenticity" of the representation and blamed for lacking in that regard.[3] These films have been unfavorably compared with the classic *Shoa,* Claude Lanzmann's documentary film recording testimonies of survivors. Lanzmann's witnesses were there; hence, their eyewitness accounts are authentic. They saw with their own eyes what happened, and the images are imprinted forever on their retinas. Begnini and Spielberg mocked this obsession with authentic vision by having the events represented by acting, the quintessential art of feigning, faking, cheating, and pretending. It is as if art itself is suspect in the face of the cultural need for authenticity.

Given how strongly vision has been bound up with truth and authenticity in the Western imaginary since the Renaissance, it comes as no surprise that the question of historical truth in the face of a truth that is unbearable is played out so strongly today in the domain of visual art.[4] An intense discussion is going on, as eyewitnesses become rarer and fiction is one of the few remaining options for keeping the memory of the events alive. Visual artists such as Christian Boltanski and Armando struggle to come up with strategies of representation that supplement the documentary mode that is no longer possible.[5] And whereas the thrust of their work is obsessively singular in this attempt, the term "authenticity" does not apply to it at all. And insofar as their work is primarily visual, a case might be made for the separation or distinction between the question of authenticity and vision per se.

But that distinction does not require surrendering the primacy of vision. Instead, my thesis will be that it might be productive to distinguish vision from its most obvious vehicle, the eye. The issue is more complex than such media essentialism as that privileging of the visual medium suggests. It is, in fact, twofold. First, vision does not automatically lead to "authentic" witnessing. For witnessing requires, in addition to seeing, accounting for what is seen, and the problem may be situated in that mediation or transmission. This problem of transmission occurs strongly in the face of traumatic experiences, and, as I will argue, it is not resolved unless language intervenes. Second, vision does not necessarily lead to representation. There are other modes of communicating—or not-being-able-to-communicate—vision, in whatever medium. The artists I mentioned, among many others, are involved in searching for such alternative modes. I propose first to probe the importance and modalities of vision itself in this context. That is to say, I will attempt to articulate what vision can mean, do, and achieve in the face of its most untenable confrontation, such as the one exemplified by

Joan B.'s testimony. On the one hand, there is the visual imprint; on the other, the need to deal with it.

Tadeusz Borowski's *This Way for the Gas, Ladies and Gentlemen* (1976), acts out the dominant role of visual imprints in Holocaust "memories" in an impressive way.[6] I will take this collection of short stories as a starting point to assess the place of visuality, seeing, and visual incapacitation in the commemoration of the Holocaust. The short stories are inspired by Borowski's concentration camp experiences. But this does not mean that they can be read like first-person testimonies in which the experiences of the narrator are central. Nor do they read that way. The first person in these stories identifies himself more like a reporter of a documentary: he recounts what happens around him. The order of the stories in the book is more or less chronological, although this order does not necessarily concern the chronological ordering of the life of the narrator. Rather, they are ordered according to the chronology of the generic event of "the camp." Thus, the first story deals with arrivals in the camp, those that follow describe life in the camp, then we are told about the liberation. The last three stories, "The January Offensive," "A Visit," and "The World of Stone," recount life after having survived the Holocaust.

Given the inevitably retrospective nature of such accounts, the moment of narration in a Holocaust testimony is by definition situated after the liberation. That is why in the case of *This Way for the Gas,* the last stories possess an essential relevance for the meaning of testimony as such. It is only in these stories that the narrated events are clearly distinguished from the narration of the events: the narration takes place after the liberation. In the stories set during life in the camp, in contrast, the often-used present tense, but also the typically narrative past tense, describe moments of narration that could, in a fictional mode, be cotemporaneous with the events.

"A Visit" begins as if it tells about life from within the camp: "I was walking through the night, the fifth in line. An orange flame from the burning bodies flickered in the center of the purple sky" (174). The first-person narrator then discusses explicitly the impossibility of relating his feelings or self-experience. He presents himself as a kind of machine that could only record what he saw: "In the soft darkness, I held my eyes open wide. And although the fever in my bleeding thigh was spreading throughout my entire body, becoming more and more painful with every step I took, I can remember nothing about that night except what I saw with my wide-open eyes" (174). The leitmotif of the visual act, of

"what the first-person narrator saw" emphatically structures most of the following text, thus qualifying the nature of that act itself:

In the days that followed I saw men weep while working with the pickaxe, the spade, in the trucks. I saw them carry heavy rails, sacks of cement, slabs of concrete; I saw them carefully level the earth, dig dirt out of ditches, build barracks, watch-towers and crematoria. I saw them consumed by eczema, phlegmon, typhoid fever, and I saw them dying of hunger. And I saw others who amassed fortunes in diamonds, watches and gold and buried them safely in the ground. . . . And I have seen women who carried heavy logs, pushed carts and wheelbarrows and built dams across ponds. . . . And I also saw a girl (who had once been mine) covered with running sores and with her head shaven. (175)

This narrative act of recounting what he has seen is first legitimized by the narrator as a kind of moral obligation to those who died in the Holocaust. This is a recurrent *topos* in many Holocaust testimonies. It is also presented as a last act of relating—recounting as a way of establishing a relationship—that the dying requested, in their desperate attempt to stay related. For "every one of the people who, because of eczema, phlegmon or typhoid fever, or simply because they were too emaciated, were taken to the gas chamber, begged the orderlies loading them into the crematorium trucks to remember what they saw. And to tell the truth about mankind to those who do not know it" (175). But gradually it becomes clear that the narrator does not tell what he has seen out of moral obligation. He simply cannot do anything else. It is still the only thing he sees, long after, even though historically the Holocaust belongs to the past.

It is only at the end of the story that it becomes clear that the story is told from the position of having survived the Holocaust. "I sit in someone else's room, among books that are not mine, and, as I write about the sky, and the men and women I have seen, I am troubled by one persistent thought—that I have never been able to look also at myself" (176). This impossibility implies that the narrator is unable to pay attention not only to what happened to him in the camp but also not to his life in the present, after the Holocaust, either. The two incapacities are, of course, causally linked, but the subject caught in its web cannot perceive causality. He can only see again what he has seen before. The substance of narration is the visual equivalent of a broken record. The record got stuck and the same images repeat themselves.

The images from the past are more vivid and intense then what he sees in the present. The impossibility of reintegrating himself in the present of post-Holocaust life is demonstrated in the last story, "The World of Stone": "In contrast to years gone by, when I observed the world with wide-open, astonished eyes, and walked along every street alert, like a young man on a parapet, I can

now push through the liveliest crowd with total indifference and rub against hot female bodies without the slightest emotion" (178). And: "I climb unimpressed up the marble staircase, rescued from the fire and covered with a red carpet. . . . I pay no attention to the newly installed windows and the freshly painted walls of the restored building. I enter with a casual air the modest but cozy little rooms occupied by people of importance" (179). The impossibility of the narrator's seeing the world around him after he survived the Holocaust forces us to reconsider the indication of time in the story "A Visit." At first sight time indications like "that night I saw . . ." and "in the days that followed I saw . . ." seem to refer to specific moments during the life in the camp. But they now have become ambiguous. They can also refer to specific moments after the narrator survived from the camp, moments in which he did not see anything other than these visual imprints from the past, more intense and immediate than the impressions in the present.

The distinctions made by Pierre Janet among habit memory, narrative memory, and traumatic memory can be helpful in further assessing the role of visual imprints in Holocaust testimonies.[7] Janet, a French psychiatrist who worked at the beginning of this century and who influenced Sigmund Freud, defines habit memory as the automatic integration of new information without much conscious attention to what is happening. Humans share with animals the capacity for this kind of automatic synthesis. Narrative memory, a uniquely human capacity, consists of mental constructs, which people use to make sense out of experience. Current and familiar experiences are automatically assimilated or integrated into existing mental structures. But some events resist integration: "Frightening or novel experiences may not easily fit into existing cognitive schemes and either may be remembered with particular vividness or may totally resist integration" (Kolk and Hart 1995, 160). The memories of experiences that resist integration into existing meaning schemes are stored differently and are not available for retrieval under ordinary conditions. It is only for convenience's sake that Janet has called these unintegrable experiences "traumatic *memory*." In fact, trauma is fundamentally different from memory because "it becomes dissociated from conscious awareness and voluntary control" (160).

Trauma is failed experience, and this failure makes it impossible to remember the event voluntarily. This is why traumatic reenactments take the form of drama, not narrative. Drama just presents itself, or so it seems; narrative as a mode implies some sort of mastery by the narrator, or the focalisor. This is a fundamental difference that will be shown to define the role of vision in memories of the Holocaust. Because of their fundamentally dramatic nature, traumatic reenactments are dependent on the time frame of the "parts" scripted in the drama. In Bal's words: "All the manipulations performed by a narrator, who can

expand and reduce, summarize, highlight, underscore, or minimize elements of the story at will, are inaccessible to the 'actor' who is bound to enact a drama that, although at some point in the past it happened to her, is not hers to master" (1999b, ix).

Although from a formal perspective Borowski's stories are narrative, not drama, the narration is overruled by the compulsive need to relate the traumatic reenactments of visual imprints. Or to put it differently: Borowski's narration loses control over what the narrator has recorded in the past. The logical coherence produced by narration fades away and we get a random sequence of descriptions of visual imprints. Within his narration Borowksi demonstrates and enacts trauma.

Janet's clinical distinction between narrative and traumatic memory ultimately concerns a difference in distance from the situation or event. A narrative memory is retrospective; it takes place after the event. A traumatic memory—or better, reenactment—does not know that distance from the event. The person who experiences a traumatic reenactment is still inside the event, present at it. This explains why these traumatic reenactments impose themselves as visual imprints. The original traumatic event has not yet been transformed into a mediated, distanced account. It reimposes itself in its visual and sensory directness.

{ KINDS OF MEMORIES }

The writings of French Holocaust survivor Charlotte Delbo convey quite intensely this feeling that she is still inside the event that she relates.[8] In her stories she does not narrate "about" Auschwitz, but "from" it. It is first of all the visual directness of her narration that produces this effect. But from time to time she explicitly comments on the position from which she speaks. The words she gives to her character Mado also account for her own writing: "People believe memories grow vague, are erased by time, since nothing endures against the passage of time. That's the difference; time does not pass over me, over us. It doesn't undo it. I am not alive. I died in Auschwitz but no one knows it" (267). "That's the difference": difference, as absolute as that between traumatic "memory" and narrative memory in Janet's theory, defines the importance and specific function of vision in Holocaust memories. Delbo tersely indicates that traumatic reenactments imply a different ordering of time. The traumatic event, which happened in the past, does not belong to a distanced past: it is still present in the present. In language, this would be the difference between the preterit or simple past, a narrative form that represents a punctual event that once happened and is now gone, and the imperfect, a form indicating an event

whose effect continues in the present. In the rest of this chapter I will show how this ordering of time caused and implied by trauma brings with it a reliving of the traumatic event as intensely sensory and especially visual.

Delbo joined a resistance group in Paris. Her husband was also a member of that group. In March 1942 she and her husband were arrested by the French police in their apartment, where they were producing anti-German leaflets. The police turned them over to the Gestapo. Delbo's husband was executed in May. She herself was sent to Auschwitz in January 1943 at age thirty in a convoy of 230 French women, most of whom (like Delbo) were not Jewish but were involved in underground activities. Until January 1944 she stayed in Auschwitz and in the camp Raisko, not far from Auschwitz. Then she was sent to Ravensbruck. Near the end of the war she was released to the Red Cross, who moved her to Sweden to recover from malnutrition and ill health. Delbo has written many plays, essays, poems, and stories, all of them based on her camp experiences. Her most famous work is the trilogy *Auschwitz et après* (translated into English as *Auschwitz and After* [1996]). She wrote the first part of this trilogy, *None of Us Will Return,* as early as 1946, but published it only in 1965 (*Aucun de nous reviendra* [1970]). The second part, titled *Useless Knowledge* and also written immediately after the Liberation, appeared in 1970 (*Une connaissance inutile*), and the third part *The Measure of Our Days* (*Mesure de nos jours* [1971]) was published shortly after that.[9]

In her essays Delbo has made a distinction between "common memory" and "deep memory." This distinction is comparable to Janet's distinction between narrative memory and traumatic memory. Common memory is capable of situating Auschwitz within a chronological ordering. If a survivor can remember Auschwitz as integrated into a chronological ordering, the very act of survival has served as redemption from the terrible events. Auschwitz is now at a distance: it belongs to the past. "Deep memory," on the contrary, does not succeed in situating the events in the past, at a distance. Auschwitz still does not belong to the past in the experience of those survivors who remember in the mode of "deep memory."

Delbo makes another distinction that acknowledges yet another crucial aspect of trauma: the one between "external memory" and "sense memory." External memory is articulated in the distancing act of narration. The person who has external memories knows that he or she remembers. When Delbo narrates "about" Auschwitz her words do not stem from deep memory but from common, external memory. The emotional and physical memory of Auschwitz is, in contrast, only approached by means of sense (deep) memory. The memory is not narrated; rather, it makes itself felt. This kind of memory is symptomatic for

Auschwitz: it is not a mediated account but a leftover that makes its ongoing presence felt.

{ BEING INSIDE THE EVENT }

In her narrative texts Delbo again and again lets external memories of events from the past slip into sense memories, which convey the events as taking place in the present. The text "Roll Call" in *None of Us Will Return* is a good example of such a slippage. The text starts out as a description of a unique event belonging to the past: "SS in black capes have walked past. They made a count" (22). The narrated event seems to concern an event that is circumscribed in time: it is not an arbitrary roll call but a specific one. The two short sentences are, however, followed by a third one: "We are waiting still." The past tense has been exchanged for the present tense; the progressive form of this third sentence is the linguistic marker of this exchange. The event, which is punctual, and hence delimited in time, has been transformed into an event that is durative, that is, which is ongoing in time and cannot be situated within a chronology.[10]

After this sentence eleven paragraphs follow, each consisting of a few (usually one) short sentences.

We are waiting.
For days, the next day.
Since the day before, the following day.
Since the middle of the night, today
We wait.
Day is breaking.
We await the day because one must wait for something.
One does not live in expectation of death. One expects it.
We have no expectations.
We expect what happens. Night because it follows day. Day because it follows night.
We await the end of the roll call. (22)

The transition from past tense to present tense and from punctual to durative event brings with it a transition in kinds of memory. The text, which begins as a narration of a memory that can be situated in a chronological past, slips into the narration of a situation that continues into the present.

This slippage into the present is accompanied by a change in the position of the narrating subject. The narrator of this eternal waiting is still "inside" the vi-

sual and sensorial experience of waiting that she describes. In the most physical way, the sensorial experiences of this eternal waiting crawl upon the narrator and upon us, the readers. The memory of the infinity of waiting is not described "at a distance" but is brought about sensorially and visually.

A similar effect is solicited in the story "One Day," also in *None of Us Will Return*. It is again produced by a subtle shift in grammatical tense. The title evokes the conventional beginning of a chronologically ordered account. First we read three long paragraphs in the past tense. In these paragraphs the efforts of a totally exhausted woman to remain on her feet, that is, to stay alive, are described in great detail:

> She was clinging to the other side of the rope, her hands and feet grasping the snow-covered embankment. Her whole body was taut, her jaws tight, her neck with its dislocated cartilage straining, as were her muscles—what was left of them on her bones.
>
> Yet she strained in vain—the exertion of one pulling on an imaginary rope. (24)

The woman's struggle is focalized externally, from a distance. After some paragraphs, the description suddenly switches to the present tense: "She turns her head as if to measure the distance, looks upward. One can observe a growing bewilderment in her eyes, her hands, her convulsed face" (24).

As unexpected as this change in grammatical tense, another change takes place: external focalization is exchanged for character-bound focalization. The thoughts of the woman are directly quoted: "Why are all these women looking at me like this? Why are they here, lined up in close ranks, standing immobile? They look at me yet do not seem to see me. They cannot possibly see me, or they wouldn't stand there gaping. They'd help me climb up. Why don't you help me, you standing so close? Help me. Pull me up. Lean in my direction. Stretch out your hand. Oh, they don't make a move" (24–25). After this quotation of the woman's thoughts, the narration falls back into the past tense and the third person for a paragraph, and after that, a first-person narrator takes the place of the external narrator.

This time, however the first person is not the struggling woman but one of the crowd of witnessing women. These onlookers are like Joan B., unable to relate to what they see themselves, hence, unable to relate to the lone woman they are getting imprinted on their retina: "All of us were there, several thousand of us, standing in the snow since morning—this is what we call night. Since morning starts at three A.M. Dawn illuminated the snow that, until then, was the night's sole light—the cold grew bitter" (25). We read another page of the third-person narration of the dying woman. Then, the first-person narrator/witness returns: "I no longer look at her. I no longer wish to look. If only I could change my

place in order not to see her. Not to see the dark holes of these eye sockets, these staring holes. What does she want to do? Reach the electrified barbed-wire fence? Why does she stare at us? Isn't she pointing at me? Imploring me? I turn away to look elsewhere. Elsewhere" (26). Looking elsewhere first takes on a spatial meaning: she looks at another woman—a dancing female skeleton—in front of the gate of block 25. This object of the look is just a continuation of the sight of the dying woman she could not bear any longer. But then the "looking elsewhere" is transformed into a temporal displacement. The following sentence constitutes a paragraph in itself: "Presently I am writing this story in a café—it is turning into a story" (26). "Presently" (*maintenant*) marks a present, the moment at which the text is being narrated or written. The description of the woman's death struggle, however, also slips into the present: the past tense is again and again exchanged for the present tense. There seem to be two "presents," existing not after each other but next to each other.

The narrator's remark that her words are turning into a story seems to imply a negative judgment on her narration. When her words are forming a story the narrated events are situated at a distance, that is, in the past. Such a mode of narration does not do justice to her immediate and visual experience in the present of these events, which consists of nothing but witnessing.

The text that follows introduces an alternative mode of narration. With no indication of the changes, the narrative situation keeps transforming, even within a single paragraph. First-person narrators change in identity: the "I" who looks on and who witnesses transforms into an "I" who narrates a childhood experience; this "I" becomes the first person, who transforms into the dying woman:

She no longer looks at us. She is huddling in the snow. His backbone arched, Flac is going to die—the first creature I ever saw die. Mama, Flac is at the garden gate, all hunched up. He's trembling. André says he's going to die.

"I've got to get up on my feet to rise. I've got to walk. I've got to struggle still. Won't they help me? Why don't you help me all of you standing there with nothing to do."

Mama, come quick, Flac is going to die.

"I don't understand why they won't help me. They're dead, dead. They look alive because they're standing up, leaning one against the other. They're dead. As for me, I don't want to die." (27)

Voices and temporalities intermingle and seem to merge: it is almost impossible to distinguish them from one another, to become part of a single present. This merging seems to be the narrative alternative for the witnessing women who cannot bear to see what they are watching. Although they are not able to relate

to the dying woman (they are not in a position to do that), they absorb her into their self-experience. They and she become one.

When an SS man's dog finally kills the woman with a bite, a scream is heard: "And we do not stir, stuck in some kind of viscous substance which keeps us from making the slightest gesture—as in a dream. The woman lets out a cry. A wrenched-out scream. A single scream tearing through the immobility of the plain. We do not know if the scream has been uttered by her or by us, whether it issued from her punctured throat, or from ours. I feel the dog's fangs in my throat. I scream. I howl. Not a sound comes out of me. The silence of a dream" (28–29). The absolute distance that had until now defined the relation between the dying woman and the witnessing women has ultimately disappeared. The external memory in the past tense of a dying woman in the camp changes gradually into the sensorial experience of someone who is dying herself. The text we have read is by the end no longer the witnessing account of a specific event in the past. It has transformed into a direct experience in the flesh. When, in Auschwitz, the act of seeing has been fundamentally disrupted and, as a result, "to see" no longer implies relating to the object of the look—when seeing can still only mean witnessing—then a narrative solution is introduced to heal the insufferable condition of witnessing. Instead of seeing the other (focalizing her), the narrator becomes her by absorbing the woman's voice into hers.

The final paragraph of the story is a telling variation on the earlier reflection on the act of narrating this text. After a blank space, the following sentence ends the story: "And now I am sitting in a café, writing this text" (29). This writing no longer consists of producing a testimony of what has happened in the past. In a painstaking process, Delbo's writing transforms before our eyes into a performance that gives voice to the object of her look: to the woman who died in the camp while she just looked on. The present in which this writing takes place emphatically does not situate the represented events in relation to it. It is not continuous with it; it rather is a second present next to the present in which the text is being written. Since the end of the woman's death struggle is systematically written in the present tense, this other or second "present" has to be explicitly marked in order not to merge with it: "And *now* I am sitting in a café, writing this text."

{ TRAUMA AND AESTHETICS }

The title of the second part of Delbo's trilogy, *Useless Knowledge,* can be read as an outspoken statement to the effect that the visual and sensorial imprints left by life in the camps should not be confused with the substance of memory. The

story "The Stream" is an especially good example of this distinction. The Holocaust is ineffable, unnarratable because of the monotony of the days. There were barely any specific events. The text begins as follows:

Strange, but I don't recall anything about that day. Nothing but the stream. Since all the days were the same, a monotony interrupted only by heavy penalties and roll calls, since the days were the same, we certainly had roll call, and, following roll call, work columns were formed, I must have been careful to stay in the same column as my group, and later, after a long wait, the column must have marched through the gate where the SS in the sentry box counted the ranks passing through. And after? Did the column go right or left? Right to the marshes, or left toward the demolition work, or the silos? How long did we walk? I have no idea. What work did we do? Neither do I recall that. (147)

While the narrator tries to recall a particular day—to represent it to her mind—she only remembers those things that recurred day after day. Nothing came to interrupt the repetition of the same.

The lack of markings in time can be sensed in the sentence that goes on and on. Just as the days were no longer separate units of time, Delbo's sentences espouse that sameness and continuity. Both are but a stream as formless as the stream in the marshes near which they were forced to dig. Now and then a comma marks a slowdown, but there is no full stop to mark the end of the sentence.

The narrator remembers only the stream. The memory of that stream has cast out all other impressions. But there are certain things that she can reconstitute: among them, how many women of her convoy were still alive on a particular day. The day of which she remembers only the stream must have been in early April, for it was sixty-seven days after their arrival in the camp. That day there were still seventy women of the group living. In the stream that is life in the camp, the only marked—the only remarkable—fact is the presence of the other women with whom she was taken to Auschwitz.

But there is a second reason why life in the camp cannot be remembered in narratable moments. And, like the strong visuality we have seen at work so far, this reason belongs to the domain of the senses. The stench in the camp was unbearable. The constant stench of the crematorium, the stench of one's own body and that of others, so many smells numbed one's senses, so that none could be specifically smelled:

What amazes me, now that I think of it, is that the air was light, clear, but that one didn't smell anything. It must have been quite far from the crematoria. Or perhaps the wind was blowing in the opposite direction on that day. At any rate, we no longer smelled the odor

of the crematoria. Yes, and what also amazes me is that there wasn't the slightest smell of spring in the air. Yet there were buds, grass, water, and all this must have had a smell. No, no memory of any odor. It's true that I can't recall my own smell when I lifted my dress. Which proves that our nostrils were besmirched with our own stink and could no longer smell anything. (149–50)

After this testimony to the death of the sense of smell, the narrator describes in great detail the moment of that one day when the kapo allowed her to wash in the stream. Yet the text ends with the sentence: "It must have happened like this, but I have no memory of it. I only recall the stream" (153).

This contradiction does not mean that the narrator invented what happened that one spring day. It means only that this day is part of her "external memory" of Auschwitz. Her deep or sense memory only sees, feels, smells the monotonous stream. It is this stream that defines life in Auschwitz and the only possible memory of it. Washing in the stream, that one event that stands out, is, in this sense, the one moment in which she could wash herself of the stream.

The existence of two kinds of Holocaust literature confirms Janet's psychiatric distinction between narrative and traumatic memory, as it confirms Delbo's distinction between ordinary and deep memory and between external and sense memory. These two kinds of literature maintain a distinctive, defining relationship with visual images as either imprints or "relatable" images—capable of entering into a relationship as well as being narrated. Thus, we can conclude that visuality, the specific power of images, is definingly significant for the specific kind of memory that struggles to survive the Holocaust and remember it, yet transform the visual fixation that assaults into the active visual remembrance that works through.

Images confirm and further qualify a distinction made in an important article by Sidra DeKoven Ezrahi (1996). Ezrahi distinguishes two different ways of representing the Holocaust that reflect, in fact, two different aesthetics. Though I wish to differentiate these two kinds of literature in terms of their relationship to vision, they share a common point of departure, which is at the same time their point of arrival: Auschwitz is the ultimate point of reference. It is a spot or event with which imaginative representations correspond or fail to do so. Both writer and reader are constantly positioned in relation to this epicenter, this point of no return. But Auschwitz as epicenter of the earthquake that the Holocaust was in human history is both a literal and a metaphoric notion. Auschwitz, writes Ezrahi, has become the metaphor of the earthquake that destroyed not only people and buildings but also the "measure" through which destruction can be gauged (122).

This destruction of the ability to measure destruction results in Auschwitz's

fundamental ambiguity as a historical site and event as well as a symbol: forever caught in the ambiguity of its signifying force, Auschwitz can never be more than a symbol of what can no longer be symbolized. For we have lost the measure to decide of what Auschwitz is a symbol. In this sense, too, Auschwitz, and the Holocaust for which it synecdochically stands, cannot be represented. For the metaphorical principles of language have ceased to function. As a metaphor, |Auschwitz| is overdetermined: "it" is so rich in meaning that nothing can be metaphorically compared to it. At the same time, |Auschwitz| is underdetermined as a metaphor because it has no precise, measurable meaning. As an "empty" metaphor, it cannot illuminate new or unexpected aspects of human existence, as metaphors are called on to do.

Ezrahi then proceeds to distinguish between two possible attitudes toward this paradoxical status of Auschwitz—as reference point of a metaphor that is both over- and underdetermined. One can adopt either a static or a dynamic attitude. The static or absolute attitude places the subject in front of a historical reality that is unbending and from which we can never be liberated. The dynamic attitude approaches the representation of the memory of Auschwitz as a construction made up of strategies deployed in order to come to terms with this historical reality, over and over again (122). This dynamic attitude implies, for example, that the unbudging reality of this past can sometimes be made livable by the deployment of certain conventions to represent the past. Such softening cannot be acceptable within the absolute attitude. For when a softening or even a curing emerges within the memory or representation of Auschwitz, the threatened relativization of the ultimate evil that happened there threatens Auschwitz's status as the ultimate point of reference of that evil.

It is here that Delbo's use of visuality can be of help. As in the case of Janet's distinction between narrative and traumatic memory, the issue is the distance that can be achieved from Auschwitz. The absolute attitude maintains that any distance is ethically unacceptable—indeed, cognitively impossible. Auschwitz is a historical reality that continues in the present; in grammatical terms, it is the agent of a progressive form. The dynamic attitude is continuous with narrative memory, whereas the absolute attitude appears to be the consequence of traumatic memory. As it happens, Ezrahi cites Borowski's use of the present tense as an example. Borowski writes that "all of us walk around naked," implying that in post-Holocaust times we can only walk around naked. The ordering of temporality in his work is the temporality of trauma in which the past is like a second present, continuously determining the present.

According to Ezrahi, Primo Levi writes about his experiences in Auschwitz from a totally different position. His mission is to testify to the events that he experienced in the past. He communicates something that is over and belongs to

the past. Thanks to that it can be narrated by means of conventional modes. This is why Levi can write in such a clear and accessible style. He does not have to struggle with a past that persists in the present in which he writes. For him, Auschwitz is an event delimited in history.

It is important to emphasize that Ezrahi's claims about Borowski and Levi are not psychological conclusions about the feelings of these authors. Her conclusions concern the position in time from which they write in relation to the time they write about. They are conclusions about different kinds of narration. From this perspective she even goes so far as to make a distinction between Levi's suicide and those of Borowski and the poet Celan. According to her, Levi's suicide was not "caused" by Auschwitz because when he killed himself Auschwitz belonged for him to the past. It must have been something arbitrary that made him do it. The suicides of Borowski and Celan, however, were direct consequences of Auschwitz. Although they survived, they still lived "inside" the Holocaust after their survival. Until their suicides, they remained "forever trapped within the electrified barbed wire" (125).

Ezrahi's analysis can help us understand the specific role of visuality. For it helps to characterize Delbo's writings as analyses of visuality as memory sense. Delbo's writings are exemplary for the aesthetic that Ezrahi has called "the static attitude towards the events." This attitude makes itself felt by the extreme visuality of the Holocaust past: it is so visual and direct that this past is experienced as present. Her character Mado's descriptions of her memories of the other inmates in the camp in *The Measure of Our Days* do not show any distance in time. She sees the other inmates and joins them. "I'm not alive. I'm imprisoned in memories and repetitions. I sleep badly but insomnia does not weigh on me. At night I have the right not to be alive. I have the right not to pretend. I join the others then. I am among them, one of them. Like me they're dumb and destitute. I don't believe in life after death, I don't believe they exist in a beyond where I join them at night. No. I see them again in their agony, as they were before dying, as they remained with me" (261). In this passage, Delbo emphatically distances herself from the idea that her visions are dreams or hallucinations of a life beyond. Her visions are her memories. They are just as visual as dreams are.

But here, a tragic irony appears. Past and present change places. Whereas memories of the past appear to her as radically visual, her sensorial awareness of life after Auschwitz is veiled. There is something in between the present and her access to it. She cannot really, clearly, see that present.

Sight is, in fact, what distinguishes two radically different types of beings—those who have not, from those who have, worked through history. The difference is attached to vision. She describes her and her husband's different conditions of being in the present as two different kinds of sight. "For him, I'm there,

active, orderly, present. He's wrong. I'm lying to him. I'm not present. Had he been deported too it would have been easier, I think. He'd see the veil over the pupils of my eyes. Would we then have talked together like two sightless people, each possessing the inner knowledge of the other?" (267). Whereas her sight of the past is bright, her sight of the present is veiled. Life in the present is literally overshadowed by the persistence of the visual and sensorial directness of when the Holocaust events happened to her in the past. Thus, the most crucial perversion the Holocaust wrought consists of blinding and sharpening sight but in inverse proportion to what makes life livable. Past horror occupies the eye, blinding it to a present that can therefore not redeem, not erase, and not facilitate forgetting.

In the tradition of Western science and art, visuality has been the domain of both truth—in a positivist epistemology of observation—and imagination—as in visual art that "presents before our eyes" what is to be seen as possessing meaning, beauty, or tragedy. This is paradoxical. The paradox is reinforced when we realize that a third domain invoked through thinking about vision is that of affect, both in sentimental and in—to cite an example that seems utterly out of place here—pornographic terms. With Delbo's probing of a vision that does not see as an image of a memory that cannot relate, a past vision whose present makes the present invisible, we understand the different possibilities of vision better. If we wish to understand the modalities of memorializing the Holocaust, as we must if we wish to prevent the past from recurring by its hallucinatory power over us, we must distinguish between different kinds of vision, different kinds of looking. It may be perverse, but then it may be for that reason only too appropriate, to invoke verbal memories written down by those who were there, to understand how it is that art, today, can work over, elaborate, work through, and keep in visual touch with a past that no image can represent.

9 Playing the Holocaust

{ PLAYACTING AND TOYS }

In an interview from 1994, French artist Christian Boltanski declares that all of his work is "more or less about the Holocaust" (Bradley, Esche, and White 1994, 13). This remark is not particularly revealing for the work that he has been making since 1984. His installations—generically titled *Shadows, Candles, Monuments, Canada,* and *Reserve*—evoke the Holocaust compellingly. But the statement is not as obvious when applied to his earlier work. Just how do *Model Images* (1975) or *Comic Sketches* (1974) relate to the Holocaust?

Model Images shows ordinary snapshots from the seventies, ones that are common in photo albums of almost anyone who lived then in Western Europe, Canada, or the United States. Their normality is the opposite of the apocalyptic horror of the Holocaust. The theme of the Holocaust is also hard to notice in the series of staged photographs titled *Comic Sketches.* In these works Boltanski himself humorously playacts scenes from an ordinary childhood.

In "The Shameful Kiss," for instance, he plays a young boy who meets a young girl at the beach. He wants to kiss her, but he is too shy. In "The First Communion," we see Boltanski playing a young boy who receives a host from a priest. In "The Doctor's Visit," we see him as a young boy who is ill. His mother is worried and calls for the doctor, who comes and says that although the little one is very ill, it is not serious. This is a great relief to the mother.[1] In short, the *Comic Sketches* show scenes that can be recognized by practically everyone. They are the most ordinary and archetypal childhood scenes imaginable (fig. 64).

There is, however, a remarkable difference between *Model Images* and *Comic Sketches.* In *Model Images,* Boltanski used found snapshots. Moreover, the images we see are "serious," not comic. The scenes in *Comic Sketches,* in contrast, are

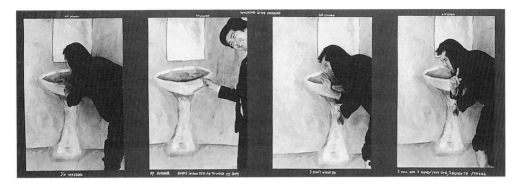

64 | Christian Boltanski, "Washing in the Morning" from the *Comic Sketches,* watercolor and crayon on black-and-white photograph, 39 3/4 x 30 inches Courtesy of Marian Goodman and the artist, Marianne Goodman Gallery, New York.

playacted. Importantly, all the roles are played by Boltanski wearing the same dark suit. By adding something simple to this outfit he can become another character—with glasses, a doctor; with a hat and flower, a mother. This minimalist play of different characters, together with the facial expressions, make the scenes comical.

It is this aspect of play that interests me. In *Comic Sketches* Boltanski, the child of a Jewish father who survived the Holocaust through hiding, foreshadows a younger generation of artists whose work deals with the Holocaust "playfully." These artists are second- or third-generation descendants of survivors or bystanders, and they use play or toys to represent the Holocaust or Nazi Germany.

I would like to single out three of theses artists. The first is American artist David Levinthal, who photographed scenes from Auschwitz in his *Mein Kampf* series (1994–96; fig. 65), staged by means of little dolls or figurines. The figurines remind us of the little tin soldiers, for decades a popular toy for young boys and a collectors' item for adult men. In a work that he made with Gary Trudeau titled *Hitler Moves East* (1977), Levinthal represented, in the same way, Operation Barbarossa, Hitler's invasion of the Soviet Union in 1941. The second of these artists is Israeli/Dutch artist Ram Katzir, who made a series of installations in which the audience was invited to color the images in a coloring book or to make additions to it (fig. 66). The images in the coloring book were based on Nazi photographs or documentary Holocaust images. The third, Polish artist Zbigniew Libera, made *LEGO Concentration Camp Set* (fig. 67). This set consists of seven boxes of different sizes from which a miniature concentration camp can be built.

65

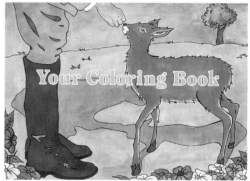

66

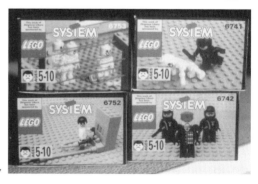

67

65 | David Levinthal, *Untitled* no.13, from the *Mein Kampf* series (1994–96), color photograph. Courtesy of David Levinthal Studios. Photograph by Jason Burch, David Levinthal Studio, New York.

66 | Ram Katzir, cover image from *Your Coloring Book* (1996). Courtesy of the artist.

67 | Zbigniew Libera, *LEGO Concentration Camp Set* (1996), seven cardboard boxes, edition of three (detail).

These artists represent a group whose work is in a particular genre with a specific epistemic-artistic thrust. Their artworks raise the following question: What is the function of play in Holocaust representation? Since Holocaust art centers on the question of remembrance, I rephrase this question more provocatively: Is there a place for "playing" the Holocaust in Holocaust remembrance? The issue of generation is important. For it is striking that until these artists came along, representing the Holocaust playfully had been taboo. Now it seems that a new generation of artists can relate to the Holocaust only in the mode of play. Why is it that the toy as memory can occur now? In other words, what does it mean and how can we evaluate this phenomenon in terms of remembrance?

I broach this issue through the question of Boltanski's playful *Comic Sketches.* Taking seriously the artist's statement that "all my work is more or less about the Holocaust," I am interested in speculating in what way these pictures relate to the Holocaust. Again, the exaggerated poses of his characters and the rather silly events they enact evoke collective, ordinary notions of childhood and parenthood. They represent neither the specificity of Boltanski's autobiographical childhood nor the situation of children in the Holocaust. I contend that their generic and ordinary plots are precisely the point.

Their point is replacement. By their normality, these comic sketches actively and playfully replace the abnormality we expect from "Holocaust Sketches" with sketches of ordinary childhood and parenthood. In an interview with Paul Bradley, Charles Esche, and Nicole White, Boltanski says the following about his work:

CB: When I am doing art, I am a liar and I am mostly an awful professional artist, disgusting, it is my job . . . it is true that I really wanted to forget my childhood. I have spoken a lot about a childhood, but it was not my childhood. It was a normal childhood. I never spoke about something that was true, and in my art at the beginning it seemed biographical but nothing was true, and I was never speaking about the fact that I was Jewish or that it was impossible for my mother to move because she had polio. I never spoke about that and I never spoke about my weird grandmother. When I spoke about my childhood, it was this normal childhood and when I decided to make a photo album, I chose the photo album of my friend called Durrant because Durrant is just Smith in England, Durrant is nobody, just a normal French man.

NW: Is this a way to re-create a better childhood?

CB: To erase and forget my own childhood. You know it was so tough, it was so awful, I mean all our parents are awful, but my father was so awful, my mother was so awful.

NW: But it is not just to forget, but to make something better.

CB: Yes, just normal. (Bradley, Esche, and White 1994)

In this interview Boltanski again refuses to say anything specific about his child-hood, only that his father was awful and his mother was awful. That's it. In doing so, he suggests that all parents are awful, your own always a bit worse than others. What he makes clear is that, for him, art is a mode of telling lies. Art, autobiographical or not, does not represent reality. Instead, it is a mode of transforming an insufferable reality into something normal—something sufferable. In this conception, art is not mimetic but, instead, performative. This makes it easier to understand how the *Comic Sketches* are works of art "about the Holocaust." In post-Holocaust culture they act on an intense desire for normality.

Boltanski's remarks also clarify that within his oeuvre the *Comic Sketches* are not at all unique. They are not divergent because of their playfulness. On the contrary, they are emblematic of all of his work, including the work he made in the late eighties and nineties. In another interview he explains how this is possible: "At the time of the *Saynetes Comiques* [Comic Sketches] I was asking myself questions about the nature of representation and the double meaning of the verb 'to play.' . . . In a small book of 1974, *Quelques interprétations par Christian Boltanski* I ask myself what differentiates the act of someone who drinks a glass of water and an actor's interpretation of someone drinking a glass of water. I realized that art consisted of making something with the intention of demonstrating the reality of these two situations."[2] The *Comic Sketches* emphasize an aspect of art that, for Boltanski, defines art as such. Art is "play" and "play" is its reality. The reality of play is fundamentally different from the reality to which art mimetically refers. This early work, then, has an artistic manifesto inscribed in its silly childishness.

In Boltanski's work, the notion of art as play has never been controversial. When this aspect of art becomes its theme, as happens in the *Comic Sketches,* the reference to the Holocaust is invisible or at most implicit. But that thematic restraint differs with a younger generation of artists that includes Levinthal, Katzir, and Libera. These artists enact the Holocaust playfully, with emphatic explicitness, using toys. Rightly or wrongly, toys stand for the lightheartedness of children, for the opposite of serious adult behavior. In this respect, we cannot ignore the "serious" dark suit that Boltanski wears beneath his children's attributes. In the context of modern art, toys are often considered bizarre or of marginal interest, but in the context of Holocaust representation they are provocative, even scandalous.

The work of Katzir and Libera has led to great controversies, especially because of the places where the art has been shown. When Katzir showed his installation *Your Coloring Book* in 1997 at the Israel Museum in Jerusalem, questions were even asked in the Knesset about how the installation might shock and hurt. Some people urged that it be closed down.[3] And when Libera showed and

discussed his work in 1997 in Brussels at a conference on contemporary art and the Holocaust, organized by the Fondation Auschwitz, many were scandalized. Holocaust survivors in the audience became so emotional that they had to leave the room. Throughout the conference, people could not stop discussing the controversial nature of Libera's work.[4]

It seems safe to assume that artworks on the theme of the Holocaust using toys are controversial by definition because of the special function automatically attributed to Holocaust art. Unlike other art that can claim autonomy or self-reflexivity, Holocaust art tends to be unreflectively reduced to how it can promote Holocaust education and Holocaust remembrance. Art, teaching, and remembrance are thus collapsed without any sustained debate about the bond between these three cultural activities. In the context of Holocaust education and remembrance, it is an unassailable axiom that historical genres and discourses, such as the documentary, the memoir, testimony, or the monument, are much more effective and morally responsible in teaching the historical events than are imaginative discourses.[5] Accordingly, art in general is already problematic in and of itself because it is imaginative, not documentary.

This objection to artistic engagement with the Holocaust holds much more strongly for toy art. Obviously, if art is not "serious" enough in terms of historical reconstruction, it is clear that within the realm of the imaginative, toys represent the lowest and least respected activity. For they can be seen as doubly imaginative—as things to play with and to play out some scenario, as toys and as art. Documentary Holocaust novels are also problematic, as the controversies around Jerzy Kosinski's *The Painted Bird,* D. M. Thomas's *The White Hotel,* or Helen Darville's *The Hand That Signed the Paper* have shown. But at least such novels can teach something about the past, even though they are fiction. That is why the hybrid genre of the historical novel has gained respect and popularity.

Other hybrid genres are not so lucky. Roberto Benigni's film *Life Is Beautiful* (1998), mixing the discourse of the Holocaust with that of fairy tales, caused great controversy; it was not historically engaged enough. The cardboard sets mocked realism; the script, the acting, and the filming itself emphasized that the mode of the film was a dramatic, slightly kitschy fairytale. Ignoring the cinematic genre that the film itself flaunted, it was judged on the basis of its truthfulness, a test it could only fail and emphatically sought to fail. Hence, the play the father engaged in with his child to save him from the horror around him was not appreciated as pedagogically interesting, as a refusal to subject the child to events his childhood entitled him to stay clear of but was, instead, rejected as unrealistic.

Sander Gilman, for instance, dismissed Benigni's film on such realist grounds: "Not purposeful action by adults but the accident of change allows chil-

dren to survive, and this underpins the falsity of Roberto Benigni's *claim.* . . . Benigni's *promise* is that there are no accidents, that at the end of the comedy the gods in the machine will arrive to resolve the action and rescue those in danger" (2000, 304; my emphasis). I have emphasized words in the preceding that demonstrate Gilman's unreflected attribution of a realistic intention (claim) as well as a childish attitude of expectation (promise). No other art would be subjected to such inappropriate criticism. As much as Benigni's film is already misread, this kind of reading is even more absurd for toy art. For one of the remarkable features of toy art is that it cannot be compared to such representational genres as novels and films or other narrative material used for education. Toys do not tell. But how do they teach? Do they teach at all, or do they do something else?

{ TEACHING AS A CULTURAL ACTIVITY }

In order to understand if and how toys teach, and what they teach if they do, it is necessary to reflect on teaching as a cultural activity, especially the role that teaching plays in Holocaust remembrance. As Shoshana Felman has argued, "Western pedagogy can be said to culminate in Hegel's philosophical didacticism: the Hegelian concept of 'Absolute knowledge' . . . is in effect what pedagogy has always aimed as its ideal: the exhaustion–through methodical investigation–of all there is to know; the absolute completion–termination–of apprenticeship. Complete and totally appropriated knowledge will become–in all senses of the word–a *mastery*" (1982, 28). Learning, according to this traditional conception, is linear, cumulative, and progressive and leads to mastery of the subject studied. Mastery over the Holocaust is, indeed, one of the main motivations behind Holocaust education. In order to prevent something like the Holocaust from happening again, later generations have to have as much knowledge as possible about the Holocaust. It is through knowledge that one can "master" the Holocaust. This conception of teaching assumes a collapse of two forms of mastery: to know and to dominate. If the past is known, the future can be dominated, kept under control.

But it is precisely that conception of learning as pursuing mastery over the object of study that seems to fail in the face of the Holocaust. Ram Katzir, for instance, noticed the overfamiliarity with Nazi and anti-Nazi propaganda in the Israeli schools he attended. Even the most shocking images have been robbed of the power to move or to create serious attention by being turned into just another school subject (40). In response to that education, he felt the need to revitalize Nazi photographs by using them as models for a coloring book. Boredom, not mastery, seems to be the result of the Holocaust education Katzir received.

Holocaust teaching and remembrance in Poland had a similar effect on Zbigniew Libera. At the conference on contemporary art and the Holocaust organized by the Fondation Auschwitz in Brussels, he defended his art as follows: "Of course, I was born fifteen years after the war and sometimes people call my art 'toxic' and actually it is toxic. But why? Because I am poisoned, I am poisoned of it. And that's all" (Aron et al. 1998, 225). Poisoning, like boredom, is the opposite of mastery, for it weakens a person. As a result, the weakened subject can no longer master himself or herself. Thus the subject becomes unfit to master what is being studied. But as Plato and, later, Jacques Derrida (1981) show, as they borrow a metaphor from medicine, poison can also heal by homeopathy.

I completely sympathize with this negative assessment of Holocaust education. Elsewhere I have written about the effect that Holocaust education in the Netherlands has had on me (1997). As someone born in the Netherlands in 1958, who attended primary and high school in the 1960s and early 1970s in the same country, I had the memory of World War II and the Holocaust drummed into my mind. Or rather, the Dutch school system tried to do so. But these efforts failed to have the required effect. I was bored to death by all the stories and images of that war, which were held out to me "officially" as moral warnings. At school we were shown documentaries of the war. Our teachers encouraged us to read books that informed us in great detail of what had happened not so very long ago. But I avoided my society's official war narratives. Until quite recently, for instance, I had refused to read Anne Frank's *Diary of a Young Girl.*

The kind of Holocaust teaching that Katzir, Libera, and I have been exposed to fails because of two misconceptions. The first concerns the goal of teaching. That goal cannot be reduced exclusively to the mastery of a subject. Moreover, mastery as knowledge does not entail mastery as control. The second misconception concerns the nature of the Holocaust. The Holocaust is not just a history of memory that can be mastered by memorizing it. If that is impossible, the Holocaust cannot be taught along traditional pedagogical lines. For as we know, the traditional conception of learning implies first remembering and memorizing. The Holocaust, in contrast, is first and foremost a history of trauma, that is, a history of nonmastery. Teaching a history of trauma means teaching knowledge that is not in mastery of itself. Felman's assessment of literary knowledge and its implications for teaching this knowledge seems also a precise assessment of Holocaust teaching. This teaching "*knows it knows, but does not know the meaning of its knowledge—does not know what* it knows" (1982, 41). In other words, Holocaust teaching confronts us with the problem of how to master by means of teaching a past that has not been mastered yet and cannot be mastered.

Felman analyzes the dominant conception of teaching within a framework that asks whether psychoanalysis has renewed the questions and the practice of

teaching. Unlike traditional methods and assumptions of education, she sees psychoanalysis as a radically new pedagogy. But in light of the traumatic, hence, nonmasterable nature of the Holocaust, her remarks on psychoanalysis as a mode of teaching can also provide a model for Holocaust teaching. It can provide a model, that is, for teaching knowledge that is not in possession of itself: "Psychoanalysis is thus a pedagogical experience: as a process which gives access to new knowledge hitherto denied to consciousness, it affords what might be called a lesson in cognition (and in miscognition), an epistemological instruction" (1982, 27).The mode of learning practiced by psychoanalysis is radically different from the view that learning is a simple one-way road from ignorance to knowledge. It proceeds not through linear progression but through "breakthroughs, leaps, discontinuities, regressions, and deferred action" (27). This teaching has nothing in common with the transmission of readymade knowledge. It is, rather, the creation of a new condition of knowledge—the creation of an original learning disposition (31).

This disposition is "new" in the ways it handles and structures repression. And, as those familiar with the psychology of child rearing know, repression is one of the most important strategies of traditional pedagogy. Freud understood how an excessive practice of such repressive pedagogy breeds mental illness. He wrote:

The child must learn to control his instincts. It is impossible to give him liberty to carry out all his impulses without restriction. . . . Accordingly, *education must inhibit, forbid and suppress* and this is abundantly seen in all periods of history. But we have learnt from analysis that precisely this suppression of instincts involves the risk of neurotic illness. . . . That education has to find its way between the Scylla of non-interference and the Charybdis of frustration. . . . An optimum must be discovered which will enable education to achieve the most and damage the least. . . . A moment's reflection tells us that hitherto education has fulfilled its task very badly and has done children great damage.[6]

Freud's definition of overrepressive education, as structured by prohibitions and suppression, seems to have become also the explicit guideline or epigraph for Holocaust education. In the education of the Holocaust, prohibitions usually take the form of their binary opposite: They are articulated as orders or commands. Those orders together constitute a Holocaust "etiquette," according to Sander Gilman (2000, 282). But his own indignation in the face of a film like Benigni's that disobeys the "etiquette" demonstrates that the rules also entail prohibitions.

The moral imperative of the prescriptions for "respectable" Holocaust education and studies is more than explicit in the formulations of Terrence Des Pres.

Appropriating, in a nice case of interdiscursive heterogeneity, the voice of God in his use of the "genre" of the Commandments, he dictates:

The Holocaust shall be represented, in its totality, as a unique event, as a special case and kingdom of its own, above or below or apart from history.

Representations of the Holocaust shall be as accurate and faithful as possible to the facts and conditions of the event, without change or manipulation for any reason—artistic reasons included.

The Holocaust shall be approached as a solemn or even sacred event, with a seriousness admitting no response that might obscure its enormity or dishonor its dead. (1988, 217)

No wonder that later generations get a bit restless under such weight. The Holocaust art using toys may be a deliberate violation of these commandments and their complementary prohibitions.

First of all, Levinthal, Libera, and Katzir represent the Holocaust not as unique but as a historical object that can be toyed with, one that is exchangeable with, let's say, the Wild West, knights and medieval castles, pirates and pirate ships. Second, accuracy and faithful representation do not appear to have a high priority in their artworks. That lack of representational truthfulness does not imply that these toy artworks can be taken to task for being the product of Holocaust denial. They are not untrue. In logical terms they are neither true nor false, for they are not propositional statements. But something other than accuracy or historical truth is at stake. Third, the works actively seem to ignore the seriousness related to the Holocaust as a "solemn or sacred event." Instead, these artworks make us imagine (and feel) the pleasure certain toys can provide. The toys imply pleasurable activities: identification and impersonation or playacting. They run against the grain of traditional teaching. But then, is this art at fault, or is such teaching?

{ IDENTIFYING WITH THE PERPETRATOR }

To further probe the relationship between toy art and pedagogy, a tension must be acknowledged between representation of documentation, on the one hand, and identification, on the other. Representation traditionally uses strategies that promote identification, but the relation is not reversible. Identification can be brought about outside the realm of representation. In the case of the artworks under discussion, indeed, identification is solicited while representation

is at best mocked, or otherwise discarded. The issue of identification is ticklish in a double respect. First, identification predominates in the mode of looking that is stimulated by the works, at the expense of representation. Second, the target of identification has shifted in a drastic and rather shocking way, from that of the victim to that of the perpetrator. These two aspects of identification—its centrality and predominance over representation and its shifted target—are inextricably bound together. They change Holocaust remembrance, art's role in it, and identification itself.

Presenting these artworks as toys (Libera, Katzir) or as images of toys (Levinthal) stimulates the viewer to envision herself or himself in a situation comparable to the "real" situation. Identification replaces mastery. The toys (or images thereof) function as a means to facilitate envisioning oneself in the historical situation. So, the distance from the past required for mastery, which in Holocaust representation is so tenaciously guarded in the preference for historical genres and solemn tones—even, as we have seen, religiously so, speaking in a divine voice—is not respected but provocatively challenged.

But the use of identification as pedagogical tool is not problematic, or ticklish, as such. Recently, it has been applied in several Holocaust museums in order to make visitors imagine what it meant to be victimized. For instance, in the Holocaust Museum in Washington, D.C., the itinerary leads visitors through a cattle car. The experience of being transported to the camps by cattle cars is not being told about or shown at a distance but is thrust on the visitors. Inside a cattle car, identifying with those who were transported to the camps by those cars is almost unavoidable. In that museum, the kind of identification that is allowed, and even stimulated, is identification with the victims, not with the victimizers. But of course, in the context of an outing to a museum, such identification is not real, not total, but partial. Getting a small and short taste of the experience, a tiny bit of the poison, is the goal.

What if the intended object of identification is, instead, the victimizers? The toy artworks under discussion facilitate identification not with the victims but with the perpetrators. This is, of course, much more difficult to do as well as to justify. How do the toy artworks accomplish this, and how can it be argued that this is helpful for the cultural remembrance of the Holocaust? In other words, how can this unsettling kind of identification be an effective form of pedagogy? One way to achieve this identification with an undesirable position is through making, shaping, forming the perpetrators. The visitors of Katzir's installations were invited to color in images based on Nazi photography (fig. 68). We, as visitors, are coloring Nazi leaders or members of the Nazi youth: we are giving them color, form. and substance, and in that process we "generate" them. This making of the Nazis is a convoluted yet real form of identification. In creating the per-

68 | Ram Katzir, image from *Your Coloring Book* (1996). Courtesy of the artist.

petrators, we as visitors become somewhat complicitous in the possibility of the Nazis—though not, of course, with actual Nazis.

Libera deploys a different technique to make visitors get a small taste of identification with the perpetrators. His *LEGO Concentration Camp Set* stimulates visitors of the museum or the gallery to envision the possibility of building your own concentration camp. Again viewers are put in the shoes of the victimizers, not of the victims. Here the identification concerns the acts perpetrated, conceiving of and constructing the physical tools of the Holocaust (fig. 69).

Levinthal's photographs are at first sight more ambiguous. His scenes of "playing the Holocaust" seem to facilitate identification with victims as well as with perpetrators. But the moment we start to take the title of these photographs into consideration (*Mein Kampf*) the ambiguity evaporates, and we end up with an enforced identification with Hitler, the author of *Mein Kampf*. We each have our own *Kampf,* our own ambitions that can be catastrophic. Here the identification triggers the ideological mindset out of which the historical disaster sprang (fig. 70).

This feature of the toy art calls for extending the genre or linking it to a neighboring genre. Based on the artistic strategy of soliciting identification with the perpetrator, I claim a generic grouping on a much larger scale. Other art be-

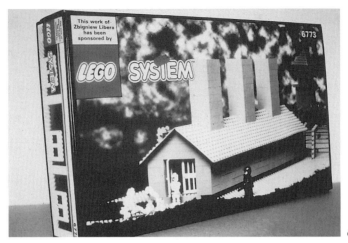

69 | Zbigniew Libera, *LEGO Concentration Camp Set* (1996), cardboard boxes (detail).

70 | David Levinthal, *Untitled* no. 16, from the *Mein Kampf* series (1994–96), color photograph. Courtesy of David Levinthal Studios. Photograph by Jason Burch, David Levinthal Studio, New York.

comes understandable under the aegis of toy art. For example, the Israeli artist Roee Rosen's installation *Live and Die as Eva Braun* (1995) activates this mode of looking without the framework of toys and children and their emphatic relation to pedagogy. His installation consists of brief texts, printed in white letters on black column-like strips that run from floor to ceiling. Between the text columns hang black-and-white acrylic paintings on paper, sixty in total (fig. 71). The texts are written in second person. This is a powerful semiotic mode to entice the addressee to respond to and hence endorse a position. This "message," although emanating from the first-person voice doing the addressing, may so strongly engage the second person—for example, for the first person to completely identify with the second—that endorsing the position put forward becomes hard to resist.[7]

This is the powerful rhetoric that Rosen deploys for the visitor to achieve identification—again, just a bit of it—with Eva Braun. The texts address the viewer. But they also address the historical figure Eva Braun, inviting the visitor to "become" Hitler's mistress, Eva Braun:

Excitement jolts through your body when you hear the steps outside. When he opens the door you gasp at the sight of his small mustache. Because you are not only Eva it seems menacing, almost monstrous. But everything around the mustache is so congenial. He comes towards you with such warmth, his smile tired, his arms open to embrace you. Remember—you are Eva. When Hitler closes his arms around you, the view darkens and you are almost overwhelmed with titillation when you feel the whiskers of that famous little facial tuft tickle your ear and the back of your neck.

71 | Roee Rosen, *Live and Die as Eva Braun*, no. 34 (1995), acrylic on rag paper, 26 × 22 $^1/_8$ inches. Courtesy of the artist.

Unlikely as it seems, this text so insists on humane qualities—warmth, a tired smile—that identification on the part of "you," the second person, with the addressee of the text becomes quite plausible.

It should be noted that the identification programmed by this text is not blind. The viewer is Eva Braun and she or he is not: "Because you are not only Eva it seems menacing." What is menacing is precisely the schizophrenic identification with someone you really don't want to be. The threat of collapse of two incompatible positions that nevertheless coincide is unsettling. Like the identification with the victims triggered by the installations and rides in the Holocaust museum, the identification is just a small taste of the actual experience. But unlike the cattle car, Rosen's work makes this restriction explicit. Moreover, focusing on Hitler's little moustache opens the story up to a rather heavy-handed irony. These two devices for partitioning off a small, bearable measure of identification is Rosen's way of being a responsible educator. Nevertheless, identification and distance are being exchanged. This rhythm of alternation facilitates reflection on the experience of identifying with Eva Braun.

The texts follow a linear narrative. First, along with Eva Braun, the viewer experiences moments of romantic intimacy and sexual pleasure, then he or she is invited to coexperience Eva's suicide. The end of the story consists of a short trip to hell:

There's no question, you are being led to hell—but why?

As you wait for your tortures to be set, you view some of the other sinners. Particularly arresting is a group of two-dimensional people hanged by their sinning organs—hair, genitalia, breasts, tongues.

You realize with some dismay that hell seems to be based on a famous painting.

How would you be hanged? What of you should be minced, sliced, burnt? What, in your eager perfection, in your life dedicated to willful servitude, in your quiet harmony, is eternally punishable and damned?

All the events the viewer is asked to experience are totally set in the realm of affect and the physical: eroticism, sexual pleasure, suicide, and torture (fig. 72). This is precisely the point.

An artwork based on the Holocaust like Rosen's cannot be dealt with simply in the framework of art and aestheticism; it inevitably activates the debate on Holocaust education and remembrance. This makes the cultural clichés acutely problematic. For it can be argued that, regardless of that context, the texts are here and there straightforwardly obscene. This obscenity produces a clash, again, a challenge to the solemnity of Holocaust education.

72 | Roee Rosen, *Live and Die as Eva Braun,* no. 2 (1995), acrylic on rag paper, 26 x 22 1/8 inches. Courtesy of the artist.

As Roger Rothman has pointed out, however, it is not in the context of art but in the context of Holocaust remembrance that Rosen's *Live and Die as Eva Braun* is "obscene":

For we are *taught* how to mourn, just as we are taught how to paint. There is nothing "real" or "natural" about it. The language of our mourning is not our own, it is given to us. This is perhaps the most repugnant of all the implications of *Live and Die.* Our Mourning is clichéd. It is not real. It is virtual. It is a game. A game we know how to play well by now. We are good at it and we know it. And we teach it to others so they will be good at it, too. This is the "obscene" aspect of Rosen's work. But it is also the obscene aspect of Holocaust mourning, an aspect all-too-often ignored or suppressed in mainstream memorials. (1997, n.p.)

Instead of rejecting the work for its obscenity, then, Rothman embraces that obscenity because of its relevance for Holocaust remembrance and mourning. Here, because of its mock dramatic style, but even more because of its second-person address that comes close to dramatic form, I consider Rosen's installation together with the artworks by Levinthal, Katzir, and Libera within the framework of Holocaust remembrance through play. In this context, we are bet-

ter off not jumping to conclusions. It is not necessary to conclude that in their provocative refusal of the "commandments" of Holocaust education and representation, these artworks imply a wholesale refusal of the relation between art and education or art and remembrance. And Rosen's work, obscenity and all, is an instructive counterexample.

Rosen's insistence on the resonance between memory and painting retains a bond in the act that severs it. The bond with representations that are both imaginative and culturally commonplace, as well as recalled from the past—medieval paintings of Hell, for example—is simultaneously evoked, activated, and severed, indicted for its loss of adequacy. For, following Freud and Felman, we can say that the artists install a new condition of knowledge that enables a production of knowledge that is first of all affective instead of cognitive. It is precisely this affective quality that is crucial in these Holocaust artworks. These artists need the concept of play and toys (or, in the case of Rosen, the reiteration of cultural commonplaces such as sexuality, suicide, and torture) to replace cognition by affect on the agenda of Holocaust remembrance and its pedagogy.

Rosen's are ambiguous texts in terms of identification; they both entice and relativize identification with the evil side of the Holocaust. Unlike the identification provided by the Holocaust museum, but equally partial, this work and the toy works solicit a form of identification that is not only different in target but qualitatively different. As Kaja Silverman has argued, identification takes one of two forms (1996). One form involves taking the other into the self on the basis of a (projected) likeness, so that the other "becomes" or "becomes like" the self. Features that are similar are enhanced in the process; features that remain irreducibly other are cast aside or ignored. Silverman calls this idiopathic identification. The other form is heteropathic. Here, the self doing the identification takes the risk of—temporarily and partially—"becoming" (like) the other. This is both exciting and risky, enriching and dangerous, but at any rate, affectively powerful.

In the case at hand, it can be argued that identification with the victims, although useful in realizing their horror, is also a way of reassuring visitors, perhaps unduly, of their fundamental innocence. To put the case strongly, this reassurance is unwarranted and unhelpful in achieving the ultimate goal of Holocaust education: preventing history from repeating itself. Victimhood cannot control the future. In contrast, soliciting partial and temporary identification with the perpetrators makes one aware of the ease with which one can slide into a measure of complicity. To raise the possibility of such identification with the fundamental, cultural other is appealing to heteropathic identification. Precisely because toys and play are not "serious," toy art is so eminently suitable to solicit such heteropathic identification, which begins to blur overly rigid boundaries.

{ ART AND PEDAGOGY }

So far, I have put forward the notion that the traditional, dogmatic rules for Holocaust remembrance and education are inevitably a framing device for understanding the Holocaust art that challenges those rules. This frame is so powerful because where the Holocaust is concerned, education more than any other cultural practice is the transgenerational tool for remembrance. This view risks subjugating art to the pedagogical pursuit of Holocaust education. Through its reference to childhood, toy art endorses this subjugation but changes its terms. This antagonistic pedagogy as a major feature of the toys suggests that Holocaust art is a special negative case of aesthetics in its "interestedness." It is not autonomous, as art since modernism likes to see itself, but subordinated, put in the service of another, inevitably "higher" goal.

In contrast, in the wake of Kant, art is usually seen as disinterested, that is, free from educational ideals. The toy art discussed here breaks through this opposition. Distinct from such a subjugation of Holocaust art to education, Libera's works seem to imply that Holocaust art and other kinds of art are not at all opposed. In this respect Holocaust art is not different but, perhaps, only a stronger, more evident case of the pedagogical ambition of art in general. Hence, the shift this art brings to the pedagogy of remembrance also entails a change of aesthetics.

Libera's artistic interest is focused on those cultural products that serve to educate or to form the human being, and to "form" should be understood in the figurative as well as in the literal sense. The objects that he creates are made up of devices that already exist in the contemporary cultural world, such as toys or machines used in fitness clubs or beauty salons. These are not related to the Holocaust. Besides the *LEGO Concentration Camp Set,* for example, he made *You Can Shave the Baby.* These are five pairs of baby dolls, with a shock of red hair emanating from their heads, and sprouting from their pubic areas, lower legs, and underarms. *Ken's Aunt* is a Barbie doll in the form of an overweight woman. These works have an upbeat tone to them that contrasts sharply with Rosen's suicide scene, yet in Rosen's work, the earlier erotic fantasies have a similar artificial positivity to them. Libera's *Doll You Can Undress* is a doll that reveals her stomach area and visible intestines. And *Eroica* is a set of fifty boxes of small bronze figurines that look like toy soldiers. But this time it is not the army but civilians, women, and the oppressed of society that are the toy soldiers we play with. The tone here is more unsettling. Other works by Libera present themselves as "correcting devices," such as *Universal Penis Expander, Body Master,* and *Placebo.* What matters in this non-Holocaust aspect of Libera's work is the emphasis on correc-

tion or "forming." "Forming" takes on a multilayered meaning. In light of this, the "making" that underlies them all receives yet another nuance.

Although Libera's *LEGO Concentration Camp Set* is unique in his artistic oeuvre in having the Holocaust as its subject matter, all of his works address, literally or figuratively, the education of body and of mind. In an illuminating essay, Andrew Boardman has argued that Libera challenges the contemporary belief that aesthetic values are disinterested, fluid, or free-form. On the contrary, contemporary Western art is essentially a remnant from an indelible nineteenth-century construct according to which art and education go hand in hand with moral strength and prudence.

Although art produced today likes to believe that it has shed the majority of those stodgy 19th century precepts, it has carefully disguised them in the fine-woven cloak of pedagogy. The built-in assumption of art today is that it acts to inform us, develop our faculties and therefore deliver us from a transgressive and earthly ignorance into the safe arms of civilization. . . . One might argue that Libera's work, because of its visual connection to child development and to learning, superficially epitomizes this 19th century bourgeois outlook. In fact, by wrapping his work in this upright mode of educational discourse, Libera questions the sweet platitudes and patronizing certainties of art that adhere in our educational aspirations for visual culture. (1998, n.p.)

From this perspective, the target of Libera's *LEGO Concentration Camp Set* is twofold. In addition to exposing the repressions and inhibitions of Holocaust education and its conceptions of remembrance, he also exposes the moral rectitude of (contemporary) art.

These two conclusions make it clear that we cannot stop at the idea that in modern Western culture art unavoidably teaches and forms. The specificity of toy art remains play, which is also the tool for freedom from pedagogical lessons. The intricate relationship between art and teaching can be neither dismissed nor endorsed. No matter what art's pedagogical mission is, the function of play in relation both to art and to teaching needs to be considered. The question that is thrust on us is also double: Does play teach, and how does play teach differently? Is the result or mastery provided by play of a different order than the mastery resulting from cumulative and progressive learning?

{ HOLOCAUST NARRATIVE VERSUS HOLOCAUST DRAMA }

To understand how the mastery provided by toys differs from the mastery provided by "learnable" knowledge, both modes of learning must be analyzed in

terms of the generic discourse to which each belongs. "Learnable knowledge" of the Holocaust takes the form of narrative. Personal narratives in the form of testimonies, diaries, or memoirs are seen as especially instructive, teaching later generations not simply the facts of the Holocaust but also about its apocalyptic inhumanity. It is safe to assume that all Holocaust education, including that in the form of art, shares this goal. But the artworks by Levinthal, Libera, Katzir, and Rosen don't tell us much about the past. Like Boltanski in his *Comic Sketches* before them, they envision playing the past. And I use the verb "envision" emphatically because—with the possible exception of Katzir, who experimented with museum visitors actually coloring the books, on which more later—these works are not real toys. Instead, they are artworks in the form of toys.

These artworks are meant to be processed by adults, not by children. The distance between children playing and adults envisioning themselves as those children adds yet another layer of identification, in which adults act—or rather play-act—like children. In the art under scrutiny, a shift in semiotic mode is at stake. The Holocaust is not represented by means of narration but in the mode of drama or a script for a drama. This is, of course, more literally true in the cases of Katzir's installation and Libera's LEGO box than in the case of Levinthal's photographs. But I contend that Levinthal's photographs should also be understood as drama. It is as such that they solicit heteropathic identification and the possibility to identify with the other. In the case of the Holocaust the other is the moral other, no longer an inevitably abstract evil force from the beyond but a person with whom one can even feel complicitous. Drama, then, becomes a centrally important semiotic mode of education.

James Young has remarked that the photographs of Levinthal's *Mein Kampf* generate a powerful sense of the past through a measured act of simulation. He uses the phrase "a sense of the past" to distinguish an effect from an actuality (1996, 72). What strikes me most, however, and in analogy to Young's view, is how these works generate a "sense of the present." I don't see fictional narrativized images of a concentration camp. What I see, what I imagine, or even what I am is a subject in post-Holocaust culture playing with a (fake) concentration camp. The narrative images are embedded in, or produced by, an act that should generically be defined as drama. And this difference between narrative and drama is of crucial importance in understanding what is at stake in the artworks under discussion.

You cannot actually play with Libera's LEGO boxes. But they evoke the possibility of a scene in which somebody in post-Holocaust culture performs Holocaust events within the setting of a camp. Constructing the setting, the artist facilitates the articulation of playacting Holocaust events. Katzir's work does not just envision the dramatic mode of representation, it really enacts it. In his installa-

73 | Ram Katzir, installation view of *Your Coloring Book: A Wandering Installation,* Utrecht. Courtesy of the artist.

tions of *Your Coloring Book,* realized in different ways in Utrecht, Enschede, Jeruzalem, Vilnius, Krakow, Berlin, and Amsterdam, visitors were invited to sit on school benches and to color or draw in the coloring books that had been placed on classrooms desks or tables (fig. 73). The visitors were drawn into a performance in which they actualized, shaped, and colored—in other words, generated—Nazi characters.

This dramatic aspect of the toy artworks is important in terms of both education and, specifically, Holocaust remembrance. For the difference between narrative and drama is particularly relevant for the understanding—a condition for curing—trauma. Drama is a very particular cultural form that is fundamentally different in form and effect from narrative. And this specificity of drama improves what toy art offers to Holocaust education and remembrance. In order to assess the crucial difference between works of art that narrate events from the Holocaust and those that perform or playact it, the distinctions the French psychiatrist Pierre Janet made between narrative memory and traumatic memory, already discussed in chapter 8, are again helpful.[8] Because this distinction is also very important for an understanding of how the artworks under discussion relate to the history of the Holocaust, let me recall this argument.

As I explained, narrative memory consists of mental constructs that people use to make sense out of experience. Current and familiar experiences are auto-

matically assimilated or integrated in existing mental structures. But some events resist integration: "Frightening or novel experiences may not easily fit into existing cognitive schemes and either may be remembered with particular vividness or may totally resist integration" (Kolk and Hart 1995, 160). The memory of experiences that resist integration in existing meaning schemes are stored differently and are not available for retrieval under ordinary conditions.

Trauma can be seen as failed experience. It is precisely this failure that makes it impossible to remember the event voluntarily. This is why traumatic reenactments take the form of drama, not narrative. Drama just presents itself, or so it seems; narrative implies some sort of mastery by the narrator. This is a fundamental difference. Bal sees this difference between narrative and drama as a matter of control over the events. Whereas the narrator of a story can always manipulate, expand and reduce, summarize, highlight, underscore, or minimize elements of the story at will, these options are inaccessible to the "actor" who is bound to enact a drama (Bal 1999b, ix).

This distinction between narrative memory and traumatic memory does not apply literally to the artworks under discussion. Although these works are not narrative, it is of little help to see them as instances of traumatic memory. These works are not involuntary reenactments of the Holocaust but, rather, purposeful attempts to shed the mastery that Holocaust narratives provide. Instead, they entice the viewer to enter into a relationship that is affective and emotional rather than cognitive.

Mastery is again the issue, but this time the method for obtaining this mastery is totally different: not mastery through knowledge but mastery by admitting affect. This is by no means a passive opening up but an active countering of the foreclosure brought about by narrative mastery. To explain how these imaginative attempts to work through trauma work, yet another distinction must be invoked. I am referring to the distinction made by Eric Santner between "narrative fetishism" and mourning. He defines narrative fetishism as the construction and deployment of a narrative consciously or unconsciously designed to expunge the traces of the trauma or loss that called that narrative into being in the first place. The work of mourning, on the contrary, is a process of elaborating and integrating the reality of loss or traumatic shock by remembering and repeating it in symbolically and dialogically mediated doses. It is a process of translating, troping, and figuring loss (Santner 1992, 144).

Santner uses, of course, Freud's discussion of the *fort/da* game in *Beyond the Pleasure Principle* to explain the mechanisms of mourning. Freud observed the *fort/da* game in the behavior of his one-and-a-half-year-old grandson. In this game, the child was able to master his grief over his separation from his mother by staging—playacting—his own performance of her disappearance. (She was

gone—*fort:* then she was there—*da.*) This little boy, we can now see, was involved in heteropathic identification with the person who was, in his everyday drama, the "perpetrator," the mother who left him. He did so by repetition, using props that D. W. Winnicott would call transitional objects (1971). This game is based on a ritualized mechanism of dosing out and representing absence by means of substitutive figures. In the words of Santner:

> The dosing out of a certain negative—a thanatotic—element as a strategy of mastering a real and traumatic loss is a fundamentally homeopathic procedure. In a homeopathic procedure the controlled introduction of a negative element—a symbolic or, in medical contexts, real poison—helps to heal a system infected by a similar poisonous substance. The poison becomes a cure by empowering the individual to master the potentially traumatic effects of large doses of the morphologically related poison. In the fort/da game it is the rhythmic manipulation of signifiers and figures, objects and syllables instituting an absence that serves as the poison that cures. (1992, 146)

In the Holocaust toys, similarly, the poisonous—also Libera's word—stuff, needed in a carefully measured dose, is the "Holocaust effect": to playact the camps instead of talking about them or looking at them.

This "playing the Holocaust" does and does not distance the Holocaust in the past. It does not because through the programmed identification the viewer is situated inside the camp, building and generating it. The heteropathic identification with the perpetrator, moreover, is effectuated through the role of the child. In the case of Freud's grandson, it was the child's own drama that was enacted. Here, the child stands for the next generations, who need to learn a trauma they have not directly lived, although, as Marianne Hirsch and others have emphasized, they may suffer from postmemory (1997). But at the same time, by the same gesture, a double distance is produced: play instead of reality and art instead of real play, an institutional frame that sets these toys apart. To playact the Holocaust in this way is performed under the strict direction of a "director," a *metteur en scène,* which is radically distinct from a "revival" or "repetition" of Nazism in the dangerous shape of neo-Nazism.

{ TOUCHING TOYS }

Why it is that this trend of "playing" the Holocaust by means of toys characterizes the art of this current second, third, and fourth generation of post-Holocaust survivors and bystanders? How can this work contribute to the cultural necessity to shake loose the traumatic fixation in victim positions that might be

partly responsible for the "poisonous" boredom that risks jeopardizing all efforts to teach the Holocaust under the emblem "never again"?

In the face of the overdose of information and educational documentary material, there is clearly a need to complete a process of working through not yet "done" effectively. The overdose was counterproductive. In the face of that overdose, "ignorance" is needed. An ignorance not in terms of information about the Holocaust events but of everything that stands in the way of a "felt knowledge" of the emotions these events entailed—primarily, of the narrative mastery so predominant in traditional education.

In that perspective, the toys, with their childish connotations, "fake" that ignorance that clears away the "adult" overdose of information that raises obstacles to felt knowledge. Mastery, then, is no longer an epistemic mastery of what happened but a performative mastery of the emotions triggered by the happenings. Only by working through knowledge that is not "out there" to be passively consumed but "felt" anew every time again by those who must keep in touch with the past can art be effectively touching.

NOTES

{ INTRODUCTION }

1. See the "Visual Culture Questionnaire," *October,* vol. 77 (Summer 1996), esp. the statements by Hal Foster, Thomas Crow, Martin Jay and Rosalind Krauss.

{ CHAPTER 1 }

1. Damisch, an emeritus professor of the history and theory of art at the École de Hautes ?tudes en Sciences Sociales in Paris, has published on a great variety of artists, themes, and problematics without limiting himself to one specific region or period. He has published articles on (among others) Mondrian, Pollock, Gropius, Goya, Dubuffet, Viollet-Le-Duc, Giotto, Cézanne, Duchamp and chess, Gustave Eiffel, Paul Klee, art historians Meyer Schapiro and Erwin Panofsky, and structural anthropologist Claude Lévi-Strauss. In addition to several volumes of collected essays, he has published three voluminous studies that have received canonical status in art history in a very short time: *Théorie du /nuage/: Pour une histoire de la peinture* (1972), *L'Origine de la perspective* (1987), *Le Jugement de Paris* (1992).

2. Damisch's *Theory du /nuage/* has recently been translated into English as *A Theory of the /Cloud/: Toward a History of Painting*, trans. Janet Lloyd (2002). The quotes from his text are my translation.

3. For an analysis of the formless, see Bois and Krauss (1997).

4. For an analysis of the relation between Damisch's rhetorical mode of writing and his vision on perspective, see Bal (1996, 165–94). See also Polan (1990).

5. This way of putting Damisch's reading activity is an allusion to Barbara Johnson's reading of "the difference within" in her book *The Critical Difference* (1980).

{ CHAPTER 2 }

1. A more sophisticated approach to the portrait can be found in Woodall (1997, 1–28).

2. For the use of the photographic portrait in medical and legal institutions, see Tagg (1988) and Sekula (1989). Sekula argues that the photographic portrait extends and degrades a traditional function of artistic portraiture, which is to provide the ceremonial presentation of the bourgeois self. "Photography came to establish and delimit the terrain of the *other,* to define both the *generalized look*—the typology—and the *contingent instance* of deviance and social pathology" (345).

3. This does not imply that the artist who has made the portrait is irrelevant in the National Portrait Gallery. The artist's name functions as an authenticating device. For critical discussions of the National Portrait Gallery, see Barlow (1997) and Hooper-Greenhill (2001).

4. See Walton (1993).

5. Brilliant sees the portrait as a transcendent entity: "Portraits concentrate memory images into a single, transcendent entity; they consolidate many possible, even legitimate, representations into one, a constant image that captures the consistency of the person, portrayed over time but in one time, the present, and potentially, forever" (1990, 13) I contend that his transcendent entity, the result of the concentration of several images into one, is based on the same representational logic as Gadamer's "increase of being."

6. See Benjamin (1991). Benjamin discusses the semantic economy of mimetic representation from a philosophical perspective. I follow here the main points of his argument.

7. This example is mentioned by Svetlana Alpers (1988). For a study of Rembrandt's self-portraits, see Chapman (1990). A semiotic perspective on his self-portraits, related to psychoanalysis, is proposed by Bal in *Reading "Rembrandt"* (1991).

8. This is not a complete characterization of these specific portraits. Buchloh argues that Sander's work has at the same time a more traditional side: "It shifts between a reactionary impulse to restore the credibility of essentialist notions of subject formation, along with a revision of the traditional hierarchical and mimetic models of representation, and a conservative doubt concerning the radical, immediate, and universal applicability of an open—both photographic and social—structure" (1994, 58). For my argument here, this other side of Sander does not change the theoretical point I am making.

9. See, for a brilliant Lacanian analysis of Sherman's *Untitled Film Stills,* the last two chapters of Kaja Silverman's *The Threshold of the Visible World* (1996).

10. For a relevant discussion of Bathes's view on the mortifying effect of discourse, see Jefferson (1989).

11. See my book *Francis Bacon and the Loss of Self* (1992).

12. In chap. 3, titled "Death," of ibid., I develop a view of the portrait and of Bacon's deconstructions of that view by focusing on Bacon's famous "pope paintings." I discuss the pictorial genre of the portrait there in comparison with the literary genre of the detective.

13. This situation of a figure opening or closing a door is a recurrent motif in Bacon's oeuvre. See, e.g., the central panel of *In Memory of George Dyer* (1971), *Painting* (1978), the outer panels of *Triptych* (1981), and *Study of the Human Body* (1983).

14. See his *Fragment of a Crucifixion* (1950), *Three Studies for a Crucifixion* (1962), and *Crucifixion* (1965).

15. In Vermeer's *Woman with a Balance* in the National Gallery of Art in Washington D.C., a tiny nail in the wall on the left of the represented painting of the Last Judgment, also suggests a critical note on the illusionary quality of realistic painting. See the opening pages of Bal (1991).

16. For this concept, see my *Caught by History* (1997). The concept refers to representational practices that do not represent the Holocaust in mediated forms but that reenact it.

17. Or rather, the pieces of furniture pretend to, and thus do, represent the idea of having been contiguous to the woman. Boltanski later admitted that he had "cheated" the audience by exhibiting furniture that he had borrowed from personal acquaintances. But this only proves the semiotic status of his work. The sign, according to Umberto Eco's definition of it, is "everything which can be used in order to lie" (1976, 10).

18. For a seminal discussion of the important role of the index in contemporary art, see Krauss (1985). For an analysis of the index in relation to issues of individuality and the body, see Bal, "Deixis: Special Pleading for an Orientation of the Index" (in 1999a, 149–64).

19. In other indexical portraits, the Holocaust effect is even more directly pursued. Part of the installation *Storage Area of the Children's Museum* (1989), e.g., consisted of racks with clothing. The piles of cloths that are stored on the shelves refer to the incomprehensible numbers who died in the concentration camps.

20. For an analysis of subjectivity and the function of the mask in the work of the photographer Ralph Eugene Meatyard, see Marianne Hirsch (1994).

21. This is especially the case in *Warhol's Child* (1991) but also in those paintings that expose the tradition of the female nude: *Snow White and the Broken Arm* (1988), *The Guilt of the Privileged* (1988), *Snow White in the Wrong Story* (1988), *Waiting (for Meaning)* (1988), and *Losing (Her Meaning)* (1988).

22. See, e.g., Kathy Siegel (2001) and Jessica Morgan's interview with Dijkstra (2001).

23. The work of Nan Golden is another good example.

{ CHAPTER 3 }

1. See, e.g., Juriëns (2001).

2. The "place" I speak of here is the place left in the past that evokes a clearly bounded and rooted locale with a deeply felt sense of authenticity arising from rootedness. However, there are other ways of thinking about "place," e.g., in terms of a "global sense of place" that can be understood as an intersection of flows that is different from any other intersection. See Massey (1993, 1997).

3. See, esp. James Clifford's *The Predicament of Culture* (1988) and his more recent and specifically relevant article on migration (1999).

4. See Bardenstein (1999) and Said (2000).

5. See Silverman (1983).

6. See, e.g., Fabian's *Power and Performance* (1990) for an extensive discussion of the advantages of the model of performance over that of dialogue.

7. Calvino (1974). All quotations in this text are taken from Tan's video.

8. See for an overview of representations of Saint Sebastian in twentieth century art: Heusinger van Waldegg (1989).

9. An excellent reading of *Smoke Screen, Tuareg,* and *Cradle* is given by Cooke (2000).

{ CHAPTER 4 }

1. See Damisch (1994) and my discussion of Damisch in chap. 1.

2. See, e.g., Alpers (1983).

3. Van Mander, quoted by Melion (1991). All quotes from Van Mander, are translations found in Melion (1991).

4. In Dutch, "Een perspectyff", see Giltaij (1991, 9).

5. In her analysis of the modernist grid, Krauss has balanced the idea of the objective character of the picture surface as stated by the grid, by stressing the presupposed role of the viewing subject: "the modernist grid also has—and this very forcefully—the capacity to body forth the subjective nature of the matrix that receives it. . . . The grid occupies a subjective rather than an objective pole, and it is in this sense that it becomes the perfect vehicle for the mapping of opticality or what came to be called 'vision as such'" (1995, 308).

6. For a lucid discussion of Bond's work, see Halkes-Halim (2001).

7. Mieke Bal calls this "reversed" relation between past and present, "preposterous history" (1999a).

8. See Krauss, "Mechanical Ballets: Light, Motion, Theater" and "The Double Negative: A New Syntax for Sculpture" (in 1977).

9. Gallery Konrad Fischer ,1991; Kunsthalle Bern, 1992; and Stedelijk Museum Amsterdam 1996.

10. This is an allusion to Fredric Jameson's book on structuralism, *The Prison-House of Language: A Critical Account of Structuralism and Russian Formalism* (1972).

{ CHAPTER 5 }

1. Bal (1991) elaborates this distinction in an analysis of the nude (in Rembrandt), a subject not indifferent to the topic of this chapter.

2. Gayle Rubin takes this idea as the starting point for her famous article "The Traffic in Women" (1975), a founding article in feminist anthropology.

3. Umberto Eco makes this exchange a model for the principle of semiosis (1976, 3–31).

4. This label "romantic" must not be seen in the historically limited sense but as a cultural tendency that goes back to much earlier times. For a discussion of Italian Renaissance painting and homosociality, see Simons (1997).

5. See Bataille (1987).

6. On the possibility of the look as mutually constitutive of subjectivity, see Silverman (1996).

7. In many cultures, taking pictures is considered as similar to taking the soul away.

8. For more on this, see the chap. 6.

9. These features are all negatives of usual modes of characterization. See Bal (1997) and Rimmon-Kenan (1983).

10. For theoretical discussions of masculinity, see Silverman's *Male Subjectivity at the Margin* (1992), Bryson's "Géricault and Masculinity" (1993), and the chapter titled "Masculinity" in my *Francis Bacon and the Loss of Self* (1993). On the rewriting of this difference-based masculinity, see the chap. 6.

11. On the generation and structure of masochism, see Freud's essay "A Child Is Being Beaten" ([1919] 1955) and Silverman's analysis of this text in *Male Subjectivity* (1992).

12. From Adrienne Rich, "Sibling Mysteries," in *The Dream of a Common Language* (1978).

13. Hence, this vision not only characterizes the hierarchical system and Robert's relationship to Colin but also representation as such. The discussion of the portrait in chap. 2 is premised on this view of representation.

14. For more on the significance of the model, see chap. 7.

15. For a discussion of *mise-en-abyme,* see Bal, (1997, 57–58).

{ CHAPTER 6 }

1. See Silverman (1992, 362–73).

2. For gender and sexuality as performative effects, see Judith Butler's *Gender Trouble* (1990) and *Bodies that Matter* (1993).

3. See, e.g., Jerry Saltz, "The Next Sex" (1996).

4. See, for a reading of bodybuilding, the chapter "Masculinity" in my book *Francis Bacon and the Loss of Self* (1992).

5. Besides the gym and bodybuilding, medicine also plays an important role in Barney's work, especially in *Cremaster 1*. Although medicine is not associated with masculinity in the same way that bodybuilding is, what the two practices have in common is that they both define the body as something to act on and that they both attempt to surpass the body's limits.

6. In Barney's work, the body must always strain against resistance. In the *Drawing Restraint* series, e.g., actual drawings were made by building and using various prostheses that required acts of strength, athleticism, and endurance by Barney just to get pencil to paper in the first place. *Drawing Restraint* is predicated on the idea of defeating the facility of drawing through the application of arbitrary, self-imposed restraints.

7. Two key figures in Barney's work are the master escapist and the legendary all-pro center of the Oakland Raiders football team who continued playing even with a plastic knee.

8. See Deleuze's book on Francis Bacon (1984).

9. When Barney is asked if his work is about adopting different personas, about the social roles we all play, he denies that: "I think that it exists more as an internal structure. Although I refer to them as characters, I think that they're internal constructions, psychological facets, I don't think there is enough character development to consider them as personas" (Sans 1995, 29) Barney's resistance to persona, or character, can be seen as his resistance to fixed identities. He wants to explore the possibilities from within the body and resist or postpone character development: "In that way there is a lack of character development that interests me—the fact that they can quiver between something that is understood as a character with agency and something that operates more as a state of some sort, or a zone" (Sans 1995, 30).

{ CHAPTER 7 }

1. Dumas is not only a visual artist but also a prolific writer. Her texts have been collected in *Sweet Nothings: Notes and Texts* (1998).

2. For a discussion of the female nude, see Nead (1992) and Pointon (1990).

3. For a discussion of this ambiguity in the concept of mimesis, see Bal (1982), a propos of Dupont-Roc and Lallot (1980).

4. These two aspects of the grotesque—the inside turned outward and the fascination with gaps—were represented by two exhibits at the 1995 Biennale in Venice. Mona Hatoum's video of the interior of the body represents the former (*Corps étranger* [1994], Centre Georges Pompidou), whereas Sammy Cucher's *Dystopia,* a series of photographic portraits where mouth, eyes, and sometimes nose had been edited out, represents the latter by way of contrast.

5. I have examined the shattering effect of sexuality and the experience of the bodily self in my book *Francis Bacon and the Loss of Self* (1992), esp. in the chapters "Bodyscapes" and "Masculinity."

6. On the aggressive fragmentation of women that underlies this ideal, see Francette Pacteau's chapter "Shattered Beauty" in her book *The Symptom of Beauty* (1994).

7. For a discussion of the use of models in the training programs of the academies in nineteenth-century Europe, see Linda Nochlin, "Why Have There Been No Great Women Artists?" in *Women, Art, and Power and Other Essays* (1988). And for a discussion of the same issue for the American context, see Elizabeth Hollander, "Artists' Models in Nineteenth-Century America" (1993).

8. Dumas, personal communication, June 1995.

9. Dumas's critique of art history and its practitioners is emphatic in her work *Hell* (1987–90). In an allusion to Sartre's play *Huis clos* ("L'enfer, c'est les autres"), she depicts hell as a gathering of art historians and art critics drowning in Monet's *Nymphéas,* as the subtitle indicates ("The people of the Artworld in Monet's lake of searoses").

10. The most blatant example of the refusal to assign meaning to Dumas's work is an essay by Marcel Vos ("Maken en betekenis") in the catalog *Miss Interpreted* (1992). In a religious idealization of speechlessness, Vos, acting as the quintessential "pornographic" critic, writes his essay solely on the uninterpretability of art. Thus, he bypasses not only the work itself but also the very title of the exhibition he was commenting on: the second *s* of "miss" made him miss the miss that he was misinterpreting.

11. For a detailed analysis of the mechanisms of sexual engagement by vision and of Rembrandt's countering these mechanisms, see Mieke Bal (1991).

{ CHAPTER 8 }

1. Lawrence Langer also discusses this videotaped testimony in his book *Holocaust Testimonies: The Ruins of Memory* (1991, 123).

2. For an extensive analysis of why Holocaust experiences have disrupted the ability to remember, see my book *Caught by History* (1997), esp. chap. 2, "Testimonies and the Limits of Representation."

3. See, e.g., Sander Gilman's essay on Benigni's film (2000), which I will address more elaborately in the chap. 9.

4. Shakespeare's *Lucrece* is entirely structured around the opposition between vision as "true" and language as a fallen state of man, in which deception is the order of the day. But already there in the play, the opposition falls apart. And so it does today. For a discussion of Shakespeare's *Lucrece* in these terms, see Mieke Bal's "The Story of W" in her *Double Exposures* (1996).

5. For a more extensive discussion of Armando's work, see my book *Armando: Shaping Memory* (2000).

6. These originally Polish texts have since 1967 been available in English under the title *This Way for the Gas, Ladies and Gentlemen*.

7. For a discussion of Janet's ideas, see Kolk and Hart (1995, 158–82).

8. Charlotte Delbo, *Auschwitz et après* (Paris, Les Éditions de Minuit, 1970–71). This trilogy consists of *Aucun de nous reviendra* (1965), *Une connaisance inutile* (1970), and *Mesure de nos jours* (1971). The trilogy has been translated into English by Rosette C. Lamont as *Auschwitz and After* (1995); quotations in the text are from this edition.

9. For a more extensive account of Delbo's life, see the introduction by Lawrence Langer to the English translation of her trilogy *Auschwitz and After* (1995).

10. For the distinction between punctual and durative events, see Bal (1997, 93).

{ CHAPTER 9 }

1. The series *Comic Sketches* consists of the following "short stories": "Le Mariage des parents," "La Maladie du grand-père," "Les Souvenirs du grand-père," "La Toilette du matin," "La Mort du grand-père," "La Grosesse de la mère," "Le Baiser caché," "Le Grand-père a la pêche," "Les Bonnes notes," "L'Horrible découverte," "La Toilette de la mère," "Le Récit du père," "L'Anniversaire," "La Naissance de Christian," "Le Baiser honteux," "La Tache d'encre," "La Dureté du père," "La Première communion," "La Visite du doc-teur," "Le Père à la chasse," and "La Grimace punie."

2. The French term *interprétation* means interpretation in the sense of explanation but also "performance." The quotation comes from Renard (1984, 85).

3. See, for the documentation of this controversy, Katzir's catalog *Your Coloring Book: A Wandering Installation* (1998).

4. A transcript of this emotional discussion can be found in Aron et al. (1998).

5. See, for an elaboration of this argument, my book *Caught by History* (1997).

6. *New Introductory Lectures on Psychoanalysis* (1964, 149), quoted by Felman (1982); 23, emphasis in Felman.

7. See, on the issues of second-person narrative, Bal (1999a, chap. 6).

8. For a discussion of Janet's ideas, see Kolk and Hart (1995, 158–82).

BIBLIOGRAPHY

Abrams, M. H. 1953. *The Mirror and the Lamp: Romantic Theory and the Critical Tradition.* Oxford: Oxford University Press.

Adrichem, Jan van. 1993. "Al het nieuwe doet zich voor als dubbelzinnigheid." In *Vormgeven aan veelzijdigheid. Opstellen aangeboden aan Wim Crouwel ter gelegenheid van zijn afscheid als directeur van Museum Boijmans Van Beuningen.* Rotterdam: Museum Boijmans Van Beuningen, 154–63.

Alpers, Svetlana. 1983. *The Art of Describing: Dutch Art in the Seventeenth Century.* Chicago: University of Chicago Press.

———. 1988. *Rembrandt's Enterprise: The Studio and the Market.* Chicago: University of Chicago Press.

Alpers, Svetlana, and Michael Baxandall. 1994. *Tiepolo and the Pictorial Intelligence.* New Haven, CT: Yale University Press.

Alphen, Ernst van. 1992. *Francis Bacon and the Loss of Self.* London: Reaktion Books; Cambridge, MA: Harvard University Press.

———. 1997. *Caught by History: Holocaust Effects in Contemporary Art, Literature and Theory.* Stanford, CA: Stanford University Press.

———. 2000. *Armando: Shaping Memory.* Rotterdam: NAi Publishers.

Altman, Dennis. 1982. *The Homosexualization of America.* Boston: Beacon Press.

Amishai-Maisels, Ziva. 1993. *Depiction and Interpretation: The Influence of the Holocaust on the Visual Arts.* Oxford and New York: Pergamon Press.

Aron, Jacques, Claude Lorent, Yannis Thanassekos, Zbigniew Libera, and Samis Taboh. 1998. "Discussion." *Bulletin Trimestriel de la Fondation Auschwitz.* Special no. 60 (July–September), 225–40.

Bal, Mieke. 1982. "Mimesis and Genre Theory in Aristotle's Poetics." *Poetics Today* 3 (1):171–80.

———. 1991. *Reading Rembrandt: Beyond the Word-Image Opposition.* Cambridge and New York: Cambridge University Press.

———. 1996. *Double Exposures: The Subject of Cultural Analysis.* New York: Routledge.

———. 1997. *Narratology: Introduction to the Theory of Narrative.* Toronto: University of Toronto Press.

———. 1999a. *Quoting Caravaggio.* Chicago: University of Chicago Press.

———. 1999b. Introduction to *Acts of Memory: Explorations in Memory,* edited by Mieke Bal, Jonathan Crewe, and Leo Spitzer. Hanover, NH: University of New England Press, vii–xvii.

Bal, Mieke, and Norman Bryson. 1991. "Semiotics and Art History." *Art Bulletin* 73 (2):174–208.

Bann, Stephen. 1984. *The Clothing of Clio: A Study of the Representation of History in Nineteenth-Century Britain and France.* Cambridge and New York: Cambridge University Press.

———. 1989. *The True Vine: On Visual Representation and the Western Tradition.* New York: Cambridge University Press.

Bardenstein, Carol. 1999. "Trees, Forests, and the Shaping of Palestinian and Israeli Collective Memory." In *Acts of Memory: Cultural Recall in the Present,* edited by Mieke Bal, Jonathan Crewe and Leo Spitzer. Hanover, NH, and London: University Press of New England, 148–70.

Barlow, Paul. 1997. "Facing the Past and Present: The National Portrait Gallery and the Search for 'Authentic' Portraiture." In *Portraiture: Facing the Subject* edited by Joanna Woodall. Manchester: Manchester University Press, 219–38.

Barthes, Roland. 1982. *Camera Lucida: Reflections on Photography.* Translated by Richard Howard. London: Fontana.

Bataille, Georges. 1987. *Erotism.* Translated by Mary Dalwood. London: Boyars.

———. [1947] 1991. "Concerning the Accounts Given by the Residents of Hiroshima." *American Imago* 48 (4):497–514.

Baxandall, Michael. 1985. *Patterns of Intention: On the Historical Explanation of Pictures.* New Haven, CT: Yale University Press.

Benjamin, Andrew. 1991. "Betraying Faces: Lucien Freud's Self-Portraits." In *Art, Mimesis and the Avant-Garde.* London and New York: Routledge, 61–74.

———. 1994. "Installed Memory: Christian Boltanski." In *Object Painting.* London: Academy Editions, 54–69.

Benveniste, Emile. 1966. *Problèmes de linguistique générale.* Vol. 1. Paris: Gallimard.

———. 1970. "L'appareil formelle de l'énonciation." *Langage* 17:12–18; reprinted in *Problems in General Linguistics.* Translated by Mary Elizabeth Meek. Coral Gables, FL: University of Miami Press, 1971.

Bergmann, Martin S. 1976. "Love That Follows upon Murder in Works of Art." *American Imago* 38 (1):98–101.

Bergson, Henri. [1908] 1991. *Matter and Memory.* Translated by N. M. Paul and W. S. Palmer. New York: Zone Books.

Bersani, Leo. 1986. *The Freudian Body: Psychoanalysis and Art.* New York: Columbia University Press.

———. 1989. "Is the Rectum a Grave?" In *AIDS: Cultural Analysis, Cultural Activism,* edited by Douglas Crimp. Cambridge, MA: MIT Press, 197–222.

Bersani, Leo, and Ulysse Dutoit. 1985. *The Forms of Violence: Narrative in Ancient Assyria and Modern Culture*. New York: Columbia University Press.

——. 1990. *The Culture of Redemption*. Cambridge, MA: Harvard University Press.

Boardman, Andrew. 1998. *Zbigniew Libera*. Warsaw.

Bois, Yve-Alain. 1987. "Kahnweiler's Lesson." *Representations* 18:33–68; reprinted in *Painting as Model*. Cambridge, MA: MIT Press, 1990.

Bois, Yve-Alain, and Rosalind Krauss, 1997. *Formless: A User's Guide*. New York: Zone Books.

Borowski, Tadeusz. 1976. *This Way for the Gas, Ladies and Gentlemen*. Selected and translated from the Polish by Barbara Vedder; introduction by Jan Kott. New York: Penguin Books.

Bradley, Paul, Charles Esche, and Nichola White. 1994. "An Interview with Christian Boltanski." In *Christian Boltanski: Lost*. Glasgow: CCA Tramway, 3–4.

Brilliant, Richard. 1990. "Portraits: A Recurrent Genre in World Art." In Jean M. Borgatti and Richard Brilliant, *Likeness and Beyond: Portraits from Africa and the World*. New York: Center for African Art, 11–27.

——. 1991. *Portraiture*. London: Reaktion Books; Cambridge, MA: Harvard University Press.

Brydon, Anne. 1994. "Notes toward Situating *Social Centers*." In *Elenor Bond: Social Centers*. Winnipeg: Winnipeg Art Gallery, 49–53.

Bryson, Norman. 1983. *Vision and Painting: The Logic of the Gaze*. New Haven, CT: Yale University Press.

——. 1993a. "Géricault and Masculinity." In *Visual Culture: Images and Interpretation,* edited by Norman Bryson, Michael Holly, and Keith Moxey. Hanover, NH: Wesleyan University Press, 228–259.

——. 1993b. "House of Wax." In Rosalind Krauss, *Cindy Sherman, 1975–1993*. New York: Rizzoli, 216–23.

——. 1994. "Art in Context." In *Studies in Historical Change,* edited by Ralph Cohen. Charlottesville: University of South Carolina Press.

——. 1995. "Matthew Barney's Gonadotropic Cavalcade." *Parkett* 45:29–35.

Buchloh, Benjamin H. D. 1994. "Residual Resemblance: Three Notes on the Ends of Portraiture." In *Face-Off: The Portrait in Recent Art,* edited by Melissa E. Feldman. Philadelphia: Institute of Contemporary Art, 53–69.

Butler, Judith. 1990. *Gender Trouble: Feminism and the Subversion of Identity*. New York: Routledge.

——. 1993. *Bodies That Matter: On the Discursive Limits of "Sex."* New York: Routledge.

Calvino, Italo. 1974. *Invisible Cities*. (New York: Harcourt).

Caruth, Cathy. 1990. "The Claims of Reference." *Yale Journal of Criticism* 4 (1):193–205.

——. 1995. *Trauma: Explorations in Memory,* edited, with an introduction, by Cathy Caruth. Baltimore and London: Johns Hopkins University Press.

Cassirer, Ernst. [1924] 1955. *The Philosophy of Symbolic Forms*. Translated by Ralph Mannheim. New Haven, CT: Yale University Press.

Certeau, Michel de. 1984. *The Practice of Everyday Life*. Translated by Steven Rendall. Berkeley: University of California Press.

Chapman, H. Perry. *Rembrandt's Self-Portraits*. Princeton, NJ: Princeton University Press, 1990.

Clifford, James. 1986. "Introduction: Partial Truths." In *Writing Culture: The Poetics and Politics of Ethnography,* edited by James Clifford and George E. Marcus. Berkeley; University of California Press, 1–26.

———. 1988. *The Predicament of Culture: Twentieth-Century Ethnography, Literature, and Art.* Cambridge, MA: Harvard University Press.

———. 1997. *Routes: Travel and Translation in the Late Twentieth Century.* Cambridge, MA: Harvard University Press.

———. 1999. "Diasporas." In *Migration, Diasporas and Transnationalism,* edited by S. Vertovec and R. Cohen. Cheltenham: Edward Elgar Publishing, 215–51.

Cooke, Lynne. 2000. "Fiona Tan: Re-Take." In *Fiona Tan: Scenario.* Amsterdam: Vanderberg & Wallroth, 20–34.

Craft, Christopher. 1989. "Kiss Me with Those Red Lips: Gender and Inversion in Bram Stoker's *Dracula.*" In *Speaking of Gender,* edited by Elaine Showalter. New York: Routledge, 216–41.

Crimp, Douglas. 1999. "Getting the Warhol We Deserve: Cultural Studies and Queer Culture." *In Visible Culture: An Electronic Journal for Visual Studies* 1:1–20.

Damisch, Hubert. 1972. *Théorie du /nuage/: Pour une nouvelle histoire de l'art.* Paris: Editions du Seuil; translated as *A Theory of the /Cloud/: Toward a History of Painting.* Translated by Janet Lloyd. Stanford, CA: Stanford University Press, 2002.

———. 1987. *L'origine de la perspective.* Paris: Flammarion.

———. 1992. *Le jugement de Pâris.* Paris: Flammarion; translated as *The Judgment of Paris.* Translated by John Goodman. Chicago: University of Chicago Press, 1996.

———. [1987] 1994. *The Origin of Perspective.* Translated by John Goodman. Chicago: University of Chicago Press.

da Vinci, Leonardo. 1956. *Treatise on Painting.* Translated and annotated by A. Philip McMahon. Princeton, NJ: Princeton University Press.

Delbo, Charlotte. 1965. *Aucun de nous reviendra.* Paris: Les Éditions de Minuit.

———. 1970. *Une connaissance inutile.* Paris: Les Éditions de Minuit.

———. 1971 *Mesure de nos jours.* Paris: Les Éditions de Minuit.

———. 1996. *Auschwitz and After.* Translated by Rosette C. Lamont. Introduction by Lawrence L. Langer. New Haven, CT: Yale University Press.

Deleuze, Gilles. 1984. *Francis Bacon: Logique de la sensation.* Paris: Éditions de la différence.

Derrida, Jacques. 1978. *La vérité en peinture.* Paris: Editions du Seuil.

———. 1981 *Dissemination.* Translated, with an introduction and additional notes, by Barbara Johnson. Chicago: University of Chicago Press.

Des Pres, Terrence. 1988. "Holocaust Laughter." In *Writing and the Holocaust,* edited by Berel Lang. New York and London, Holmes & Meier, 216–33.

Dumas, Marlene. 1982. "Statements." *Dutch Art and Architecture Today* 12 (December): 14–19.

———. 1992. *Miss Interpreted.* Eindhoven: Van Abbe Museum.

——. 1998. *Sweet Nothings: Notes and Texts.* Edited by Mariska van den Berg. Amsterdam: Uitgeverij De Balie.

Dupont-Roc, Roselyne, and Jean Lallot. 1980. *La poétique: Aristote.* Translated and annotated by Roselyne Dupont-Roc and Jean Lallot, with an introduction by Tzvetan Todorov. Paris: Seuil.

Eco, Umberto. 1976. *A Theory of Semiotics.* Bloomington: Indiana University Press.

Ellis, John. 1980. "Photography/Pornography, Art/Pornography." *Screen* 20, no. 1 (Spring): 81–108.

Ezrahi, Sidra Dekoven. 1980. *By Words Alone: The Holocaust in Literature.* Chicago and London: University of Chicago Press.

——. 1996. "Representing Auschwitz." *History and Memory* 7, no. 2 (Fall/Winter): 121–54.

Fabian, Johannes. 1990. *Power and Performance: Ethnographic Explorations through Proverbial Wisdom and Theater in Shaba, Zaire.* Madison: University of Wisconsin Press.

Felman, Melissa. 1994. "The Portrait: From Somebody to No Body." In *Face-Off: The Portrait in Recent Art,* edited by Melissa Felman. Philadelphia: Institute of Contemporary Art, 9–50.

Felman, Shoshana. 1982. "Psychoanalysis and Education: Teaching Terminable and Interminable." *Yale French Studies* 63:21–44.

Fine, Ellen S. 1988. "The Absent Memory: The Act of Writing in Post-Holocaust French Literature." In *Writing and the Holocaust,* edited by Berel Lang. New York and London: Holmes & Meier, 41–57.

Fischer, Michael M. J. 1986. "Ethnicity and the Postmodern Arts." In *Writing Culture: The Poetics and Politics of Ethnography,* edited by James Clifford and George E. Marcus. Berkeley: University of California Press, 194–233.

Foster, Hal. 1996a. "The Archive without Museum." *October* 77 (Summer): 97–119.

——. 1996b. *Return of the Real: The Avant-garde at the End of the Century.* Cambridge, MA: MIT Press.

Freud, Sigmund. [1905] 1953. *Three Essays on the Theory of Sexuality.* In *The Standard Edition of the Complete Psychological Works of Sigmund Freud.* Translated and edited by James Strachey. Vol. 7. London: Hogarth Press, 125–230.

——. [1919] 1955. "A Child Is Being Beaten: A Contribution to the Study of the Origin of Sexual Perversions." In *The Standard Edition of the Complete Psychological Works of Sigmund Freud.* Translated and edited by James Strachey. Vol. 17. London: Hogarth Press, 175–204.

——. [1920] 1955. "The Psychogenesis of a Case of Homosexuality in a Woman." In *The Standard Edition of the Complete Psychological Works of Sigmund Freud.* Translated and edited by James Strachey, Vol. 18. London: Hogarth Press, 145–74.

——. [1930] 1961. *Civilization and Its Discontents.* In *The Standard Edition of the Complete Psychological Works of Sigmund Freud.* Translated and edited by James Strachey. Vol. 21. London: Hogarth Press, 64–148.

——. [1933] 1964. *New Introductory Lectures on Psychoanalysis.* In *The Standard Edition of the Complete Psychological Works of Sigmund Freud.* Translated and edited by James Strachey. Vol. 22. London: Hogarth Press, 5–184.

Friedlander, Saul. 1993a. *Memory, History and the Extermination of the Jews of Europe.* Bloomington: Indiana University Press.

———. [1982] 1993b. *Reflections of Nazism: An Essay on Kitsch and Death.* Translated by Thomas Weyr. Bloomington: Indiana University Press.

———, ed. *Probing the Limits of Representation: Nazism and the "Final Solution."* Cambridge, MA: Harvard University Press.

Fuchs, Rudi. 1987. "The Eye Framed and Unframed." In *Jan Dibbets.* Minneapolis: Walker Art Center, 47–67.

Gadamer, Hans-Georg. [1960] 1975. *Truth and Method.* Translated by Joel Weinsheine and Donald G. Marshall. New York: Continuum.

Garber, Marjorie. 1992. *Vested Interests: Cross-Dressing and Cultural Anxiety.* New York: Routledge.

Gilman, Sander. 2000. "Is Life Beautiful? Can the Shoah Be Funny? Some Thoughts on Recent and Older Films." *Critical Inquiry* 26 (Winter): 279–308.

Gilroy, Paul. 1993. *The Black Atlantic: Double Consciousness and Modernity.* Cambridge, MA: Harvard University Press.

Giltaij, Jeroen. 1991 "Perspectieven, Saenredam en de architectuurschilders van de 17e eeuw." In *Perspectieven: Saenredam en de architectuurschilders van de 17e eeuw,* edited by Jeroen Giltaij and Guido Jansen. Rotterdam: Museum Boijmans Van Beuningen, 8–18.

Girard, René. 1961 *Mensonge romantique et vérité romanesque.* Paris: Grasset; reprinted as *Deceit, Desire, and the Novel: The Self and Other in Literary Structure.* Translated by Ivonne Freccero. Baltimore: Johns Hopkins University Press 1965.

Gombrich, E. M. 1986 "Ideal and Type in Italian Renaissance Painting." In *New Light on Old Masters.* Oxford: Phaidon Press, 89–124.

Goux, Jean-Joseph. 1978. *Les iconoclastes.* Paris: Éditions du Seuil.

Gumpert, Lynn. 1994. *Christian Boltanski.* Paris: Flammarion.

Gupta, Akhil, and James Ferguson. 1992. "Beyond 'Culture': Space, Identity, and the Politics of Difference." *Cultural Anthropology* 7 (1):6–23.

Halkes-Halim, Petra. 2001. "Aspiring to the Landscape: Investigations into the Meaning of Nature in Works by Wanda Koop, Stephen Hutchings, Susan Feindel and Eleanor Bond." Ph.D. diss., Leiden University.

Hartman, Geoffrey H. 1994. "Public Memory and Its Discontents." *Raritan* 13, no. 4 (Spring 1994): 24–40.

———. 1996. *The Longest Shadow: In the Aftermath of the Holocaust.* Bloomington: Indiana University Press.

Heidegger, Martin. 1977. *The Question concerning Technology and Other Essays.* Translated by William Lovitt. New York: Garland Science.

Herman, Judith Lewis. 1992. *Trauma and Recovery.* New York: Basic Books.

Heusinger van Waldegg, Joachim. 1989. *Der Künstler als Märtyrer: Sankt Sebastian in der Kunst des 20. Jahrhunderts.* Worms: Wernersche Verlagsgesellschaft.

Hirsch, Marianne. 1994. "Masking the Subject: Practicing Theory." In *The Point of Theory: Practicing Cultural Analysis,* edited by Mieke Bal and Inge E. Boer. Amsterdam: Amsterdam University Press.

———. 1997. *Family Frames: Photography, Narrative and Postmemory.* Cambridge, MA: Harvard University Press.

Hollander, Elizabeth. 1993. "Artists' Models in Nineteenth-Century America." *Annals of Scholarship* 10 (3–4):281–304.

Hooper-Greenhill, Eleane. 2000. *Museums and the Interpretation of Visual Culture.* London: Routledge.

Ian, Garcia. 1996. "When Is a Body Not a Body? When It's a Building." In *Stud: Architectures of Masculinity,* edited by Joel Sanders. New York: Princeton Architectural Press, 188–205.

Jameson, Fredric. 1972. *The Prison-House of Language: A Critical Account of Structuralism and Russian Formalism.* Princeton, NJ: Princeton University Press.

Jefferson, Ann. 1989. "Bodymatters: Self and Other in Bakhtin, Sartre and Barthes." In *Bakthin and Cultural Theory,* edited by K. Hirschkop and D. Shepherd. Manchester: Manchester University Press.

Johnson, Barbara. 1980. *The Critical Difference.* Baltimore: Johns Hopkins University Press.

Juriëns, Edwin. 2001 *Cultural Travel and Migrancy.* Leiden: CNWS.

Kant, Immanuel. [1790] 1987. *Critique of Judgment.* Translated by Werner S. Pluhar. Indianapolis: Hackett Publishing.

Katzir, Ram. 1998. *Your Coloring Book: A Wandering Installation.* Amsterdam: Stedelijk Museum.

Kolk, Bessel A. van der, and Onno van der Hart. 1995. "The Intrusive Past: The Flexibility of Memory and the Engraving of Trauma." In *Trauma: Explorations in Memory,* edited by Cathy Caruth. Baltimore: Johns Hopkins University Press, 158–82.

Krauss, Rosalind. 1977. *Passages in Modern Sculpture.* New York: Viking.

———. 1979. "Grids." *October* 9 (Summer): 51–64.

———. 1985. "Notes on the Index: Part 1" and "Notes on the Index: Part 2." In *The Originality of the Avant-garde and Other Modernist Myths.* Cambridge, MA: MIT press, 196–209 and 210–220.

———. 1994. *Cindy Sherman, 1975–1993.* New York: Rizzoli.

———. 1995. "The Grid, the True Cross, the Abstract Structure." *Studies in the History of Art* 48: 303–12.

———. 1996. "Agnis Martin: The /Cloud/." In *Inside the Visible: An Elliptical Traverse of Twentieth-Century Art, in, of, and from the Feminine,* edited by Catherine de Zegher. Cambridge, MA: MIT Press.

Lacan, Jacques. 1977. *Écrits: A Selection.* Translated by Alan Sheridan. New York: Norton.

Langer, Lawrence. 1991 *Holocaust Testimonies: The Ruins of Memory.* New Haven, CT: Yale University Press.

Lefebvre, Henri. 1991 *The Production of Space.* Translated by Donald Nicholson-Smith. London: Basil Blackwell.

Lévi-Strauss, Claude. [1949] 1969. *Les structures élémentaires de la parenté.* Paris: Plon; reprinted as *The Elementary Structures of Kinship,* translated by James Harle Bell, John Richard von Sturmer, and Rodney Needham. Boston: Beacon Press.

Mander, Karel van. 1973. *Den Grondt der edel vry schilder-const: Uitgegeven en van vertaling en commentaar voorzien door Hessel Miedema.* Utrecht: Haentjes Dekker & Gumbert.

Massey, Doreen. 1993. "Power-Geometry and Progressive Sense of Place." In *Mapping the Futures: Local Cultures, Global Change,* edited by J. Bird, B. Curtis, T. Putman, G. Robertson, and L. Tickner. London: Routledge, 315–23.

——. 1997. "A Global Sense of Place." In *Reading Human Geography: The Poetics and Politics of Inquiry,* edited by T. Barnes and D. Gregory. New York: Arnold Press, 315–23.

McEwan, Ian. 1981 *The Comfort of Strangers.* London: Jonathan Cape.

Melion, Walter S. 1991 *Shaping the Netherlandish Canon: Karel van Mander's "Schilder-Boeck."* Chicago and London: University of Chicago Press.

Menke, Christoph. 1998, *The Sovereignty of Art: Aesthetic Negativity in Adorno and Derrida.* Translated by Neil Solomon. Cambridge, MA: MIT Press.

Morgan, Jessica. 2001 "Interview." In *Rineke Dijkstra: Portraits.* Ostfildern: Hatje Crantz Verlag, 74–81.

Morrison, Toni. 1987a. *Beloved.* New York: Alfred A. Knopf.

——. 1987b. "Site of Memory." In *Inventing the Truth: The Art and Craft of Memoir,* edited by William Zinsser. Boston: Houghton-Mifflin, 111–12.

Nead, Linda. 1992. *The Female Nude: The Art of Obscenity and Sexuality.* London: Routledge.

Nochlin, Linda. 1974. "Some Women Realists." *Arts Magazine* (May), 29.

——. 1988. *Women, Art, and Power and Other Essays.* New York: Harper & Row Publishers.

Onfray, Michel. 1995. "Mannerist Variations on Matthew Barney." *Parkett* 45:50–56.

Pacteau, Francette *The Symptom of Beauty.* London: Reaktion Books.

Panofsky, Erwin. [1924–25] 1991. "Die Perspektive als 'symbolische Form." *Vortrage des Bibliothek Warburg,* 258–330, reprinted in *Aufsätze zu Grundfragen des Kunstwissenschaft.* Berlin, 1964, 99–167, and, in English, as *Perspective as Symbolic Form.* Translated by Christopher Wood. New York: Zone Books, 1991.

Pointon, Marcia R. 1990. *Naked Authority: The Body in Western Painting, 1830–1908.* Cambridge: Cambridge University Press.

Polan, Diana. 1990. "History in Perspective, Perspective in History: A Commentary on *L'origine de la perspective* by Hubert Damisch." *Camera Obscura* 24 (September): 89–97.

Proust, Marcel. 1954. *A la recherche du temps perdu.* Paris: Gallimard (Pléiade).

Renard, Delphine. 1984. "Entretien avec Christian Boltanski." In *Boltanski.* Exhibition catalog. Paris: Musée National d'Art Moderne, 70–85.

Rich, Adrienne. 1978. *The Dream of a Common Language.* New York: Norton.

Rimmon-Kenan, Shlomith. 1983. *Narrative Fiction: Contemporary Poetics.* London: Methuen.

Rothman, Roger. 1997. "Mourning and Mania: Roee Rosen's Live and Die as Eva Braun." In Roee Rosen, *Live and Die as Eva Braun: Hitler's Mistress, in the Berlin Bunker and Beyond— an Illustrated Proposal for a Virtual-Reality Scenario, Not to Be Realized.* Jerusalem: Israel Museum, n.p.

Rubin, Gayle. 1975. "The Traffic in Women: Notes on the Political Economy of Sex." In *Toward an Anthropology of Women,* edited by Rayna R.Reiter. New York and London: Monthly Review Press, 157–210.

Said, Edward. 2000. "Invention, Memory and Place." *Critical Inquiry* 26 (Winte): 175–92.

Saltz, Jerry. 1996. "The Next Sex." *Art in America* (October), 85–91.

Sans, Jérôme. 1995. "Matthew Barney: héros modernes/Modern Heroes." *Art Press* 204 (July–August): 25–32.

Santner, Eric. 1992. "History beyond the Pleasure Principle: Some Thoughts on the Representation of Trauma." In *Probing the Limits of Interpretation: Nazism and the "Final Solution,"* edited by Saul Friedlander. Cambridge, MA: Harvard University Press, 143–54.

Saunders, Gill. 1989. *The Nude: A New Perspective.* Philadelphia: Harper & Row.

Schmidt-Wulffen, Stephan. 2000. "With My Own Eyes." In Fiona Tan, *Scenario.* Amsterdam: Vanderberg & Wallroth, 161–70.

Sedgwick, Eve Kosofsky. 1985. *Between Men: Homosocial Desire and the English Novel.* New York: Columbia University Press.

———. 1990. *Epistemology of the Closet.* Berkeley and Los Angeles: University of California Press.

Sekula, Allan. 1989. "The Body and the Archive." In *The Contest of Meaning: Critical Histories of Photography,* edited by Richard Bolton. Cambridge, MA: MIT press. 343–89.

Siegel, Katy. 2001. "Real People." In *Rineke Dijkstra: Portraits.* Ostfildern: Hatje Cantz Verlag, 8–21.

Silverman, Kaja. 1983. *The Subject of Semiotics.* Oxford: Oxford University Press.

———. 1989. "Fassbinder and Lacan: A Reconsideration of Gaze, Look, and Image." *Camera Obscura* 19:54–84.

———. 1992. *Male Subjectivity at the Margin.* New York: Routledge.

———. 1996. *The Threshold of the Visible World.* New York: Routledge.

Simon, Patricia. 1997. "Homosociality and Erotics in Italian Renaissance Portraiture." In *Portraiture: Facing the Subject,* edited by Joanna Woodall. Manchester: Manchester University Press, 29–51.

Stewart, Susan. 1984. *On Longing: Narratives of the Miniature, the Gigantic, the Souvenir, the Collection.* Baltimore: Johns Hopkins University Press.

Sylvester, David. [1975] 1987. *The Brutality of Fact: Interviews with Francis Bacon.* London: Thames & Hudson.

Tagg, John. 1988. *The Burden of Representation: Essays on Photography and Histories.* Amherst: University of Massachusetts Press.

Tan, Fiona. 2000. *Scenario.* Amsterdam: Vanderberg & Wallroth.

Theweleit, Klaus. [1977] 1987–89. *Male Fantasies.* Translated by Stephen Conway in collaboration with Erica Carter and Chris Turner. Minneapolis: University of Minnesota Press.

———. 1985. "The Politics of Orpheus between Women, Hades, Political Power and the Media: Some Thoughts on the Configuration of the European Artist, Starting with the Figure of Gottfried Benn; Or, What Happens to Euridice?" *New German Critique* 36:133–56.

———. 1988. *Buch der Könige.* Basel: Stroemfeld Roterstern.

Tickner, Lisa. 1988. "Feminism, Art History, and Sexual Difference." *Genders* 3:92–128.

Vischer, Theodora. 1996. *FremdKörper–corps étranger–Foreign Body: Videoinstallationen von Matthew Barney, Mona Hatoum, Gary Hill, Bruce Nauman, Marcel Odenbach, Bill Viola.* Basel: Museum für Gegenwartskunst.

"Visual Culture Questionnaire" 1996. *October,* vol. 77 (Summer).

Vos, Marcel. 1992. "Making and Meaning in the Marge of Miss Interpreted." In Marlene Dumas, *Miss Interpreted.* Eindhoven: Van Abbe Museum, 102–10.

Walton, Kendall L. 1993. *Mimesis as Make-Believe: On the Foundations of the Representational Arts.* Cambridge, MA: Harvard University Press.

Wakefield, Neville. 1995. Untitled contribution in *Matthew Barney: Pace Car for the Hubris Pill.* Rotterdam: Museum Boijmans Van Beuningen, 15–19.

Watney, Simon. 1987. "The Spectacle of Aids." *October* 43:78–79.

Williamson, Judith. 1983. "Images of Women." *Screen* 24 (November): 232–48.

Winnicott, D. W. 1971. "Transitional Objects and Transitional Phenomena." In *Playing and Reality.* New York: Basic Books, 1–25.

Woodall, Joanna, ed., *Portraiture: Facing the Subject.* Manchester: Manchester University Press.

Young, James. 1996. "David Levinthal's *Mein Kampf:* Memory, Toys, and the Play of History." In David Levinthal, *Mein Kampf.* Santa Fe, NM: Twin Palms Publishers, 67–82.

INDEX OF TERMS AND CONCEPTS

aesthetic/aesthetics, xxi, 5, 12–18, 152, 154,
 174–79
 of art as agency, xiii, xiv
 experience, xv, 149
 judgment, 13–18
 modern, xv
 understanding, xvi
affect/affective/affecting, xix, xx, 179
agency, xiv, xvi, xvii, 119, 142
 of art xiii
allegory, 115, 117, 119, 120
anthropology, 58–59, 69–70, 100–101, 208n2
Apartheid, 43
architecture, xvii, 71–95
art history, xiii, 2–5, 9, 10–11, 146, 154–59,
 210n9
 social, xiv
art (that) "thinks," xiv, xv, xvi, xvii, 1–18
authenticity, xvi, 21, 23–25, 165
authority, xvi, xvii, 22, 25, 43–44, 106, 160
autonomous art / autonomy of art, xvi, 18,
 108

beauty, xix, 12–18, 62–65, 152–57
body, female, xix
bodybuilding, 128–33, 136–37, 209n4

canon/canonization/canonizing, xiv
celebrity, xiv
class society, xvi

/cloud/, 5–9, 35
collecting/collection, xiv
consumption, xiv
copy, 153–55
culture/cultural
 "high," xiv
 "mass" or popular, xiv
 studies, xv, 4

diaspora, 54–55
discourse, discursive, xiii, xv, 31
documentary, 165
Dracula, 118

elite/elitist, xx
epistemology, 5, 49, 56, 69, 164, 179
exhibitionism, 124, 142
experience, aesthetic. *See* aesthetic/aesthet-
 ics, experience
eyewitness, xx, 164

femininity, xviii, 28–30, 110–11, 125–26,
 128–39, 140–60
feminism, 28, 208n2
first person, 11–12, 166–67, 172
footage, archival, 48, 51, 56, 59, 70
formlessness, 16, 175, 205n3
frame/framing, xiii, xviii, 4, 30, 86–88
freak, 148–51

gaze, 99–119, 145

gender, xviii, xix, 43

genealogy, xiv

genitals, xviii, 13–18, 120, 124, 137

glance, 99–100, 109

grid, 71–72, 85–86, 90, 92, 113, 208n5

grotesque, 145–48, 151, 155

historical/history/historicity, xiii, 2–5, 18,
 40–43, 50, 60, 73, 165, 178
 of art (*see* art history)
 of artistic forms, xiv

Holocaust, xix, xx, 38, 40–41, 163–79
 education, xx
 effect, 40–41, 44, 207n19
 literature, 163–79

homeland, 50, 60–61

homosexual/homosexuality, 103–5, 111,
 116–18, 123–28, 139

homosocial/homosociality, xviii, 99–119, 129

hybridity, 53, 134

iconography, 6

ideal/idealization, 23, 146–48, 152–55, 210n6

identification, xv, 1, 55, 61, 107, 125–27

identity, xiv, 30, 40–41, 45–47, 49–56, 107,
 115, 124, 127, 134, 142–45, 151, 209n9

illusionism, 75–83

image, xvii, xx, 61–69, 163–79

imagination, 49, 54, 66–67, 163, 179

incest taboo, 101

individualism/individuality, xvi, xviii, 2,
 21–23, 27–28, 37–38, 44–47, 143,
 207n18

intention/intentionalism, xiv

interdisciplinary/interdisciplinarity, xiii, xiv,
 xv, 3–4

interpellation, 11

intertextuality, 28, 51

Judgment of Paris 15–18, 102

landscape, xvi, xvii, 71–95

linear perspective, 7–12, 18, 71, 78–83, 205n4

literary studies, xiii

male, xviii, 113
 body, 62

Mary Magdalene, 157–60

masculinity, xviii, 43, 62, 107, 110–19,
 120–39, 208n10

mask, 40–41, 207n20

masquerade, 30, 37, 45, 125, 133, 142

mass media, 30

memory, 38–39, 49–50, 166, 170–71, 174–79,
 206n5
 common, 170
 deep, 170
 external, 170, 171, 174, 176
 habit, 168
 narrative, 168, 169–70, 177
 sense, 170, 171, 176
 traumatic, 168, 169–70, 177

migrant/migration/migrancy, 49–61, 207n3
 virtual, 53

mimesis, xix, 22–25, 27, 35, 43, 47, 151–55,
 206n6, 210n3

mirror, 8, 37, 100, 108–10, 113, 157

mise-en-abyme, 114–15, 209n15

model, xix, 142–48, 151–60
 artist's, xix, 142–47, 155–57, 210n7
 fashion, xix
 pornography, xix

modernity, xvii, 25

narrative/narrativity, xx, 65–66, 110–11, 134,
 157, 164, 166–74

nation state, 53, 55

negative/negativity, xv

Oedipus complex, 102, 126

originality, 25, 28, 47

patronage, xiv

penis, 128, 134, 139

performance, 7, 28, 139, 207n6

performative/performativity, xiii, xiv, xvi,
 xviii, 50–51, 125, 127

phallus, 128

photography, 10, 22–23, 27, 31, 37–40, 44–47,
 49, 50, 62, 66, 77–79, 85, 100–104,
 109, 113, 117–18, 153, 155, 205–6n2

place, 51–53, 207n2
pornography, 147–48, 154–55, 179
portrait/portraiture, xvi, xvii, 21–47, 140–42,
 205n2, 206n12
 group portrait, 40–44, 140–42
 groups of portraits, 140–43, 151
posing, 45–47
prothese, 129
psychoanalysis, 5, 13–18, 30, 136

reason, limits of, xv
reflection, 35
representation
 mimetic, xvii
 of space, xvii
rhetoric
 of illusionism, 75–77
 of rhetoric, 75

satyr, 120–23, 131, 136
Sebastian, Saint, 61–67, 207n8
second person address, 11–12
self, loss of, xvii, 25, 31
selfhood, xiv
self-reflexivity, 149
semiotic/semiotics, xv, xvi, xvii, 24–25, 31,
 39, 206n7
sexual/sexuality, xiv, xviii, 12–18, 123, 147,
 159
 desire, 14–15
 excitement, 13–14
shadow, xvii, 49, 66–67
shooting, xvii
simulacrum, 25, 28, 37
space, xvii, 11, 67, 72–73, 77, 85, 90–91, 133
 illusionistic, 75–77, 79–84, 86
 of representation, 73–74, 83
structuralism, 3
subject/subjectivity, 9, 18, 21–47, 109, 112,
 126, 129, 147–48, 160, 207n20, 208n6
sublimation, 14
symbolic form, 9
symbolic order, 11, 30, 47

testicles, 133–34
testimony, 164, 166–68, 174, 210n2

thematic/theme, xiv
trauma/traumatic, xix, xx, 106, 165–79
 memory, 163, 168
 reenactment, 168–69

video, xvi, 10, 48, 50, 65, 129
visibility/visible, xiv
visual/visuality, xx
 imprint, 164, 168–69, 174
 studies, xv
 thought, 1–18, 47, 59

working through / worked-through, xx, 164,
 178

INDEX OF NAMES AND TITLES

Adorno, Theodor W., xv
Adrichem, Jan van, 85
Alpers, Svetlana, 2
Altman, Dennis, 124
Arends, Jan, 44
Aristotle, 146
Armando, 165

Bacon, Francis, 31–35, 47
Bal, Mieke, 99–100, 168–69, 201, 208n1,
 208n7, 211n4, 211n10
Balzac, Honoré de, 15, 140
Barney, Mathew, xviii, 120–39, 209n6
Barthes, Roland, 31, 66
Bataille, Georges, 108
Baxandall, Michael, 2
Benigni, Roberto, 185–86, 188
Benjamin, Andrew, 24, 35–37
Benveniste, Emile, 11
Boardman, Andrew, 198
Bois, Yve-Alain, 25, 205n3
Boltanski, Christian, xvi, xx, 37–44, 47, 165,
 180–84, 199, 207n17, 211n1
Bond, Eleanor, 81–84
Borowski, Tadeusz, 163, 166–69, 177–78
Brilliant, Richard, 22, 206n5
Brown, Norman O., 128
Brunelleschi, Filippo, 8–9, 12
Bryson, Norman, 99–100, 109, 128–31,
 153–54

Buchloh, Benjamin, 25–27, 41, 206n8
Butler, Judith, 209n2

Calvino, Italo, 59–60
Cassirer, Ernst, 9–10
Celan, Paul, 178
Clifford, James, 53–54, 59
Comfort of Strangers, The. See McEwan, Ian
Cooke, Lynn, 207n9
Craft, Christopher, 118
Crimp, Douglas, xiv
Crow, Thomas, 205n1

Damisch, Hubert, xiv, xv, xix, 1–18, 35, 72,
 102, 205n1
 Judgment of Paris, The, xv, xix, 5, 12, 13,
 18, 102
 Origin of Perspective, The, xv, 3, 5, 8, 12,
 18, 58, 84
 Theory of the /Cloud/, xv, 2, 5, 8, 12, 18
Darville, Helen, 185
Dekoven Ezrahi, Sidra, 176–78
Delbo, Charlotte, xx, 169–79
Deleuze, Gilles, 134
Derrida, Jacques, 187
Des Pres, Terrence, 188–89
Dibbets, Jan, xviii, 77–81, 84–85
Dijkstra, Rineke, 44–47
Dumas, Marlene, xvi, xix, 40–47, 140–60

Eco, Umberto, 207n17

Felman, Shoshana, 186–87, 196
Fischer, Michael M. J., 51
Flinck, Govert, 24
Flood, Richard, 133
Foster, Hal, 56, 205n1
Frank, Anne, 187
Freud, Lucien, 35–37
Freud, Sigmund, 13–18, 102, 125–27, 136,
 168, 188, 196
 Beyond the Pleasure Principle, 201–2
 Civilization and Its Discontents, 13, 15
 Three Essays on the Theory of Sexuality, 13
Fuchs, Rudi, 79–80

Gadamer, Hans-Georg, 22–24, 35
Galileo, 7
Garber, Marjorie, 136
Gilman, Sander, 185–86, 188
Gilroy, Paul, 54–55
Giltaij, Jeroen, 208n4
Girard, René, 100, 102
Gombrich, Ernst, 152–57, 160
Gumpert, Lynn, 38

Hatoum, Mona, 210n4
Hegel, 186
Heidegger, Martin, 58
Hirsch, Marianne, 202, 207n20
Hollander, Elizabeth, 210n7
Hong Kingston, Maxine, 50
Houckgeest, Gerard, 87

Janet, Pierre, 168–70, 176–77, 200
Jay, Martin, 205n1
Johnson, Barbara, 205n5
Judgment of Paris, The. See Damisch, Hubert

Kant, Immanuel, 13–18, 102, 197
Katzir, Ram, xx, 181–82, 184, 186, 189–91,
 195, 199–200
Koninck, Philips, 83–84, 90
Kosinski, Jerzy, 185
Krauss, Rosalind, 8, 28–30, 71, 205n1, 205n3,
 207n18

Lacan, Jacques, 11, 30, 124, 147
Langer, Lawrence, 210n1
Lefebre, Henri, 80
Leonardo da Vinci, 1, 2
Levi, Primo, 177–78
Levinthal, David, xx, 181–82, 184, 189–91,
 195, 199
Lévi-Strauss, Claude, 100–102
Libera, Zbigniew, xx, 181, 184, 187, 189–91,
 195, 197–99, 202
Lievens, Jan, 24

Mander, Karel van, 74–77, 84–85, 88, 92, 95
Manet, Édouard, 15, 160
Martin, Agnes, 71
McEwan, Ian, xviii, 99–119, 139
 Comfort of Strangers, The, xviii
Melion, Walter, 74–76
Menke, Christoph, xv, xvi
Michelangelo, 155
Morris, Robert, 90
Morrison, Toni, xx, 163–62

Nead, Linda, 210n2
Nochlin, Linda, 2, 210n7

Origin of Perspective, The. See Damisch, Hubert

Panofski, Erwin, 9
Picasso, Pablo, xvi, 15, 25–27, 44, 80–81, 84
Plato, 152–54
Proust, Marcel, 99

Raphael, 152–53, 155, 160
Rembrandt, 24
Rich, Adrienne, 112
Ripa, Cesare, 6
Rosen, Roee, xx, 193–99
Rothman, Roger, 195

Sander, August, 27
Santner, Eric, 201–2
Schmidt-Wulffen, Stephan, 52
Schouten, Marien, xviii, 71–95
Schrader, Paul, xviii, 105
Sedgwick, Eve, 100, 116

Sekula, Allan, 205n2

Shakespeare, 211n4

Sherman, Cindy, 28–30, 37, 40, 44, 47

Silverman, Kaja, 124–27, 196, 206n9, 208n10

Stewart, Susan, 140, 146–49

Sylvester, David, 31

Tagg, John, 205n2

Tan, Amy, 50

Tan, Fiona, xvii, xviii, 48–70

 Facing Forward, 56–70

 Kingdom of Shadows, 49, 66

 Lift, 67–69

 Linnaeus' Flower Clock, 48–49

 May You Live in Interesting Times, 50, 55

 Saint Sebastian, 61–67, 109

Theory of the /Cloud/. See Damisch, Hubert

Thomas, D. M., 185

Vasari, Giorgio, 10, 74

Wakefield, Neville, 128

Warburg, Aby, 15

Warhol, Andy, xiv, xvi, 28, 37, 40, 146

Watteau, Antoine, 15, 16, 102

Winnicott, D. W., 202

Woodall, Joanna, 205n1

Young, James 199